THE ART OF
JOHN HIGGINS

First published 2017 by
Liverpool University Press
4 Cambridge Street
Liverpool
L69 7ZU

British Library Cataloguing-in-Publication data
A British Library CIP record is available

ISBN 978-1-78694-027-8

Typeset by Carnegie Book Production, Lancaster
Printed and bound in Poland by Opolgraf

CONTENTS

Writer – Designer John Higgins
Editor Michael Carroll

THANKS TO:

Sally Jane Hurst for here and now.

Dave Gibbons for being there right from the beginning.

Curator of exhibition, Leonie Sedman, with valuable support and assistance from Kirsty Hall.

Michael Carroll for being the best other *Razorjack* writer and for his firm editing.

Mike Edwards for connecting all the dots and always pushing me in Liverpool.

Matthew Clough for making the exhibition and the book possible.

Julian Ferraro for the support and postscript.

Avram Buchanan for giving me an alternative view all those years ago.

Ken Jones for being a long-time supporter and collector.

Phil Rowland for being a dangerous artist.

And my favourite cartoonist ever, John "Herdy" Herdman.

Bren Evans for all her many years of belief and encouragement.

And the many, many people over the years who have been there for me, and in particular all those who worked, strived and drank at Courtney House in the golden years.

All at Liverpool University Press and Lucy Frontani at Carnegie without whose help it would have been less of a book. Any confusion, misinformation or lack of research is all my own responsibility.

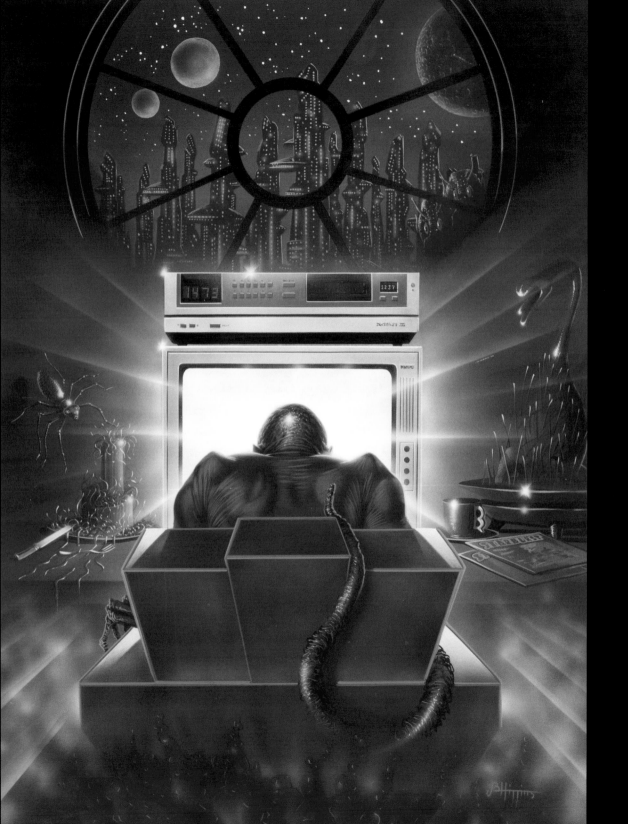

A speculative cover illustration I did for *Starburst* – editor Alan Mackenzie, future editor of *2000AD*.

The VCR (video recorder) and TV were not meant to be futuristic!

(Marvel) 1986

FOREWORD

John and I have been friends and collaborators for so long now that I'm unsure when it was that I first saw his work. I suspect it was probably in the pages of a *2000AD* annual, illustrating a full-colour Judge Dredd story. *Dredd* often appeared in colour in the weekly comic, but it utilised a cheap, crude, flat colouring process which often swamped the black line work beneath. By contrast, in the more expensively produced annual, John's vision of the character was printed in full colour with a gorgeous, rich palette and a full range of painterly effects. It was a revelation. The lush execution added a reality and drama which seemed to almost reinvent Dredd's world. I could feel the heat and dust of the Cursed Earth coming off the page.

I was soon admiring John's talent in a variety of *2000AD* and Marvel UK publications and I expect we finally met at a London comic mart or a meeting of the fledgling Society of Strip Illustration. Wherever it may have been, we hit it off from the start. John proved to be an affable, unassuming Scouser, with a dry sense of humour and a ready laugh. Like all of the most talented creators, he has no pretension about his work but approaches it enthusiastically and with a deep but understated skill. He is a consummate professional in everything he does.

Around the time we met, I was working on *Dr Who Weekly* for Marvel UK and was asked to do a full-colour cover for a collection of the early stories. I didn't have time to do the whole thing but suggested that I might draw it out in pencil and get John to finish it in paint. Everyone agreed and the final result lifted what I'd drawn to a whole new level. John completely understood my intentions with the piece and added a dramatic charge that greatly augmented what I'd drawn.

It was hardly surprising, therefore, that when Alan Moore and I got the go-ahead to develop *Watchmen* we chose John as our colourist. We wanted to have as much control over the look of the series as possible and not only was John highly talented and a friend, but he lived about ten miles away from me. In those pre-internet days, that meant we could review artwork together in person, with a beer in hand, rather than wait for the postman.

But it was more than just the practicalities. I had a hunch that, just as Alan and I wanted to do things that hadn't been seen in American comics before with the script and line art, John would be able to bring an equal freshness to the colouring. I had a vague idea that the colouring should look "European", but John went beyond that and planned sequences in terms of relative colour temperature, with connected scenes echoing each other, and using a palette based around secondary, rather than primary colours. It was a *tour de force* on his part, made all the more remarkable by the primitive technology available to provide colour separations. This involved painting Xerox copies of the line art with watercolour dyes and annotating each and every area of colour with arcane separation codes. These were then converted by lowly paid piece workers at the printers into separate acetate sheets painted with rubylith paint. Both John's and the separators' work was all made all the more difficult by the extreme level of detail crammed into each three-by-three page grid.

Watchmen #1 featuring the iconic image of the smiley badge with splash of blood. (DC) 1986.

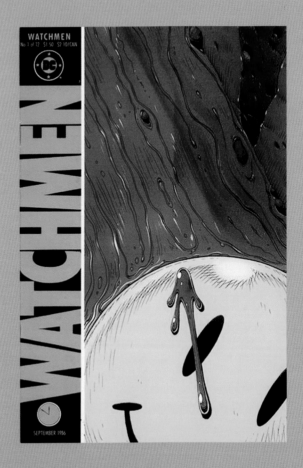

I was a hard taskmaster, too, initially concerned by just how far John had gone from what I imagined when labouring over the line work. But John could justify to me why he had made every colour choice and, as issues passed, I became more and more comfortable with what he was doing. Today, I cannot imagine *Watchmen* looking any other way, particularly once John had the chance, in the mid–2000s, to use computer technology to restore the parts of his master plan that had been blunted by the Dickensian production process originally available.

Watchmen went on to become, after the release of the 2009 movie adaptation, the best-selling graphic novel of all time, so his talents have been widely appreciated. But John is far, far more than "the guy who coloured *Watchmen*", as this current celebration of his work will attest.

Some of John's earliest professional work was as a medical illustrator and the combination of art and precision that this training required still infuses everything he does; exact effects of lighting and atmosphere are thrillingly depicted in all the images he produces. However bizarre the subject matter, there is always a sense of reality and believable functionality present. Not to mention an almost tactile quality to surfaces which further immerses the viewer in the imaginary scenes he creates. From the epic to the everyday, John has the talent of imbuing even the most outlandish subject with the crackle of experienced reality.

Take children's toys, for example. I rarely buy original artwork but one of my most prized pieces is John's painting of Optimus Prime who, I surely need not remind the reader, is the leader of the Transformer robots. The Transformers were a hugely popular toy franchise in the 1980s, featuring on everything from lunch boxes and sticker sets to T-shirts and a TV series. Marvel UK published their adventures and hired John to paint the cover of a Christmas annual. My son was a huge fan of the toy line and he loved the annual cover so much that I bought the original painting for him. He has long outgrown the toys but we both still love the image. Accurately drawn, to please even the most obsessive of nit-picking Transformer enthusiasts, the painting manages to be full of drama and artistic flourish, satisfying the fan of toy robots and beautiful painting equally.

While a great illustration almost inevitably tells a story, John's storytelling skills extend far beyond single images. The art of illustrating strip cartoons has complex requirements of its own, relating to clarity, continuity and composition. John has mastered all of these, too, producing a wealth of comic pages for both British and American publishers, sometimes rendered in full colour and sometimes in his vivid black-and-white line art techniques.

Often working with a writer, John displays a command of staging and action that draws the reader into the heart of the drama. He has brought life to the work of some of the most outstanding comic writers, from *2000AD*'s inspirational founders Pat Mills and John Wagner through Alan Moore to Garth Ennis, creator of hard-hitting, hard-boiled stories of war and crime for Marvel and DC Comics.

The first collected edition of the graphic novel showing how recognisable the smiley badge and blood-splash had become, even in extreme close-up.

(DC) 1988.

John's early work with writer Jamie Delano, *World Without End*, still stands, in my mind, as one of comics' most truly innovative series. A hallucinatory fantasy of an alien society, its fully painted pages crackle with life and invention and it is long overdue a reprinting for new generations of comics readers.

I've been lucky enough to write scripts for John myself, reviving an obscure British comics character called Thunderbolt Jaxon for no better reason than that I loved the name. We set the story in northern England and explored what would happen if the Norse gods still survived, immortals stripped of their powers until a gang of hapless kids unearth some magic objects. John's art perfectly added potency to my script, vividly evoking the windswept northern winter and bringing the cast of characters, both young and very old, vibrantly to life.

Given his grasp of dramatic storytelling, it's not surprising that John has felt the call to create story worlds of his own. Beginning in 1999, he has been at the helm of *Razorjack*, a complex and disturbing drama of hard-boiled cops on the trail of a serial killer from another dimension. Unsurprisingly, John's writing proves to be every bit as visceral, compelling and well-crafted as his artwork.

It's been a huge pleasure, over the years that I've known John, to see his art and accomplishments evolve and grow. It's been an equal pleasure to have had his friendship, through the thick and thin of both our professional and personal lives. We've travelled many a mile, enjoyed many a pint and many a rambling conversation on life, the universe and comic books.

I'm greatly pleased to have the opportunity to write this short personal appreciation of the man and his work. The recognition here afforded to him by the city of his birth is well-deserved and a fitting tribute to his contributions to the popular culture of the whole world.

And now, I think it's your round, John.

Dave Gibbons
June 2015

The monthly *Watchmen* covers. The use of extreme close-up of the first panel created a clever graphic lead-in to the first story page. Art by Dave Gibbons, colours John Higgins.

INTRODUCTION

I hadn't always wanted to be an artist. At one stage I wanted to be a writer of science fiction novels, but I soon found out for that you needed to know punctuation and the difference between a diphthong and a lace thong! I now know what a lace thong is but I'm still not too sure about the other. SF was a passion, and still is. Seeing different artists' visions or reading stories of strange worlds and future imaginings of human or alien societies … all of this still inspires me and drives me on to create the dark and twisted things that populate my worlds.

I want to make people believe in the impossible, and to give people a peek inside my tortured and twisted mind. Actually, I don't really think I *do* have a tortured and twisted mind, but to quote an anonymous Yorkshire man, "Everyone in this world is mad except for me and thee … and I am not too sure about thee!" I believe everyone has inside them the potential to create wonderful imaginings, but not many people have the opportunity to express them.

When I rediscovered comics as an art student, I found that it was possible to tell stories combined with the sort of imagery that impressed me. The SF artists that influenced me most in the early days were Roger Dean and Bruce Pennington, and once I discovered Richard Corben in the pages of American underground comix I knew the direction I wanted to take as an SF artist. Corben combined everything I loved about SF in one impressive whole, the colour of a Pennington with the SF story concepts of a Harry Harrison. Along with all this he brought visual storytelling in a dynamic way that I had not seen before. Extreme perspective, close-ups and highly detailed character depictions with such voluptuous sensibilities they appeared to be a whisker away from breathing into your face.

In his early days he used an airbrush to achieve three-dimensional tonal effects. Learning on the underground comics – which tended to be very cheap with everyone joining in to help produce the comic book for print – he found a way of using hand-separations to create a cost-effective, full-colour printing process using overlays. It was the same traditional flat-dot process used in every American news-stand comic at that time, but with his imagination and use of airbrush the effect Corben achieved was similar to the more expensive full-colour process used on quality magazines. His use of extreme colour combinations – such as placing deep purples against a green or an orange – gave a vibrancy to his slavering werewolves and glowing post-apocalypse mutants, colours that shrieked up into a radioactive haze. In a colour-theory sense these combinations should not work together, but they did.

This rediscovery of comics happened when I attended the Wallasey College of Art in Merseyside. I was fortunate in the principal, John Heritage, a fine artist and an open-minded tutor; Bob Hayward, our year-tutor and a lover of the British daily comic strip *Garth*; and Eric Foster, a younger tutor who had a fine-line style as an illustrator using Rotring technical pens and whose freelance work appeared in *Science Fiction Monthly*. I blame and bless a fellow student, Avram Buchanan, in equal measure for being the main reason for me being in comics. Avram's interest in the alternative culture introduced me to underground comics and subsequently to Richard Corben, and the rest is history.

Ten-year-old me – a long time before I knew the different between a diphthong and a lace thong.

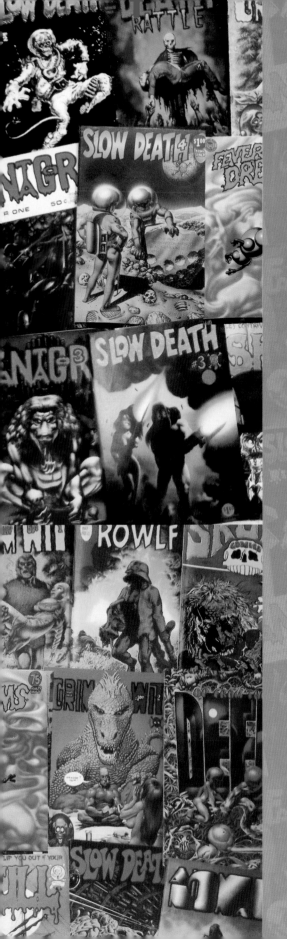

Science Fiction Monthly was a large-format newspaper-style magazine with original short stories by the then current SF writers, along with poster-size reproductions of SF book covers published by the parent company of the publication, New English Library (NEL). It was a brilliant way to be exposed to fantastical art that was reproduced five times larger than your standard paperback cover. To see Bruce Pennington's or Chris Foss's work in such detail was inspirational. They were instrumental – along with Frank Hampson, the British creator of Dan Dare for *Eagle* comic in the 1950s – in giving me the love of great SF illustration: you should only learn from the best.

The comics that surprised and influenced me at that time were mainly underground comics coming out of the US alternative scene. We were years behind what was happening in the USA or Europe in the context of comics for adults. Initially these appeared to me to be drug- or sex-themed comics, nothing more than prurient juvenile thumbing of the nose at the establishment, and – in America – at the Comics Code Authority in particular. The Comics Code dictated what the mainstream publishers could show in regular news-stand comics (one of the reasons why superheroes before the 1980s had no nipples – this included men).

The more I searched out "underground comix" – the "x" made all the difference – the more I realised that the majority of the creators loved SF. Alternative worlds have always been a literary device to express ideas in an entertaining and educational way, usually reaching a wider audience who might never read an earnest polemical article, no matter how heartfelt and honest. In mainstream writings from *Animal Farm* to *1984* by George Orwell, and almost anything by Philip K. Dick in SF, the use of ordinary everyday themes and ideas extrapolated to the extremes of possibility have always been a way of saying, "Look, stop and think!"

In the underground comix, SF gave the writers the opportunity to make satirical points about all aspects of modern-day society, racism, ecology and all the other "ologies and isms". Even if some did go into prurient juvenile themes, they were still making a point about the freedom of the press … Okay, we can debate *that* one!

Dark They Were and Golden-Eyed in London in the 1970s was one of the first specialist bookshops around. There were a few head- and music-stores in my home town of Liverpool (Probe and Atticus Books) that did have – intermittently – some alternative magazines or underground comics, but I needed a regular fix, and Dark They Were and Golden-Eyed was a place of pilgrimage for me when I was a student.

A small selection of my Richard Corben collection of underground comix. A fun search over many years, bookshop by bookshop.

My Corben-esque attempt for the cover of *Brainstorm Fantasy Comix*.

(Alchemy Press) 1979.

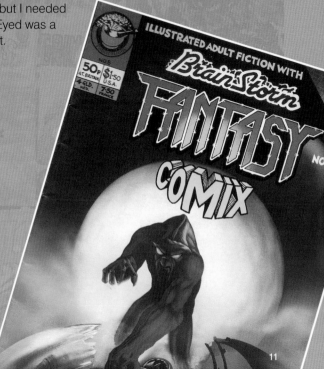

ILLUSTRATED ADULT FICTION WITH *Brainstorm* FANTASY COMIX

Compared to a normal bookshop, DTW&GE was a comics fan's heaven in the days of searching out (on foot!) the latest titles, because here, rather than maybe *one* title, you'd find hundreds. It was a joy to be able to pick and choose from the latest underground comics, to discover new artists such as Greg Irons, Robert Crumb and of course Richard Corben – a giant among comic artists and still producing work today. Any cover by Corben was a find, any complete story was a pot of four-colour gold. *Gore*, *Grim Wit*, *Rowlf* and *Cannibal Funnies* led me kicking and screaming (in sheer spine-chilling delight) down the horror SF path. Throw in a sick joke and I was hooked.

That shop also gave me a lesson in how a superstar acts … Harlan Ellison (SF writer of *A Boy and his Dog*, *"Repent, Harlequin!" Said the Ticktockman* etc.) had just been on a TV arts programme in the UK and I recognised him standing outside the shop among crates of fruit from the street market in Berwick Street, just down the road from Raymond's Revue Bar (tourists wending their way to that and other Soho strip-joints, squishing rotten fruit underfoot and stepping over junkies, avoiding drunks and prostitutes). With a camel-hair coat hanging off his shoulders and looking like Teflon man (nothing was sticking to him even in all this squalor), he instructed his minder to go in and tell the owner that Harlan Ellison was just about to walk into his shop! That was style with more than a smidgeon of self-confidence. I still can't bring myself to do that. "John who…?" would be the most likely reply.

Dark They Were and Golden-Eyed – along with the string of popular second-hand bookshops that you can find in most cities – is the reason I will never leave hard-copy books and comics behind, and the reason I still flick through piles of SF books in search of authors like Jack Vance or Robert E. Howard. I discovered Howard because of a cover by Frank Frazetta, and found that there was a power to the writing in pulp fiction. In the great pulp-writing tradition of Howard's day – the 1930s – the more words you wrote the more you earned. You did not have to be a good writer then, just fast. But out of that we got great characters and, sometimes, great writing.

Flicking through the books and comics, I discovered pure SF art and literature. Collecting became the thing, and don't forget the smell of a new book or an old comic. Some of my most prized comics are four well-thumbed, stained and yellowing *Green Lantern and Green Arrow* comics by Neil Adams and Denny O'Neil, with a number of price-stamps across the covers as each reader returned them to the popular second-hand bookshop, going from a high of 25 cents all the way down, four times, to 5 cents! Bargain.

My cover for an alternative lifestyle magazine.

(Lee Harris) 1980.

Metal Hurlant. (les humanoids). Covers by various artists.

12

I do not intend to get lost in trying to be too accurate with this book, and I hope not to drift into "dry" while trying to express what made me the artist that I am today. I do hope this book will be informative, with some pointers that might help new artists and storytellers, and even if you have no interest other than a love of reading comics, if I can offer you a sense of *my* love of comics, and my excitement at being allowed to tell comic stories, then it will be worth my while writing it and, I hope, yours reading it.

Memory *should* be slightly fuzzy, preferably with a rosy glow, and I hope not to dwell too much on those people who've said, "I have no idea how you can find work with a folder of art like this – it's rubbish" (thank you, a certain book company art director early in my career). Not too many of those types of comment, thank goodness, but artists are an ego-fragile breed: one misplaced criticism will stick in our brains like a seed burr on a woolly jumper. I stopped reading comments or criticisms a long time ago, after a particularly unfair fanzine review of one of the *Hellblazer* issues I had illustrated for DC Comics in the 1990s. I was at a convention soon after and met the editor of that fanzine. I told him that I felt the review was a bit unfair with no constructive perspective at all from the reviewer, and the editor said, "Oh don't worry about it. Sometimes we just pick a comic book at random and be intentionally critical. It doesn't mean anything." Yeah right!

To build worlds through words and pictures, and make them places in which people can believe, is for me the height of creativity. I intend to continue doing this until I slip, trip or step into some other world.

There is still a whole universe of untold stories I want to tell.

John Higgins
South coast of England, 2016

One of my favourite Dan Dare story arcs, *Safari in Space*. Cover by Dan Dare creator Frank Hampson.

From Warren publishers – *Creepy* comic magazine. Covers by various artists.

ONCE UPON A TIME
GETTING STARTED

Comic artist is not one of those careers you can really plan for. You can't go up to a careers officer at school and expect a sympathetic ear. It must come a close second to, "I want to be a reality show star." Is it even a real job? I sometimes wonder because I can't believe this is what I do for a living: I am paid to create impossible places and creatures, to try to make the unbelievable believable. The French have a saying: "If you have a job you love you never work a day in your life." Which means I've not worked for the last thirty years.

If you can't take criticism, then comic art is not for you, and, believe me, everyone is a critic and everyone will have an opinion. Comics is an industry that breeds dedicated aficionados who care deeply about their particular comic passion. But for a developing artist, the only criticism you need to accept and take to heart is constructive criticism from a trusted source, from someone who you know has an insight into what you are doing, or understands the technical points that will make you a better artist.

The only other people – arguably the most important ones – to take note of are your commissioning editors; the people who are going to pay you. They might well talk a load of bollix but, if you want to work, listen to them.

A career adviser can point you to an art college, but that is by no means the only third-level education path that can lead to a career in comics. Graphic novels and comics in general have become a more recognisable and recognised form of art and have even been called literature. There are colleges in the UK that do have specialist modules for comics along with creative writing courses that encompass writing for visual storytelling.

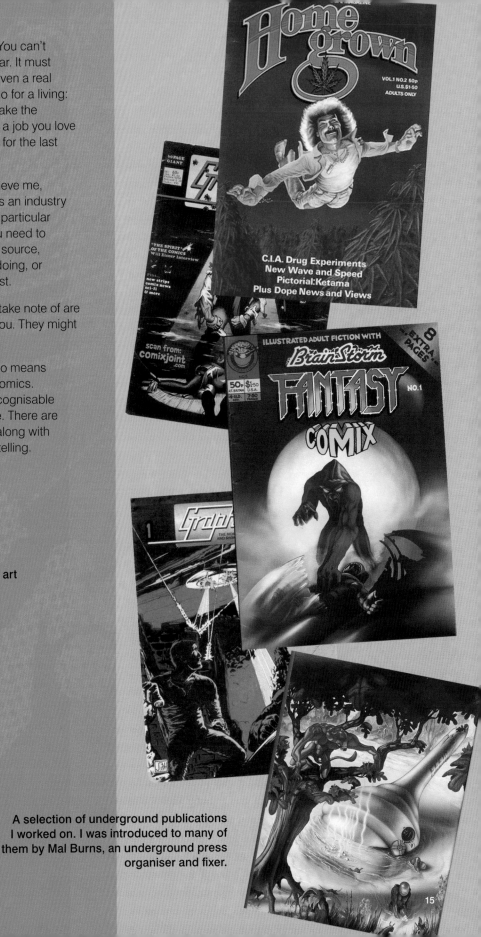

My one and only art qualification.

A selection of underground publications I worked on. I was introduced to many of them by Mal Burns, an underground press organiser and fixer.

15

Liverpool and Dundee are among the top universities in the UK and have courses that give a comic direction in their curriculum. In the USA there are specialist schools and colleges that concentrate solely on comics publishing with very strong connections to the major publishers. The best-known of these, with a proven track record, is the Kubert School, founded by the legendary artist Joe Kubert (artist on classic strips *Sgt. Rock*, *Hawkman*, *Tarzan* etc.).

Even if a college does not have a course for sequential art, it gives you time to practise your craft and, maybe even more importantly, to find fellow students who also have an interest in comics. I can almost guarantee that in a group of more than ten creative people you will find at least one comics fan.

The most important thing an artist needs is a portfolio of work to show examples of art and storytelling to a prospective client, so while you will be investing a lot of time creating art that might never see publication, it is an investment worth making. In the art section you will see a number of portfolio pieces I did on spec that *did* get me work, and some work I did in the 1980s that finally saw print in 2015 with *2000AD* … a thirty-year wait for a return in my investment of time!

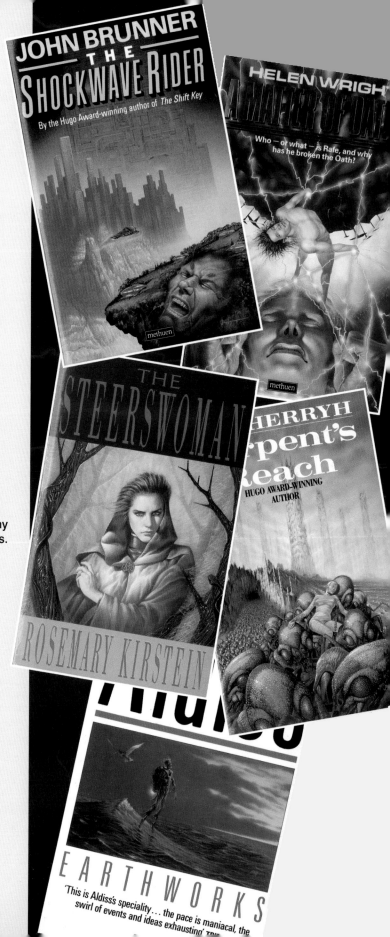

A small selection of my early book covers.

My first business card. I am not sure why I put myself in a dress.

No professional art job in the early days will give you the time that you need to produce that special portfolio page of art (this should be the best possible work you can do and time should not be a factor). Your professional clients expect a different approach and will dictate the schedule: miss this deadline at your peril. You won't get paid and you won't be employed by them again.

There are no real training or step-in positions at a comic studios where you can learn on the job. Larger publishing companies do offer internships but every advertised position draws thousands of applicants and they do not usually pay.

Phil Gascoine, one of the British artists I met in the early years of my career through the Society of Strip Illustrators, was the source of a wealth of information he was happy to share. Phil began work in a comic art studio in the 1950s as a real novice, starting off drawing backgrounds and learning on the job until he had enough experience to be promoted to foregrounds. In the 1950s and 1960s, comics had a resurgence with publishing companies such as Marvel and DC in the USA and Amalgamated Press and DC Thomson in the UK. There were also many other publishing outlets for the type of studio that used comics in all forms, either for other smaller publishers or in advertising and education. Art studios in those halcyon days did seem to have a massive market for which to produce generic comic work. Every niche had a guaranteed audience, due mainly to there being fewer distractions for the audience: no computers, no video games, no TV. I know it's hard to believe, but there *was* a time before there was a TV in every home – never mind computers.

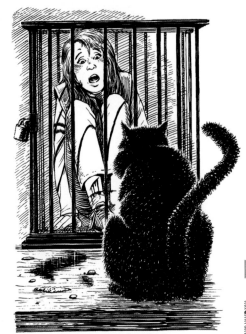

Interior illustrations I did for *Nightmares* – scary stories for children. (Armada) 1988.

Throughout comics-publishing history, successful artists have invariably gone through periods when the work they were offered was more than they could possibly handle, and they would often create a studio to deal with all this work. Will Eisner, creator of *The Spirit*, had one of the first studio set-ups in the 1940s and 1950s in the Hell's Kitchen area of New York. Nearby was the studio of Jack Kirby and Joe Simon, who worked for many of the publishers based in New York and most famously for Marvel Comics in the 1960s, creating The Hulk, Fantastic Four and reviving Captain America – a character Simon and Kirby first created in the 1940s to fight the fascist threat of Nazism. Both of these studios produced more than just hero or superhero comics: they did Westerns, romance, war, funnies or anything else that might have an audience. The British artist Frank Hampson, creator of Dan Dare, had a studio in downtown Southport on the west coast of the UK.

To a large extent the talent taken on by these named-artists – as opposed to a "generic" art studio – had to be good artists already. There were no ground-level entry positions in those small studios: if the newcomers were not close to the standard of the named artist already, they soon would be and then they went off and got their own commissions.

So how do you get this experience in comics creativity if you are just starting out?

A tourist lost in New York asked a rushing passer-by carrying a violin case, "Excuse me sir, how do I get to Carnegie Hall?" The reply was, "Practice!"

There is no Golden Ticket into the great chocolate comic-producing factory, Charlie. There are no short cuts. You need to keep practising until you can be compared to the artists you see in the professional comic books.

A great way to learn from other artists is to meet like-minded people. Going to college gives you that head start. Your local comic shop and comic conventions – particularly conventions where publishers have portfolio reviews, where you will get a professional critique of your work – are another vital step.

(Some tips if you are attending a portfolio review: do not have massive unwieldy portfolios! Instead, reduce everything to A4 size and present the pages in plastic sleeves so the reviewer can easily flip through your work. An iPad is now an acceptable way to display your work, particularly if it's in colour. Always have your best and latest work to show and never, *never* apologise for a piece of work: they won't care what reasons you give, and if you feel the need to explain or apologise for a piece, then that piece should not *be* in your portfolio. Have a print of your work with your contact details on the reverse side to leave with the editor.)

Another great way to get experience is to start your own fanzine with fellow collaborators, someone else who might want to be a comic writer, colourist or inker (not *everyone* can be good at everything … ahem!) If you are confident enough in your work, writing and art, starting a regular online comic or a visual blog is a good way of learning the discipline of producing a regular page of work. You will definitely get immediate feedback from that. Online you have a potential audience of millions – unlikely, but there – but a hard-copy fanzine works on a number of other levels, one of which is that it could be possible to earn from it: book a table at a convention to sell your wares, or approach your local friendly comic shop to see if they might stock some issues on sale or return.

After all of that, let's say you do start to receive paid work … any sort of paid work is worth doing.

As a new creator you won't want to hear this, but it was so much more fun and a lot easier when I first started in the business. All of the many small book companies that I walked around with my portfolio are now gone. Panther, Sphere, NEL, Futura, Armada, Pan, Heinemann, Corgi, Transworld. They have been bought out and consolidated under a few multinational publishers who, while they might publish as many titles, are less inclined to give time to new straight-off-the-street talent, and no way are you ever going to be able to turn up with your portfolio and meet an editor after one phone call.

The first time I went to New York, there was the same friendly interest in seeing new talent. I did manage to get into see editors at Marvel and DC Comics and a few SF book publishers; ACE, DAW and *Analog Science Fiction and Fact*. As in the UK, most of the smaller publishers have now been bought out by the same international publishing conglomerates.

The style of SF illustration in the USA was different to the UK in those days. It was photo-realistic featuring highly finished figure work. In the UK it was predominantly floating space hardware. By this time, the mid-1980s, I was starting to lean more towards comic SF but still did other illustration work – as a freelance artist you are constantly looking for *any* outlets for your work.

The work I did for Armada paperback publishers was one of my favourite jobs. It might not be comics but it was a major learning curve for me. The opportunity to be paid to do line art – a technique of which I had little experience at that time – was invaluable. I know life is so much easier and faster now with internet connections, but meeting your client face-to-face – even if you "waste" a day getting there and back – makes an invaluable personal connection. I always aimed to visit any publishers an hour before lunch. That way, I was usually invited to go out with them for a pub lunch. I made friends who were more likely to remember me than if I'd been just a voice at the end of the phone.

Around this time the tabloid press in the UK began to attack book publishers for producing children's books that they considered too violent. It was solely a press-generated, self-righteous outrage for no other reason than to sell papers to shocked parents and people who did not read books – an easy target picked by papers that usually printed pictures of semi-naked young women next to articles that sensationalised violence with reportage that tended towards bigoted, narrow-minded opinions … Whoa boy, steady now, steady … just reining in my high horse so I can climb down off it. A bit of a bug-bear for me: easy, lazy reporting that can have a negative effect on the victims of this form of "journalism".

Anyway, that spurious newspaper campaign closed off a number of work opportunities for me. The *Nightmares* series of books by Armada – a very popular series of books for young readers – was terminated. The conversations I had with the editorial staff at this time were not dictated so much by outside censorial pressures but an acknowledgement and professional consideration of their young readership.

I was given editorial direction on how far to go in any depictions of horror, and the letter reproduced later in this chapter has remained one of my all-time favourites on how far I could go. That was up until 2015, when I was working on *Jacked*, a six-issue mini-series for DC Comics. When trying to finalise the costume designs for one of the minor characters, I received an email from the editor with this line: "Take the tiara off the porn star!" Only in comics!

Now we have the web, which is one of the biggest shop windows in the universe. No more hacking around half a dozen different publishers on a trip to London or New York! But how do you get noticed among the many? And how do you get paid? That is the flip-side.

It is impossible for a new artist just to phone an editor up or drop in with a portfolio as I – and a great many other freelancers – did in those pre-internet days. Even if the work we showed was not right for that editor, we usually came away with comments and critiques on what we had. That made the next portfolio audition a little better, and we got to know people.

You have to have a thick skin. Criticism can be hard to take when you are showing your best stuff, even if it *is* constructive, but when someone says, "This is rubbish, I don't know how you make a living as an artist doing this stuff!" Grr! I didn't receive many of them, thank goodness, but one is one too many. Another comment I received that still niggles me: Critic: "I don't like that painting." Me: "Okay." Through gritted teeth: "Why not?" Critic: "I don't like orange." It was an effing *sunset*!

After a while the constructive criticism starts to make sense, but you also notice that one editor's dislike is another editor's favourite, so you start to put everything into context. Plus you learn how to give a good presentation, which is as important as your best piece of art.

Your aim as a freelance artist is to find an outlet for your work. You have to research your market, find the type of publications that you can see your work appearing in, and – not always possible but a good move if you can manage it – learn the name of a good contact there.

In the beginning you have to be completely open to suggestion, and learn how to bite your tongue when it might seem at odds with all your sensibilities. You are trying to sell yourself to them: they are the client and they are *always* right … even if they don't like orange in a sunset!

Do not lose copyright. Never sign away your rights unless the cheque is so big you have won the lottery, and even then ensure you have a share in its continued success, and a reversion clause stipulated in the contract.

The *Writers' & Artists' Yearbook* in the UK is a major resource under one banner with addresses, advice and suggestions on how to approach publishers to get that first job. It is not specific to comic publishing but will feature comic publishers along with other publishing information. In the USA there are a lot more opportunities for all types of illustration and it obviously has a very strong comic publishing industry.

Online resources are a great way to get advice and addresses, but as in all web-related things, sometimes there is *too much* information: how do you find the right information, and can you trust the source completely? Making personal contacts is of major importance and networking with editors, other artists and writers is imperative.

To get my first interview at Armada paperbacks I used the *Writers' & Artists' Yearbook* of 1984, checking down the lists for any outlet for my art. Upon seeing that children's books had a demand for line art and colour cover art, I checked in my local library to see what type of books Armada published. Back then, game-books were just starting to make in-roads into children's publishing. For those unfamiliar with that once-flourishing scene, game-books give the reader a choice of story-paths by numbering various separate scenes. At crucial moments in the story, the reader is asked to choose between two or more options, with each option leading them to a different scene. Often, the books were extensively illustrated, with full-page drawings for the start of chapters and spot illustrations spread throughout the text. They were great fun to read and for a wannabe comic artist it was as close to an illustrated form of sequential storytelling as prose books could ever get. In 2012, Al Ewing (writer of *Judge Dredd, Zombo, Jennifer Blood* etc.) wrote a Judge Dredd Christmas story for *2000AD* which I illustrated – "Choose your own Christmas" – that used this premise to do a very funny and clever time-travel story. I think we can guess what Al read as a kid.

The *Writers' & Artists' Yearbook* gave me Armada's address and phone number. I rang and asked to speak to the art director of Armada paperbacks, but was told they *had* no art director. I was put through to the editor and arranged a portfolio review for the following week.

If it's my first time visiting a particular publisher I tend to arrive at least an hour ahead of the meeting in the general area – to actually find the place and to arrive in reception ten minutes before the interview is due to start (no phone GPS in those days). The worst thing next to a bad portfolio is to be late.

I met with Marion Lloyd and her assistant Jackie Dobbyne at the right time. Timing for the interview is very important but also being in the right place at the right time, and this time it *was* just right. I did around twelve books for Armada. I feel I have been fortunate in working not only with the best writers and collaborators but also with the best editors.

Marion Lloyd was running the Armada children's paperback group at that time. She was probably not much older than I was but well experienced in children's book publishing already. Along with Jackie she oversaw the production of everything that was produced by that section. She commissioned new titles and processed the classics, such as Enid Blyton. She published puzzle books, pony books and anything she felt would have a market.

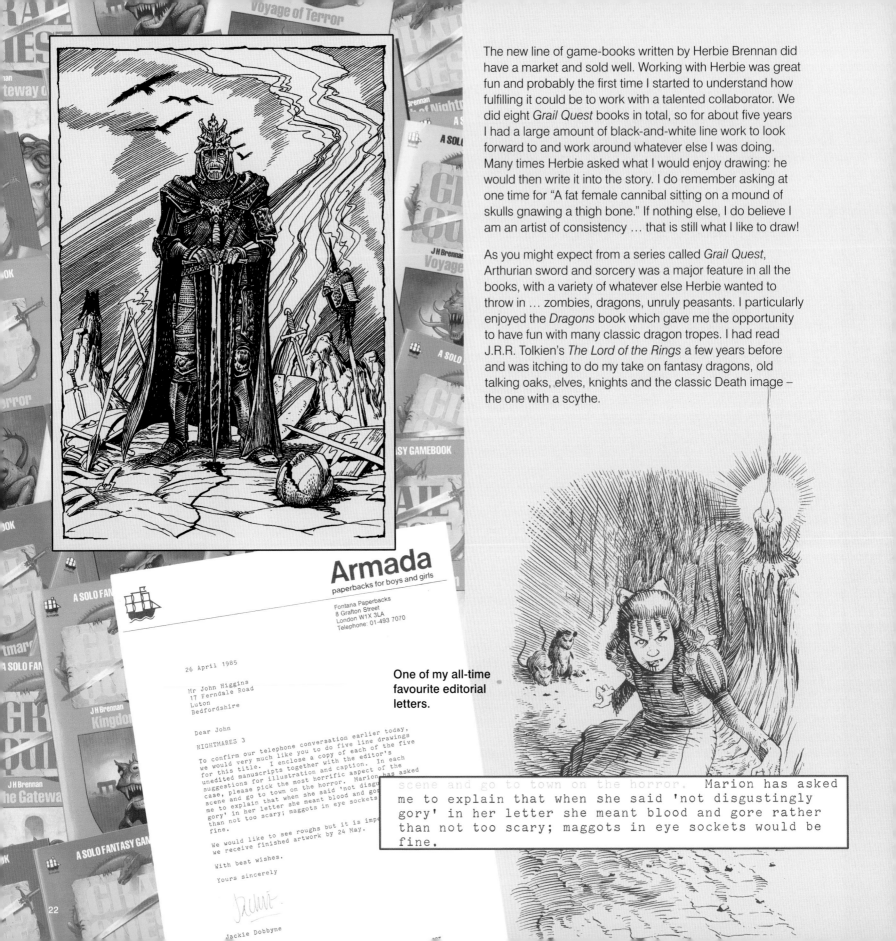

The new line of game-books written by Herbie Brennan did have a market and sold well. Working with Herbie was great fun and probably the first time I started to understand how fulfilling it could be to work with a talented collaborator. We did eight *Grail Quest* books in total, so for about five years I had a large amount of black-and-white line work to look forward to and work around whatever else I was doing. Many times Herbie asked what I would enjoy drawing: he would then write it into the story. I do remember asking at one time for "A fat female cannibal sitting on a mound of skulls gnawing a thigh bone." If nothing else, I do believe I am an artist of consistency … that is still what I like to draw!

As you might expect from a series called *Grail Quest*, Arthurian sword and sorcery was a major feature in all the books, with a variety of whatever else Herbie wanted to throw in … zombies, dragons, unruly peasants. I particularly enjoyed the *Dragons* book which gave me the opportunity to have fun with many classic dragon tropes. I had read J.R.R. Tolkien's *The Lord of the Rings* a few years before and was itching to do my take on fantasy dragons, old talking oaks, elves, knights and the classic Death image – the one with a scythe.

Armada
paperbacks for boys and girls

Fontana Paperbacks
8 Grafton Street
London W1X 3LA
Telephone: 01-493 7070

26 April 1985

Mr John Higgins
17 Ferndale Road
Luton
Bedfordshire

Dear John

NIGHTMARES 3

To confirm our telephone conversation earlier today, we would very much like you to do five line drawings for this title. I enclose a copy of each of the five unedited manuscripts together with the editor's suggestions for illustration and caption. In each case, please pick the most horrific aspect of the scene and go to town on the horror. Marion has asked me to explain that when she said 'not disgustingly gory' in her letter she meant blood and gore rather than not too scary; maggots in eye sockets would be fine.

We would like to see roughs but it is imperative we receive finished artwork by 24 May.

With best wishes.

Yours sincerely

Jackie Dobbyne

One of my all-time favourite editorial letters.

scene and go to town on the horror. Marion has asked me to explain that when she said 'not disgustingly gory' in her letter she meant blood and gore rather than not too scary; maggots in eye sockets would be fine.

Around this time I had discovered the artists the Hildebrandt brothers. They, along with Frazetta, were a great influence on my work with their fantasy imagination and incredible detail and finish, and their use of colours, which – like Richard Corben's work – had the type of vibrant palettes that I found particularly appealing. But there was no colour – except for the covers – on children's paperbacks. I had always wanted to do a cover for the *Grail Quest* books but the interiors, all black and white, were the editor's responsibility. The covers were the responsibility of the art director who tended to have a creative overview for that imprint of books and was in a completely different department (I never *did* find that department). The paperbacks were printed on the cheapest newsprint paper possible. This meant that the illustration had to be a line and cross-hatching style, because with too much solid black the ink tended to pool in printing and look particularly bad.

Along with the above great artists, my all-time favourite Gothic horror artist was Bernie Wrightson, Warren Comics artist extraordinaire and co-creator, with Len Wein, of *Swamp Thing*. Wrightson also produced probably one of the finest and most evocative illustrated versions of Mary Shelley's *Frankenstein* in the 1980s. The *Grail Quest* illustrations were a great opportunity for me to try my hand at a dip-pen inking technique to emulate my art hero. I found, after many hours of trial and error, the right technical process needed to do a finish that I was satisfied with. I focused on learning which pen nibs suited me, which ink flowed the best and how to correct an ink splatter and the hugely frustrating smudging caused by inadvertently dragging a shirt-cuff across the wet lines – all very irritating, particularly as that tended to happen when you were rushing to deadline.

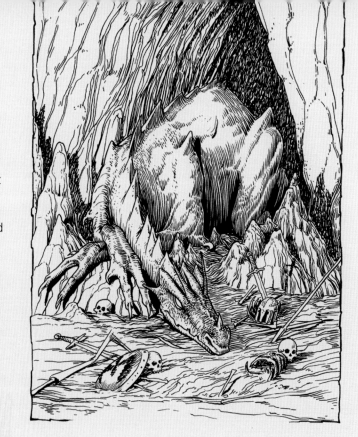

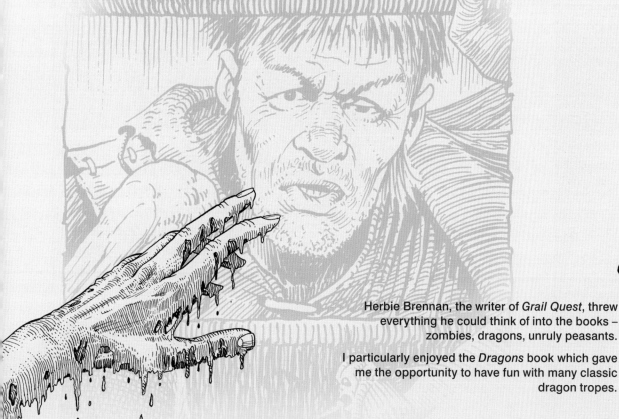

Herbie Brennan, the writer of *Grail Quest*, threw everything he could think of into the books – zombies, dragons, unruly peasants.

I particularly enjoyed the *Dragons* book which gave me the opportunity to have fun with many classic dragon tropes.

I discovered another important part of the learning process when working in a home studio. While waiting for the ink to dry I would lay my finished pages on any flat surface available, even the floor if space was tight. Once, having done so, I returned from a toilet break to find a three-year-old artist called Jenna helping Daddy by drawing in green felt-tip across most of the finished line illustrations. Get out of *that* one, Daddy!

After getting out of that one, I soon found that dip-pen inking was a time-consuming technique, even without the help of a three-year-old artist. It was a technique that appeared to have no short cuts and was very hard on the eyes, but incredibly fulfilling once you felt you had a handle on it and discovered for yourself a new drawing technique. I never felt I had fully mastered it, but to see the work of an artist who did, check out Bernie Wrightson's *Frankenstein*.

In any multiple illustration commission it is always swings and roundabouts or, if you are unlucky, just swings, when you lose money on every illustration. Children's book publishing on a work-for-hire basis is not the best for page-rates, as I was also still using every opportunity I had to create portfolio art and examples of work I could show to any new clients. This meant that, even though it was my choice, the earnability was pretty low and that the island in the sun and early retirement were some ways away yet.

I soon found dip-pen inking was a time-consuming technique.

And beware three-year-old daughters.

The illustration page-rates are broken down into full-page, half- and quarter-page. The fee was $1200 for approximately 45 illustrations, That comes to roughly $26 an illustration, some of which would take a day, while others would take an hour. Swings and roundabouts. (To keep it simple I will be using the dollar equivalents for all commissioning fees throughout this book, as most of my income in my career has been paid in that currency.)

You always have to remember you are only as good as your last job – for future clients or for going back to your current employer. One advantage of working in book publishing (allowing for the low page-rate) as opposed to comic publishing is that the contract gives the artist automatic copyright. This is standard in book publishing, which means that if the work is reprinted or foreign editions are published the artist will receive additional monies. The Grail Quest series did get reprinted all over Europe so every now and then I receive a small cheque for work I finished years ago. That's a nice feeling that not only makes the extra work you put into a project recognised but gives you pride in being associated with a successful, well-executed project along with a group of very nice talented people: writer and editors.

Herbie gave me plenty of scope to have fun with the illustrated content, and I never felt restricted by the editorial team. The best sort of collaboration.

I used a variety of techniques to create the best art I could within the timescale I had (the daily earning rate and deadline). Composition can be used in ways that give the strongest presentation to an image but still save time; cropping-in gives a drama to a composition but can take less time. Also covering one part of the central image with a less time-consuming object – the dragon with the stalagmite – saves time and also creates depth. (How does it go with stalagmite and stalactite? Mites go up, tites come down?)

Another method I used was a sequential type of comic styling. This was a sequence of separate illustrations in a sort of time-lapse. This saved time in the thought process for all the illustrations and in establishing their composition. In some of these sequences I created a complex establishing image that had a lot of detail and work. This one image was then used over five pages, with maybe four acetate overlays that would change just one small aspect of the overall image. A dragon breaking out of a skull egg over time, or one of my favourites, a prisoner in a cage decomposing a little more in each image until he was just sinew and bones.

If I could, I'd give the picture an additional twist in a story-mood sense – even if no one else got it – such as in the sequence for the candle on the skull. When it is covered completely in wax and the candle has died, it has brought back from the dark side the spirit of the deceased. The magician can then use it as an oracle to whisper to him secrets of the dead.

Even after all these years this series is still finding an audience around the world, which I find a source of constant delight. That a new audience will be reading the books and looking at my illustrations afresh makes all the hard work worthwhile!

I enjoyed creating sequential illustrations even outside comics.

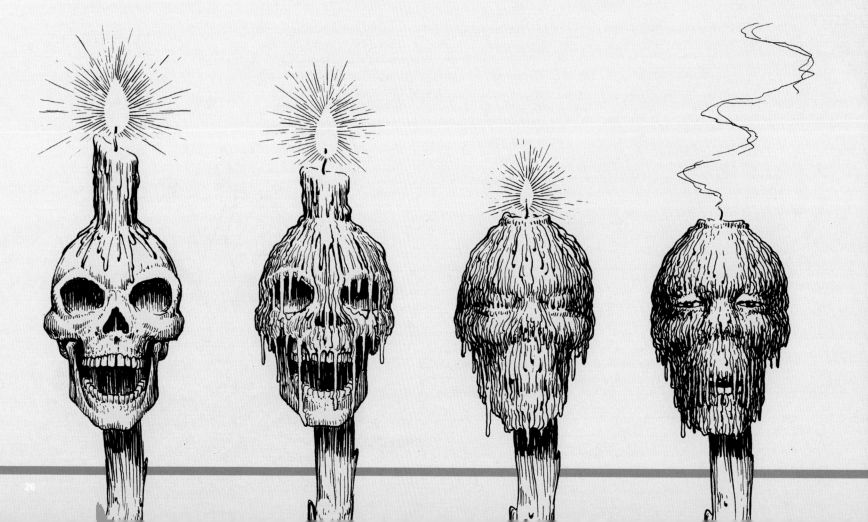

A portfolio piece painted in 1984, used in 2016 for the cover of *Il Ritorno di Pip*, an Italian *Grail Quest* fan-fiction paperback book.

Even after all these years *Grail Quest* is still finding an audience, which I find a source of constant delight. Fans in France, Belgium, Italy and the Netherlands have asked Herbie and me about the series and produced fanzines.

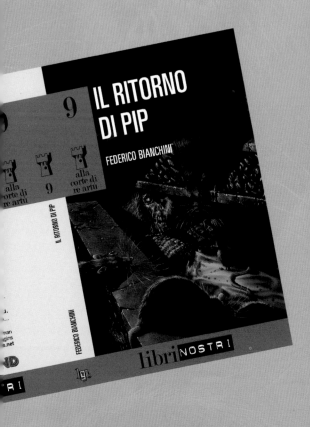

Wraparound cover
for *Exile's Gate*
by C.J. Cherryh.
(Mandarin) 1989.

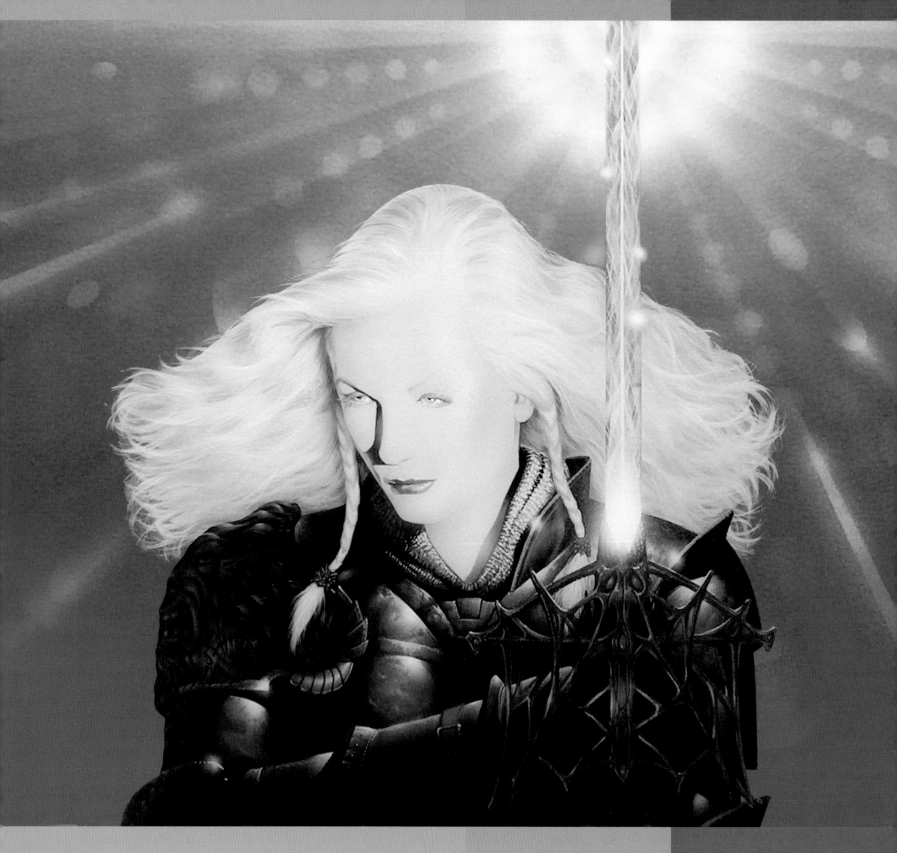

Cover for *The Chronicles of Morgaine* by
C.J. Cherryh. (Mandarin) 1989.

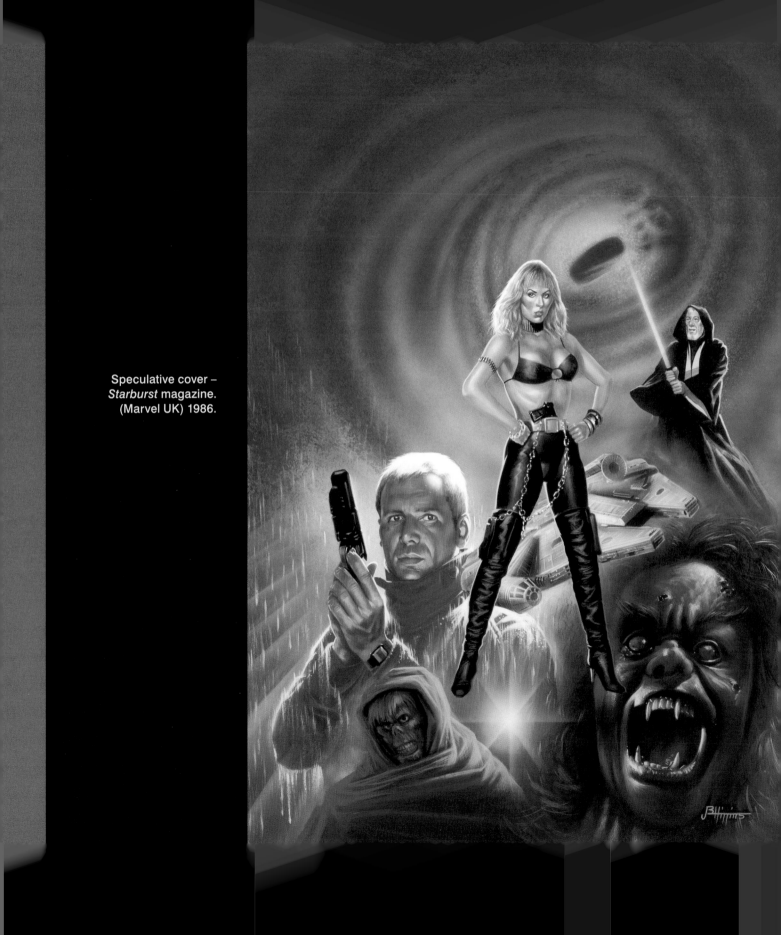

Speculative cover –
Starburst magazine.
(Marvel UK) 1986.

und cover
swoman by
y Kirstein. (Tor)

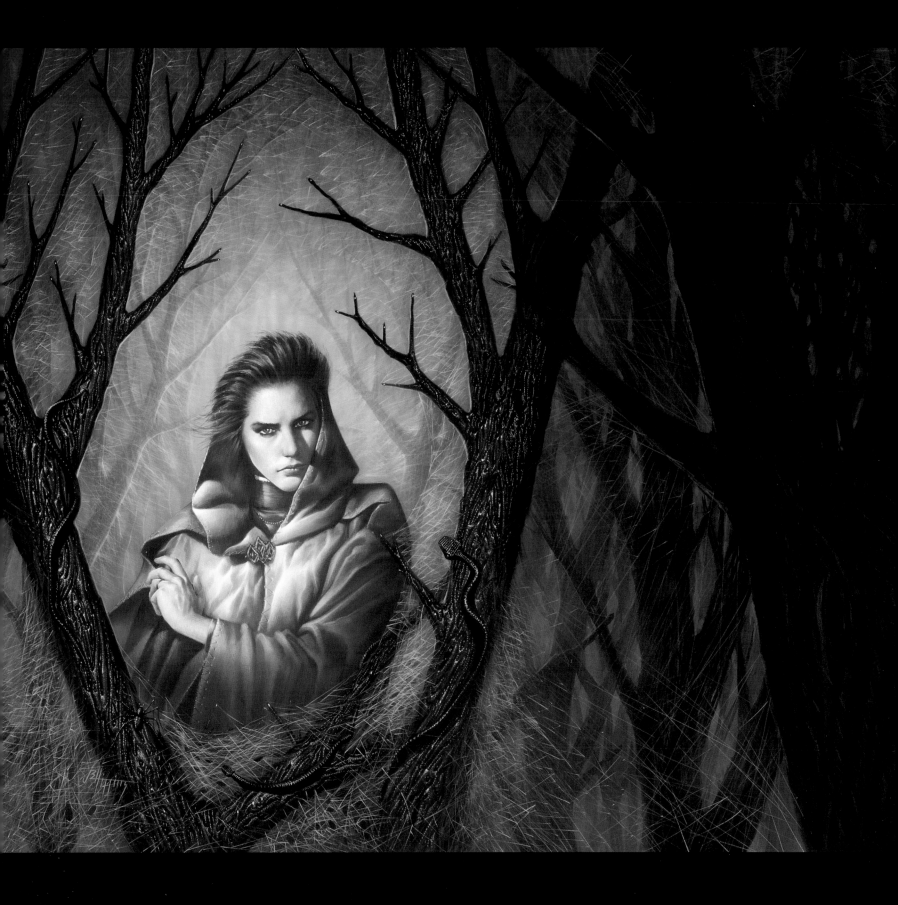

Wraparound cover
for *A Matter of Oaths*
by Helen Wright.
(Methuen) 1988.

Cover for *Serpen[t's]*
Reach by C.J. Ch[erryh]
(Mandarin) 1989.

Cover for *Doctor Who Monthly*. (Marvel UK) 1986.

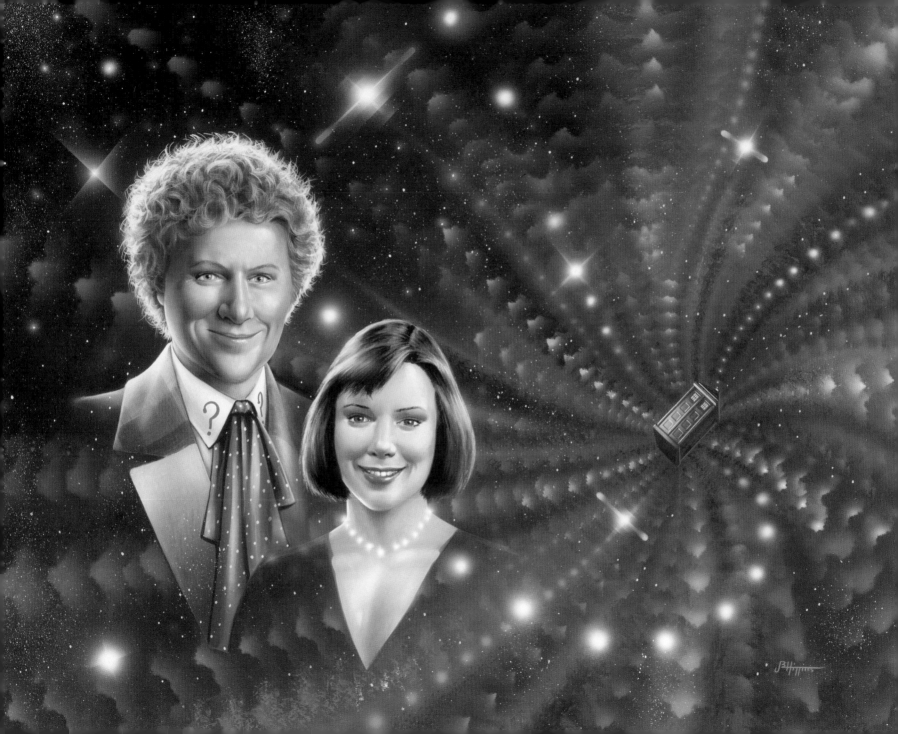

Selection of YA book covers, mid-1990s.

WATCHMEN
COLOUR AND COLOURING

In a many ways, *Watchmen* has defined my career. I certainly consider my comics career to start in the year of *Watchmen*; all of the work I had done on books, magazines and animation before was the foundation to my comic career. The colour I had done on everything else up to that date was the reason Dave Gibbons considered me to be the right colourist for this new all-encompassing creative approach to comic-strip storytelling.

To be defined or known by such a monumental creative work has been a double-edged sword. Many more people know me as the colourist on *Watchmen* than for any other part of my career, a period of work that really only lasted maybe just one-thirtieth of my whole career so far, and represented an even smaller fraction of the total physical output of all my other work.

To be a colourist is to have an immediate visual impact in a way that not even the writer or artist can have. This does not make you the most important person in this creative line-up … I will let the writer and artist fight that one out! A good colourist can make a contribution that creates a mood and an emotional response by the choice of colour and colour combinations that will be "felt" without reading the words or even scanning the storytelling pictures. Today colour is recognised as an integral part of the storytelling and not just the filling of any pretty colour between the lines, as it had been for most of comics publishing history (with the odd exception).

In 1986 Dave Gibbons first approached me to be involved with a new maxi-series that he and Alan Moore were about to start for DC. Importantly, I had just (as back then my career in comics was only in its infancy) completed my first fully painted comic strip for the *Judge Dredd Annual*. So, much as I have always admired Dave's work, to be a colourist for it was just another job among a variety of different strands of work I was doing at that time, such as drawing the B/W *Judge Dredd* for *2000AD* weekly, working in advertising illustration, painting covers for computer games magazines and doing children's book illustration. I was also colouring other artists' work: I had a particularly enjoyable colour collaboration with Steve Dillon – probably best known now as the artist and co-creator of *Preacher* – so *Watchmen* did not appear to be an especially important job.

Alan and Dave had explained to me early on about the rights issue and had asked DC whether I could share somehow in its success. But the company had no colour contract in place to accommodate this and even Dave and Alan's contract was a completely new deal. So I went into *Watchmen* knowing that my part was a work for hire, and as I had said earlier, it was then "just another job". I do think, however, that DC's commitment to *Watchmen* was total after a short time, and they did initially behave generously to me in relation to *Watchmen*'s success. I got my flat-fee colouring page-rate, but they also surprised me when someone in DC's hierarchy arranged for me to receive a number of additional ex-gratia payments during the first year it was being produced, which did endear me to DC Comics for a long time: not many companies would have done that. This obviously stopped after the twelve-issue run and the first collected edition in 1988, even though that continued to sell comfortable numbers for the next two decades. I had no problem with that even when fans came up over the years saying, "Wow, you must be doing all right with the reprint royalties!" Me, through gritted teeth: "Nope, not really."

But on to more of the creative "fun" part of comics publishing. Or the Hell-on-Earth part if you are working on a regular scheduled book, as the deadline starts to get closer and closer. Dave had a six-week turnaround for each issue, and even now when I look at the amount of detail in *Watchmen* I find it hard to believe that he did pencils, inks and lettering in that time! What a professional. Being the colourist and the last in the creative line did put deadline pressure on me, but my being so close to Dave's studio made it a lot easier than it might have been.

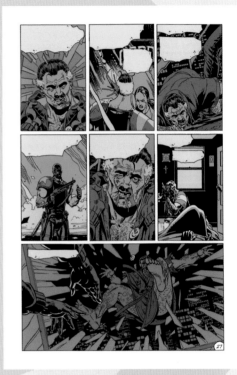

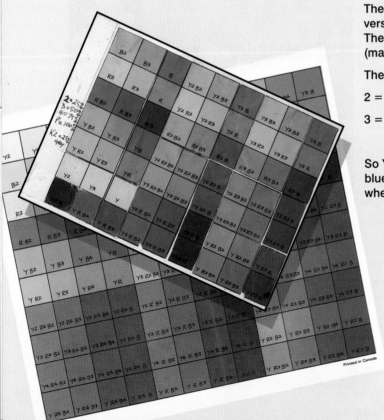

The DC printers' chart and my cut-down version for the colours I used on *Watchmen*. The colour designation is B (cyan), R (magenta), Y (yellow), K (black).

The letter without a number = 100%

2 = 25%

3 = 50%

So Y2R3B = 25% yellow, 50% red and 100% blue. The 4 (75%) was too close to 100% when printed in 1986 so I never used it.

Using hot colours – red and orange – in the killing of the Comedian, these colours throw the action out towards the viewer, and the red colour of danger keys you to the violence of the scene. You can see the cool colours drop back in the bottom panel.

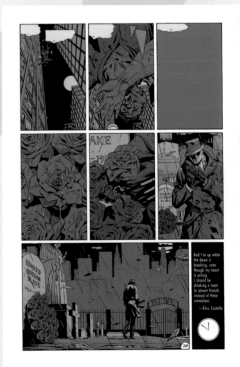

My part started as soon as Dave gave me a phone call to come to his studios in St Albans, England. He handed me the reduced black-and-white photocopies of each page and, if I didn't already have it, the script. He would give me a coffee and a chocolate biscuit or two; I'd say hello to Kate, his wife, and Dan, his son. After a while I used to bring my daughter Jenna around, and she and Dan would play as Dave would show me his new collection of *Lieutenant Blueberry* comic albums or any of a multitude of new European comic imports or books about graphic arts that he had just received. It was a most enjoyable and highly stimulating social evening. We would go over the art, and to be only the third person to see the completed pages and to read that new issue was a huge thrill for me.

An example of warm colour to cool colour. Rorschach dropping the sugar wrapper that he picked up in Dreiberg's kitchen into a snow drift.

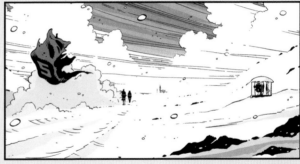

"You can never see colour by itself, it is always affected by other colours" – Bridget Riley. One of my favourite Pop Artists whose paintings used colour to confuse, excite and define abstract concepts using block lines and curves.

How the green is affected by the surrounding colours.

Dave and Alan might have colour suggestions for something specific in a chapter such as a red flashing neon sign, so I had to work out how to incorporate those colour ideas into what I had in each issue. This might sound simple and I might be a bit dense, but boy did it start to create colour conundrums very early on, and more so as the story unfolded in all its complex brilliance. For example, in issue one, Rorschach takes the sugar cubes from Daniel's kitchen, and in issue eleven he drops a sugar wrapper in the Antarctic snow! So, do you do the wrapper the same colour as in Daniel's kitchen under strip-lighting against hard edges and the primary colours of the kitchen units, or allow the wan Antarctic light to affect its tone? Is it falling on to a white snow-drift or a shadowed one?

Yes, the madness of the *Watchmen* detail had bitten me well before I reached issue eleven. Initially I didn't make colour notes of every sugar cube wrapper, light switch or Gunga Diner take-away box on the ground, but I *should* have!

Seeing Dave and Alan's commitment to the project at work, I had to be completely honest to their vision of the world of *Watchmen*. I used my choice of colour first and foremost to complement and accentuate the art, but also to enhance the mood and sense of drama of the story. One prime example would be the Rorschach episode, with the opening scenes of Rorschach/ Walter in prison talking to the psychiatrist. The issue started with sunny early-morning light streaming into the prison room as the psychiatrist, in a bright and breezy manner, tried to get through to Walter, to cure him. As the story unfolds and the horrors of Walter's life begin to permeate the story, the colours start to darken and reflect the sense of corruption and despair that created Rorschach. I tried to use colour in this way throughout the series, and to go beyond what was usually done in monthly comics at that time.

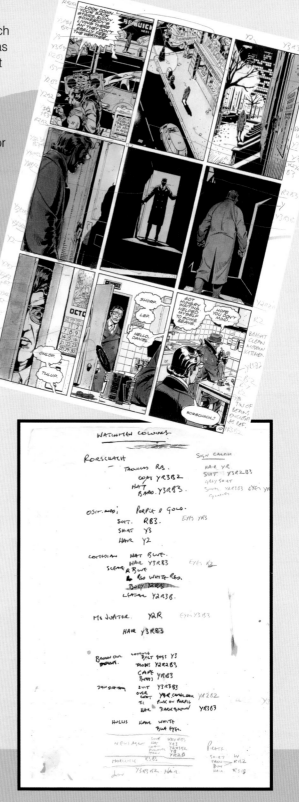

A page of mark-ups.

The colour designations Dave and I decided on.

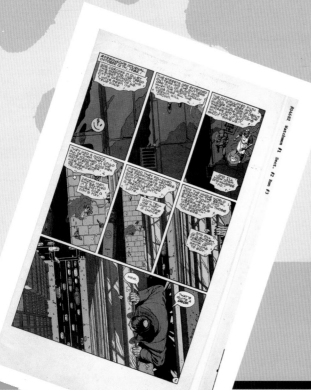

First issue proofs; this was when we discovered using a grey tone was not a good idea. In those days, printed inks could be 12% to 16% lighter or darker as the print-run ran through from start to finish. With computer-controlled printing presses this does not happen today.

I had a number of conversations with Dave as to why I had coloured such and such a scene in that way, and according to Dave – in a conversation for the digital repackaging of *Absolute Watchmen* (DC Comics 2005) in 1986 – when he initially saw some of the more "Watchmenesque" colouring choices I made that might have surprised him, I always had a reason and an explanation of why I had coloured it in that way, and he always accepted the explanation: it wasn't just because it was a nice colour combination.

As usual, I learned on the job, discovering how to work within the confines of the very limited, almost primitive, printing format we had to use with pre-computer colouring. It had probably not changed since the 1930s when the first superhero four-colour comics appeared. A very brief colour history for all of you who now can print in your own homes near-perfect facsimiles of any colour art you can imagine … In 1986 *everything* was done by hand. I coloured the black-and-white copies of Dave's pages with watercolour, and then marked the equivalent printing ink combination for each colour. So for Rorschach's brown overcoat it would be Y3R2B1. (I do not know why, but CMY became YRB for separators' notes. See Chapter 12 for technical details.) Then that page would be sent to hand-separators who would do up to twelve separate acetate overlays for each page to create a four-colour effect. Every colour – and every percentage tone within that colour – had hard edges: there were no smooth transitions from one colour to another. No matter how subtle I tried to be with the colour, what I was trying to get from my mind on to the page was diluted before it had even been printed. Early on we were given the new option of using tones of grey, but after the first couple of issues were printed we realised that it was a mistake, and we only had the opportunity to rectify that in 2005.

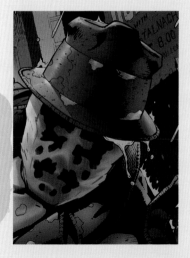
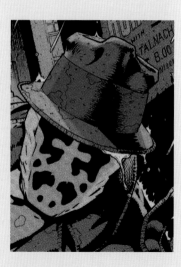

For my limited edition *Watchmen* poster set. I did two types of prints, a modern digital colouring and a colour dot, a facsimile of the traditional type of cheap comic printing from the 1980s.

A close-up of Rorschach from the set.

The colour wheel. How the colour spectrum mixes hues and the relationships between colours and how they affect each other.

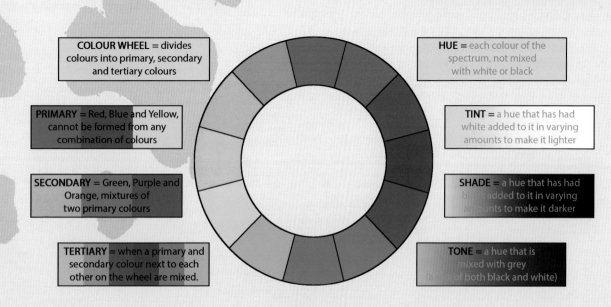

COLOUR WHEEL = divides colours into primary, secondary and tertiary colours

PRIMARY = Red, Blue and Yellow, cannot be formed from any combination of colours

SECONDARY = Green, Purple and Orange, mixtures of two primary colours

TERTIARY = when a primary and secondary colour next to each other on the wheel are mixed.

HUE = each colour of the spectrum, not mixed with white or black

TINT = a hue that has had white added to it in varying amounts to make it lighter

SHADE = a hue that has had black added to it in varying amounts to make it darker

TONE = a hue that is mixed with grey (a mix of both black and white)

As *Watchmen* became a crossover graphic novel, it was one of the first modern comics to create a market for merchandizing that sold and became a money making asset for the company.

light purple. Varying the percentages could give a sense of a tonal form, mixing and matching the colours to give complementary colour palettes that would counterpoint the story. The murder of the Comedian is an obvious example of colour being used in a scene for the emotional response it creates.

Whenever one completes a creative endeavour, one always thinks of how it could be improved or can only see the mistakes one might have made. The same was true of *Watchmen*, multiplied and squared. *Watchmen* in a colouring sense was a major learning curve for me as a colour artist because of it size and its complexity and the sugar-wrapper conundrums.

Because of all these limitations, my colour approach to *Watchmen* was different to anything I had done before or even seen in traditional comic colouring of the day. I needed to give myself a colour-based framework to make it work for me as the colourist, but even more importantly to make it work for the maturity and complexity of the story.

Once I had concluded that because of the limitations it was never going to be even an approximation of a naturalistic colour approach, I decided that the colour had to respond to how the story unfolded, and used colour to engender an emotional response and to keep, if possible, a recognisable colour key for the characters and scenes. I probably did not have this colour-concept fully formed until we found that the K (black/grey) percentage tone did not work at all. By then Dave and I had talked over what I was trying to do and, as in all the best collaborations with bouncing ideas around, agreed that the colour concept of what I was trying to do was valid, and it became clear to me through talking over it with Dave.

Another limitation was not having the luxury of being able to use tone. For me as a full-colour painter it was maddening only being able to suggest graduations by colour-percentage changes. This led me to using tertiary colour extensively. This also worked on a number of levels, so a 25% blue (cyan) would blend across a yellow, giving a light green, then over a red (magenta), getting a

Due to this complexity other chromatic challenges arose. For instance, I might have done a pleasing colour combination in a particular scene in any one chapter. However, later on, replacing part of it back into the story – as a flashback and as just one part of a different scene – could change its visual colour perception in a detrimental way. To have an imperfect reproduction of my colour ideas on such a high-profile book was very galling, so the chance to digitally colour the *Absolute* edition of *Watchmen* was an opportunity I could not refuse, plus it gave me the chance to address the lack of a colour contract. A lot had changed in the twenty years since I had first coloured it. DC wanted the same creative team back. I admire them for this sense of continuity and also found upon talking to a number of the executives that they also felt it was time to redress my position in the shared remuneration table. With Dave and Alan's support I finally came away with a contract that acknowledged the colourist's contribution to a story.

The iconic smiley badge was seen by DC as a disposable promotional item. The creators thought it was merchandise for sale and profit.

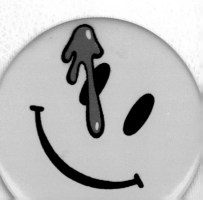

I had been living for a couple of years in Bayonne, New Jersey, which is only an hour's journey away from DC's offices in New York. I acknowledge that you can be anywhere in the world now and communicate with any company based anywhere and supply them with digital work immediately upon completion. An example of this: in the old days, it was a minimum of six weeks from sending the finished page to the editor – where it went through production, editing, lettering, colour and so on – to when it reached the printers. In this year of 2016 the deadline was tight on a book I was working on: *Jacked*, a six-issue mini-series for DC/Vertigo. I finished off the last page of pencils and inks for the final issue on the Tuesday, and sent it to the colourist Chris Sotomayor on the east coast of the USA. He coloured and finished the page before Vertigo started work in Burbank on the west coast on the same Tuesday. The completed issue was sent to the printers on the following Thursday. I know we have time zones to take into account, but that is fast.

Anyway, that is all well and brilliant, but I was based in the USA at the time of *Absolute Watchmen* so for me to be able to go into DC's offices daily to check proofs and tweak any "conundrum" that might have arisen on the production department computers was a pleasure in so many ways. Getting to know the creative production people was always a fun part of my job, as was working again with head of production Alison Gill, with whom I had worked in the 1980s when she was with Marvel UK. I mean, talk about completing a circle!

The pleasure of going back to *Watchmen* creatively with the career experience of twenty years was filled with exciting possibilities. I imagined what I could do with all the computer power we now had. Comic colouring had entered a new digital age since the book had first appeared; arguably anything could be done with tone or

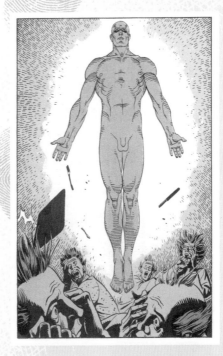
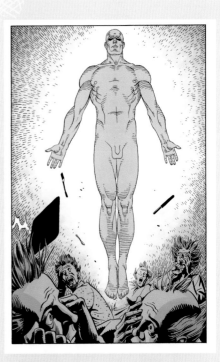

On the left is the original 1986 panel with the separator's thumbprint clearly visible. On the right is my reproduction of this effect with my digital thumbprint for *Absolute Watchmen*.

colour – a full-colour painted effect, smooth airbrush or rough oil-paint styling. I did initially think of all these possibilities and seriously consider that I might re-colour the *Absolute* edition and "modernise" that aspect of *Watchmen* and not just digitally reproduce and tweak what had originally appeared in 1986. Thankfully Dave disagreed, and other than fix some original errors and add additional tonal modelling, we kept the colouring effect I had originally decided on.

What you see in the *Absolute* edition is what I had always intended the *Watchmen* colour to be, but due to the printing limitations of the period you could never see it before. Believe me, to get the opportunity to work on the computer colour files, to finally get rid of the grey tone, to consolidate the colour conundrums, to tie all the colour threads into one united whole, was a joy. Not many artists ever get this opportunity, but after almost twenty years I was well satisfied to put to rest my loose colour threads.

Watchmen merchandise: neat little Watchmen watch, geddit?

The original *Watchmen* page Dave gave to me with the colour proof for the *Absolute* edition.

The colour palette was melancholy brown for Dan's post-Laurie tryst as he walked in a thoughtful mood through a darkened home.

I have mentioned the hand-separators … Before computers, the original comic colouring was prepared for printing by hand. American comics used the four-colour printing process, with most of the hand-sepping done in one place – Sparta, Illinois. Sparta had most of the printing presses, with warehouses and distribution of comic books also organised there. Sepping was a sort of cottage industry where almost all of the inhabitants of the town would be involved in comic reproduction in one way or another, so on dining tables and kitchen tops all over Sparta, mums, dads and grandmas and almost anyone else would be separating the colours for a comic book. All comics needed this done, from *Loony Toons* cartoon strips to *Superman* in *Action Comics*.

As in any part of comic production, some people were particularly good at separating and were employed as full-time separators, not just doing it for pin money. They were used on the prestigious titles such as *Superman*, *Batman* and of course *Watchmen*. I did ask in my instructions on the colour guide mark-ups for a lot of detail and I usually got it, and on one page in particular it is apparent how much further this particular group of separators went. In chapter 4, Jon first starts to appear as Dr Manhattan, in varying degrees of reconstruction as he returns to a humanoid form – a lovely concept depicted by Dave. By page 10 he is fully formed for the first time. In the original book I had wanted a graduated tone but we could not do that in those pre-computer days, so to get as close as we could I had marked up a graduation from 25% up to 50% in stages, I wasn't sure it could be done but asked anyway, and what that unnamed separator did was use stopping-out fluid and his thumb to break the hard edges to give a sort of painterly graduated tone. I was very impressed by anyone having the imagination to use this method and the application of thinking-outside-the-box creativity.

Rorschach writing his journal on the rooftops.

My first page of colouring for the series ... effectively an "audition" piece for Len Wein, the editor at that time.

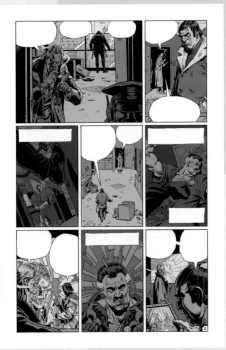

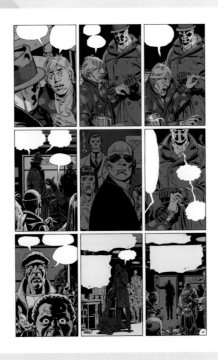

The murder scene created the colour violence palette for the rest of the book.

It is scientifically accepted that colours will engender emotional responses through their hue and saturation, so red and orange will excite and stimulate, blues and greens will have a calming effect.

To have a colour theory is all well and good, but it did produce conflicting colour combinations in different scene panels. When Rorschach goes into the bar, the warm sunset colours collide with the warm colours of the bar.

Dave did emphasise early on how important the different scene and flashback events were, and I needed to ensure that the colour palette had a clarity that did not confuse these many story strands.

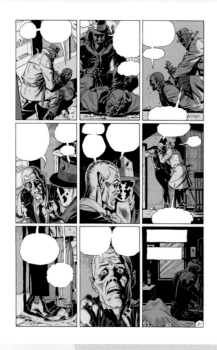

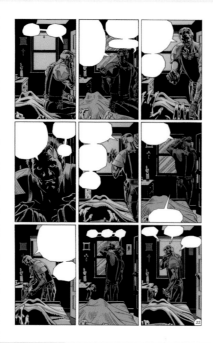

Inventive and imaginative scene-setting appeared throughout *Watchmen.* Dave created great opportunities to use dramatic light sources. The light from the fridge back-lighting Rorschach and a sick and dying Moloch.

The flashing neon light outside Moloch's bedroom. This not only gave me a great opportunity to be creative with colour combinations but subsequently created a complex set of colour rules that we had established, such as Dr Manhattan's emitted energy light.

I still used this even when we had the violent colour palette, such as the Comedian getting his facial disfigurement. When Dr Manhattan is in the panel his blue energy tints the surrounding colour palette.

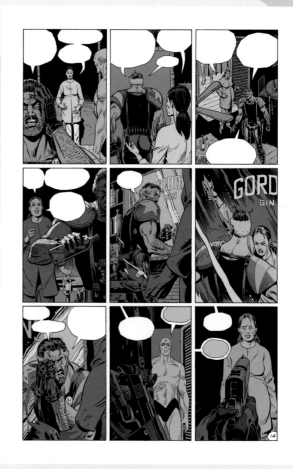

When I came to redo this page digitally for the *Absolute* edition, I could have just done a full smooth graduation from 0% to 50% cyan, but I decided to stay true to Dave's decision of staying with the spirit of what we had done originally. I created a brush in Photoshop of my thumbprint so I could recreate the creativity of that original separator.

The big companies get a lot of bad press for a number of reasons, some justified and some because they are just a big target, with all the well-known issues regarding the creators' rights. For me to get the opportunity to go back and work on *Watchmen* was a pleasure, and as the "custodian" of *Watchmen* DC has kept its flame going now for thirty years.

Allowing for my bitching about the limitations of the printing process all those years ago, a big thank you to all those unsung original hand-separators who worked on *Watchmen* and did try to make my near-impossible demands appear on the printed pages. And of course to Dave and Alan who all along had wanted to make *Watchmen* a team effort, and to Dave in particular, being the person I was in close creative contact with from day one to today. For anyone who has an interest in more detail in the creative process that led to *Watchmen* and how this work of literature came about, I would recommend the book *Watching the Watchmen* by Dave Gibbons.

1986 is the year I felt like I had finally started my career as a professional comic artist. That year most of my work was from comic publishers. It was also the first time I heard that there were only two hundred full-time professional comic artists in the world … and I was one of them! I did find that number hard to believe initially, but I subsequently found that it was the number of artists for whom the majority

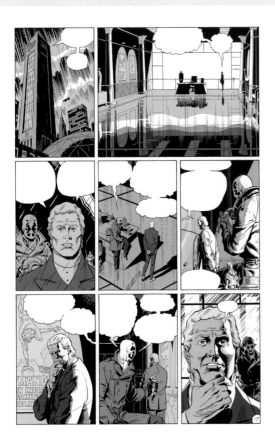

of their income came from comic-book work. I still feel chuffed that I have somehow managed to stay in that group. It is a weird and wonderful way to make a living. If you are a good artist you can find work in other, more lucrative fields than comics. I had done most types of illustration – storyboards for movies, book and magazine covers, advertisements, etc. – all of which I do enjoy, but (and it is a big but) to tell a story, to engage with a reader, is one of the most fulfilling forms of art that I can ever imagine. It works on so many levels for me that I cannot imagine doing anything else as intellectually stimulating as telling a story in words and pictures for a living.

So this year being my Year Zero, it was also the year when a number of techniques came together, along with the colour theory I had learned and put into practice post-*Watchmen*. The year when the feeling of blind panic about how to approach a comic story finally faded. I was learning how to cope with deadlines that are never long enough to give a job the type of finish you would want for it. I was finding the level of professional finish that might stop short of what you want, but that is more than acceptable for publication.

During the *Watchmen* year we all got noticed, which generated more work for us all on other projects. Dave started to talk to Frank Miller about what he would like to do after *Watchmen*, which became the Martha Washington series for Dark Horse. Alan was doing a number of titles even as he was writing *Watchmen* (one of the pleasures of being a writer is of course to be able to write a page of a comic story in a fraction of the time it takes an artist to draw the same page!)

Here with Laurie, Dr Manhattan tints the surrounding walls a light green as his blue reflects over yellow doors.

In the corridor with the soldier in the bottom three panels, the colour palette alters as Dr Manhattan vanishes.

I used stark blue light and left the blank white paper on the printed page to create a bold effect for the lightning flash.

"Colour is a language that the graphic artist uses to manipulate his reader's attention as well as to create beauty. There is objective and subjective colour. The emotional states of the characters can change or influence the colour from one panel to the next, as can place and time of day. Special study and attention must be paid to the language of colour." – Moebius (Jean Giraud)

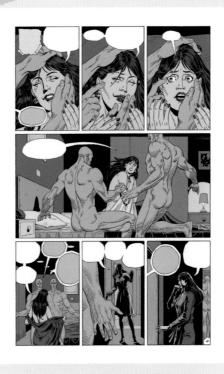

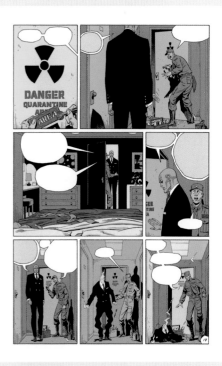

The covers for *Watchmen* were created with a full-colour blue-line technique. This allowed great tonal flexibility, with Dave's line overlay containing the colour and adding shape and form.

Dave described it as trying to present a *trompe l'oeil* tonal reality, to then crossover into the comic-book story proper.

Blue-line was only used on the prestigious books, *Watchmen* and *The Killing Joke* being two prime examples.

It's a truism that success breeds success, I suppose, but for me colouring was just an adjunct to what I wanted to do, which was the whole shebang: pencilling, inking and colour. So I felt for a while that I was driving down a dead-end street. In the USA I was known solely as the colourist on *Watchmen*, so the work I was being offered was colouring other artists' work. I did turn down work, but when I was offered the opportunity to work on *The Killing Joke* with Alan Moore and Brian Bolland I could not turn *that* gig down. Another incentive was that it was to be coloured using the blue-line technique, not the hand-separating method we had used with *Watchmen*. We did use blue-line just for the covers of the *Watchmen* issues. Conceptually Dave felt that a more realistic cover image would give a *trompe l'oeil* effect, a sense of going from everyday reality into this fantastic world of superheroes.

Blue-line is a full-colour method of colouring. The black line is printed in blue on a colour art board with a separate black plate printed off at the same time. Both boards would have to be kept together at all times so any temperature changes that might affect the boards would affect both at the same rate. Any variation in board sizes – no matter how small – might be seen in registration when rescanned for printing. Another new technique for me to learn.

I did speak to Brian on the colour approach. I don't remember that we had any deep discussions, but I did offer to come around to his studio as I had done with Dave to review what I had done on a regular basis. He did not think this was necessary – plus I think the deadline was way too tight to have that luxury.

I then approached the colour in the context of the colour theory I had used on *Watchmen*. In particular I wanted to create a purity of hue, one reason being the awful grey-tone printing we had on the first couple of issues of *Watchmen*. I think I had a phobia about muddy dirty colours – and I still do. But I also wanted to tint the colour in the context of storytelling as a reflection of The Joker's mind: mad boiling colours. The deadline ensured that I had to get it right first time, so everything was done clean and fast, using an airbrush (just like the digital one you have in Photoshop, but no command-Z to step back if you make a mistake) and water-based inks – no chance to overwork it, so it did turn out as clean and as bright as I had intended.

I subsequently found out that Brian had envisioned it as dark and moody, from the Dark Knight's perspective. Brian did get the opportunity to recolour it not long after we had revisited the *Absolute Watchmen*. I think this is all pretty cool as now we have the colour from both the protagonist's and the antagonist's perspectives, which I think engages with the concept of colour being an emotional adjunct to viewing the same story,

I suppose it is an unintentional study in colour concepts … worth checking out both versions.

The Killing Joke used this technique not just on the cover but throughout the complete graphic novel.

My favourite page, with Brian Bolland's rendition of The Joker's first appearance in *The Killing Joke*, with Richard Starking's lettering integrating so well into the artwork to create a dynamic classic graphic image.

The blue-line page reproducing Brian's black-line on a wash art board, ready for my colour washes and airbrush tone.

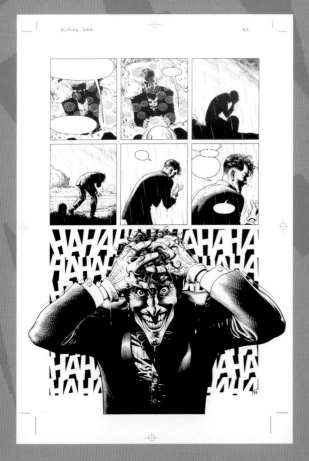

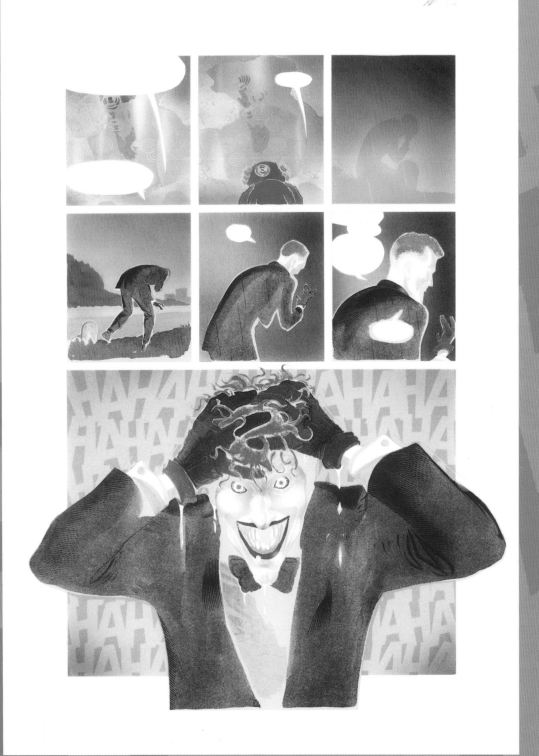

My colouring creates a ghostly unformed effect on the blue-line art board.

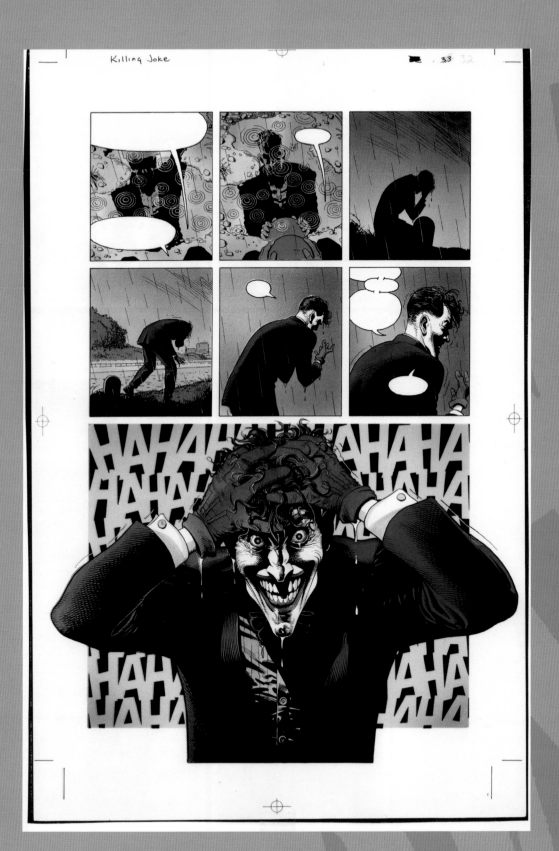

The combination of my colour and Brian's art solidifies into the page you see printed in the book.

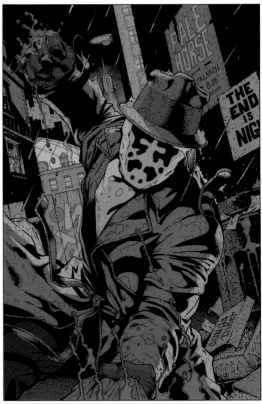

The silk screen print.

Rorschach in full vigilante mode in the alley after looking voyeuristically at the naked woman in the bedroom window. She came back to the window to the sounds of Rorschach beating a mugger to pulp.

This is Sally Jupiter in her bedroom with the clues as to who her lover in the bed is. In case you have not read *Watchmen* I will not say any more about his identity.

The silk screen print.

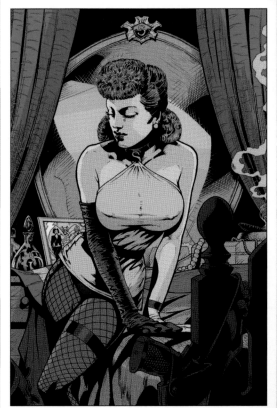

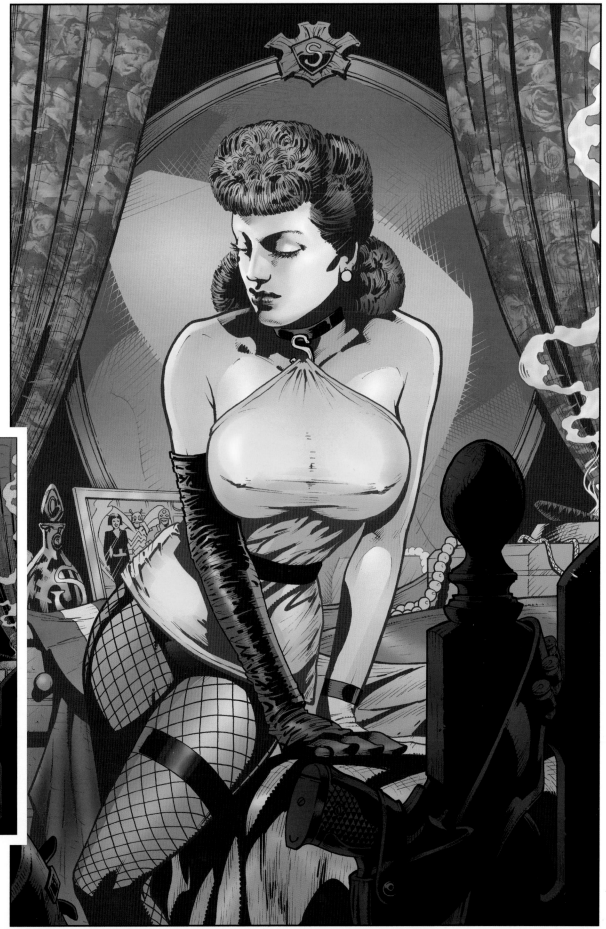

One prime example of the colouring process is the Rorschach episode.

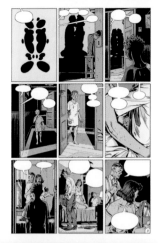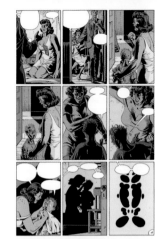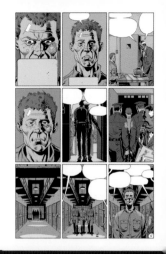

The issue started with sunny early-morning light streaming into the prison room as the psychiatrist, in a bright and breez

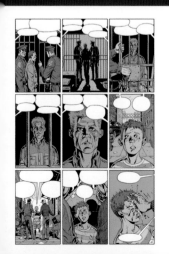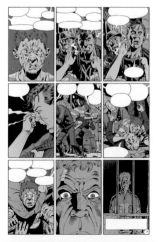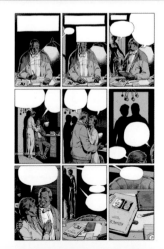

WOMAN KILLED WHILE NEIGHBORS LOOK ON

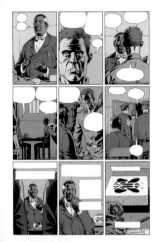
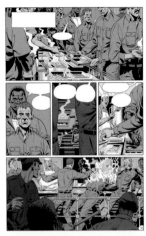
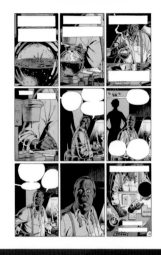
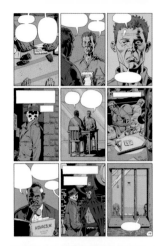
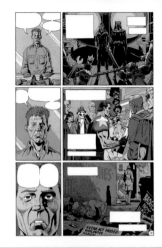

manner, tried to get through to Walter, to cure him. As the story unfolds and the horrors of Walter's life begin to permeate

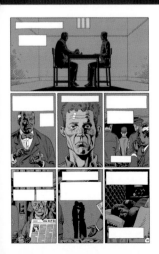

...he story, the colours start to darken and reflect the sense of corruption and despair that created Rorschach.

2000AD AND JUDGE DREDD
ANATOMY OF A FREELANCER

My daughter was asked at school, "What does your dad do for a living?" She answered, "He doesn't work, he stays at home all day!" One of the smaller problems in having a home studio: not just your children but other people assume it's an easy life working at home as a freelance artist. People pop in for coffee or a chat: "As you were in I thought I'd just come around!" Gee, thanks! Personal contact is very important in all forms of life, but not so much when you're trying to hit deadlines … then you need a quiet studio, so the first lettering job you need to do is a "KEEP OUT" sign for your door.

It is imperative to sell yourself to clients. If your work is good, you will be employed. Even if you find that initial selling of yourself hard to do, the work will and should speak for itself, as that is the whole point of a picture. "A picture is worth a thousand words!" as some perceptive ancient once said, probably Confucius (K'ung-fu-tzu).

While at college I had shown an aptitude for figure life-drawing and had a fascination with the mechanics of the human body. At that time there was a lot of publicity surrounding Leonardo da Vinci which focused on the Renaissance master's dissections and anatomical studies in a series of sketchbooks that had just been exhibited: fascinating stuff. My tutors did all they could to support and encourage this direction, and got me a work placement at the Medical Art Department at the School of Medicine in Liverpool University. This led to a portfolio with a large number of anatomical studies and full-colour illustrations which did turn out to be a good talking point at any portfolio review, and eventually got me a job in London.

Leonardo da Vinci's anatomical drawings, begun in 1489. Da Vinci discovered many features about the human body centuries before professional doctors and anatomists. The drawings were lost after his death and not published for hundreds of years.

Gravid Uterus – artist, Jan van Riemsdyk (anatomist William Hunt) 1774

My medical sketchbooks, used when attending operations as a medical artist. Finished illustrations based on the sketches were used in medical journals to accompany articles written by the surgeons on any new surgical procedures.

I remember my first day going to the Medical Art Department within the grounds of Liverpool University. It was exciting for a 25-year-old who had left school at 15 with no educational qualifications to be in such high-brow surroundings.

"Sounds like a school-drop out to me, Stan!"

I had joined the army at 15 years of age on the advice of my uncle, a serving RAF officer and a veteran of the Second World War, who had flown night sorties in Lancaster bombers. He saw the armed forces as an opportunity for me to learn a trade. He also knew that my leaving home at that time would give my mum some small respite from having brought up three kids as a single widowed parent for the previous twelve years.

I enrolled in art evening classes in Singapore when I was stationed out there as a 17-year-old. This took great will-power to attend regularly, given all the distractions around, such as the NAAFI bar, the Tokyo by Night girly bar, the Champagne Bar which had an interesting way of returning your change, Bugis Street – great street food and very interesting people who haunted its environs – and of course Gobblers Gulch.

"I think he has a whole other story to tell, Stan."

"I think you're right, Ollie!"

Here I am in my first week as a "lean mean killing machine"! Nah, just a 15-year-old boy in an itchy uniform.

However, let's jump forward in time to my two weeks working in the Medical School Art Department, alongside the medical artist who showed me the workings of her department and all aspects of what was expected to produce work for educational purposes. Every day I attended, with the first-year medical students, the anatomical dissection of a human body in the afternoon, sketching and observing in my white coat, feeling that I was in the company of a special group of people. Even now I can easily bring to mind the smell of the formaldehyde used to preserve the bodies: an eye-watering, nose-stinging, miasmic odour that clung to the clothes for hours afterwards.

This gave me an experience of anatomy far beyond most art students and it became a perfect grounding for when I was interviewed by Ms Pegus, the head of the Medical Art Department at the Royal Marsden Hospital. That was where I subsequently started work, training as a medical illustrator, attending operations, post mortems and nurses' parties. It was here that I met my future wife, Selina Aston.

Medical art was a career direction I had not expected, but it became one of the most interesting and rewarding learning curves of my career, and gave me the opportunity to get paid to live close to all the SF publishers that I hoped to work for: Pan Books were in a building a short walking distance down the same road as the hospital. One time when visiting the editor Dave Larkin (who had a brilliant open-door policy for young artists with potential: he would give them two SF covers to do as a try-out, very helpful with good advice and great for your confidence), a young woman exited through the door opposite the one I was entering. The sign on her door said "Fine Art Prints." We both carried portfolios.

I entered a local painting competition in Liscard, Wallasey, with a portrait of a hobo in the students' section and placed first. From this I was commissioned to paint an official portrait of the Lord Mayor, with great advice and support from the college principal John Heritage.

At the showing of the portrait. 1972.

I had never experienced this sort of publicity or attention before, but I found the free bar a neat little perk.

John "Herdy" Herdman, a fellow student, found humour in all aspects of life in his cartoon strips. As a fellow freelancer he gave me appropriate help and advice over the years. One particularly difficult year I had, he just proffered this comment – "My dad used to say that if I fell into a barrel of tits I'd come up sucking my thumb!" It helped … it made me laugh.

Herdy, in the second-year art studio at Wallasey College of Art. 1972.

Fame 'N' Fortune
A true Story

Airbrush, a well-used piece of equipment, still in my studio, still being used.

TIT (Trans-Interplanetary Trading) Company Ltd. My first published comic strip, done in the evenings while working at the Royal Marsden Hospital medical art department. 1978.

I said, "Snap!"

She said, "I think not!" and walked away haughtily.

"Stuck-up cow!" I thought, and stumbled through the Pan Books door, on into the future.

Rejection and disappointment is the lot of a young artist, and perseverance and optimism is the armour against a seemingly continuous assault on any self-confidence the artist might have in his or her abilities. But bit-by-bit, we meet more Dave Larkins. We improve as we go through a constant learning process ... who to listen to – the Daves of the world and not the "stuck-up cows" – and then what to do with all that information. Never stop learning and never rest on your past successes. Always strive to improve, learn new techniques and you will get there in the end. An artist might be the best in the world but never manages to see print because he or she lacks perseverance. Stickability is one of the most important attributes in a freelance artist's make-up.

Subsequently – upon seeing in the comic book pages artists whose understanding of the human figure was exceptional; the form and the shape of the musculature was as good as any classical or medical artist – I knew it was a place I could enjoy pure figure work as part of my daily job ... once I got in, that is! And, yes, I did consider Richard Corben to be one of those artists.

The British underground comix and magazines that I discovered when living in London were a great grounding in illustration. They required all types of illustration from full-colour covers to black-and-white art, tone and line. To learn on the job gives a different dynamic to how you approach the work. Working from a professional brief is completely different to picking and choosing whatever you want to do while at college, where to a large extent you are working to your strengths and not really stretching yourself.

One of the first underground comix I worked on, colouring this cover by Garry Leach (*Miracleman, Warpsmith* etc.). The first time I used hand-separations. 1974.

Underground comic,
Graphixus #2, cover by
Garry Leach.

Alpha, one of the first – if not *the* first – comic strips I drew,
when I was at Wallasey College of Art. 1972.

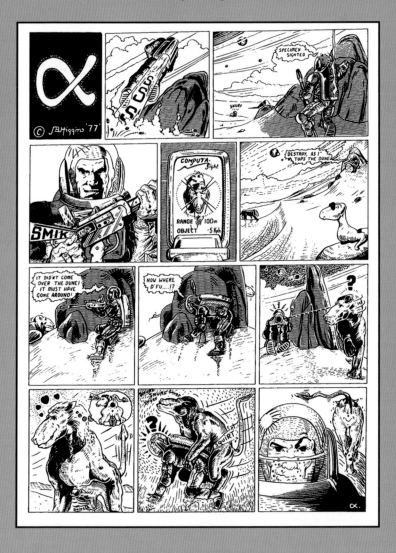

My very first illustration
for *2000AD*. 1977.

A character for a Colyer Graphics advertising campaign. 1984.

Laurel and Hardy poster. 1980.

COLYER GRAPHICS PRESENT

Deadline Demon and poster for Colyer Graphics advertising campaign. 1984. The payment for this was $2000: $800 in cash and $1200 in materials.

Going into their art department was like being a kid in a candy store.

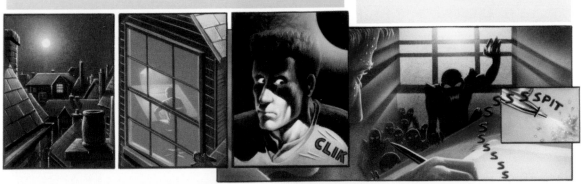

ODE TO JUSTICE

Into the city of death stole the four hundred,
Intent upon a lightning midnight raid.
Now they're on their way to the cubes, 'cos
they reckoned without
The city's **HEAVY DREDD BRIGADE!**

Pin-up of Judge Dredd. 1983.

From the collection of Les Minney.

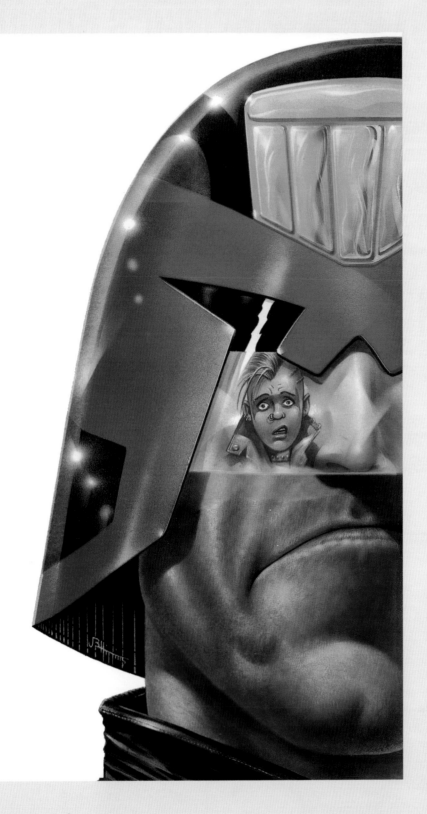

Cover for *2000 AD Sci-Fi Special*. 1987.

From the collection of Ken Jones.

My first Judge Dredd story, "Beggars Banquet". 1986.

From the collection of Mick Ashpool.

2000AD, a pin-up of Crazy Chrissy from *DR & Quinch*, costume designed by Jenna, aged nine years.

Jenna and I being introduced on stage in 1990 by Frank Plowright, one of the organisers of UKCAC, a successful British comic convention that ran from 1985 to 1998.

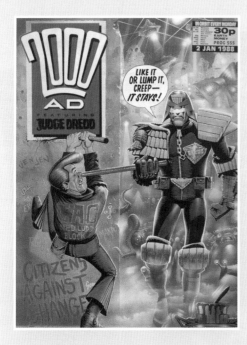

Me and continuity, when they changed the logo in 1988 and 2001. I repeated the cover composition, a neat editorial concept by Andy Diggle (editor *2000AD*, writer: *Losers*, *Hellblazer* etc.)

2000AD covers. (Rebellion) 1997.

From the collection of Ken Jones.

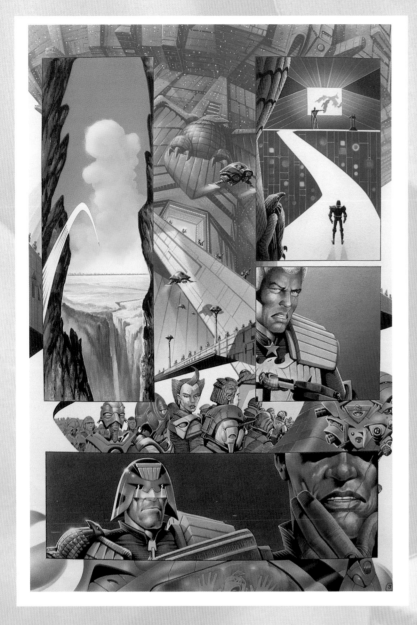

The opportunity for me to explore alien radioactive landscapes and mutant creatures was pure SF bliss. Writer John Wagner gave me plenty of scope to have fun in this dystopian hell.

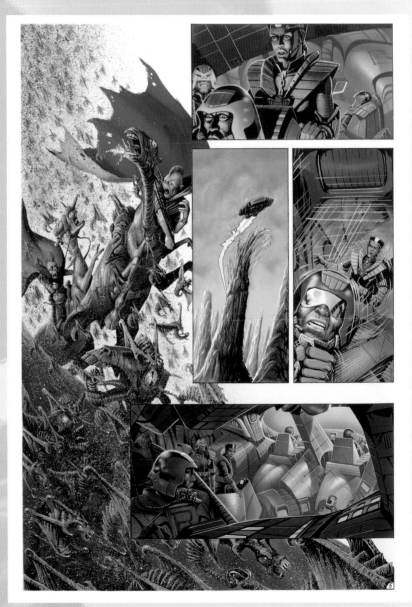

Art page *Judge Dredd Annual 1988*.

The Princess of Mars by Edgar Rice Burroughs.
Cover painted by Bruce Pennington.

The first cover I saw of 2000AD, issue #26,
by Lopez.

Art page *Judge Dredd Annual 1988.*

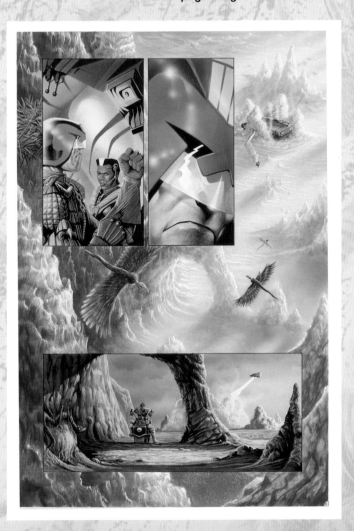

However, soon to come over the horizon was a British comic that would show me into a future world, right here, almost right now and a lot closer to home than the publishers of Marvel, DC or *Metal Hurlant* – at last came *2000AD*. On one bright day – not in the hallowed halls of Dark They Were and Golden-Eyed but in a lowly newsagents – I saw my first issue of this SF publishing triumph. The first SF book cover that shivered the timbers of my mind was Edgar Rice Burroughs' *The Princess of Mars*, painted by Bruce Pennington, and in a symmetry I have just now spotted, the first cover I saw of *2000AD* was issue #26, by Lopez … both featured a neatly realised alien steed.

I could not imagine at that time just how important *2000AD* would be to me and how much it would feature in my career – so far. The only disappointment: it was all black-and-white line art, not a technique I could do to any great effect at that time. But it *was* science fiction, so I had to try to get in it, and I did manage that later in its first year, a black-line cover used for issue #43. It was not a particularly well-constructed or finished piece of art, but I was finally starting to get published.

From that day in the newsagents I became a fan of *2000AD*, and of all the characters I have had the pleasure of working on, Judge Dredd is my all-time favourite (closely followed by Batman). Dredd works on so many levels, due mainly to the original creators who put in place the template for such a nuanced character. The very first Dredd strip I had the pleasure of drawing was "Beggar's Banquet", written by John Wagner and Alan Grant (collaborating under their pseudonym of TB Grover). As I keep continuously banging on about – all jobs should be a learning curve and with "Beggar's Banquet" I started to learn how to pace myself for storytelling. The double page spread (DPS) opening scene of the seven-page story took probably 60 per cent of all the work and time I put into the whole strip. I then had to finish off the next five pages in double-quick time. This was when I first realised how time-efficient you had to be to do comic strips as opposed to single editorial illustrations or covers. Much time can be saved if you prepare the foundations properly, even though it might be frustrating working your way methodically through the story, doing thumbnails and then roughs, when all you want to do is rush into doing the fun pages first.

Dave Gibbons, in our many talks about comics and storytelling, once said "comic storytelling is not a sprint, it's a marathon". You need to pace yourself. It is the cumulative effect you are trying to achieve, to create flow and a sense of immersion within the story. Comics should not be a series of static, wonderfully rendered works of art. Comic art is only a success if the story is realised completely. You have to make each page interesting, realise the characters and be consistent in the depiction of your story world.

More Cursed Earth mayhem from "Last of the Bad Guys". DPSs (double-page spreads) gave great compositional opportunity, with plenty of room to play with perspective and cropping.

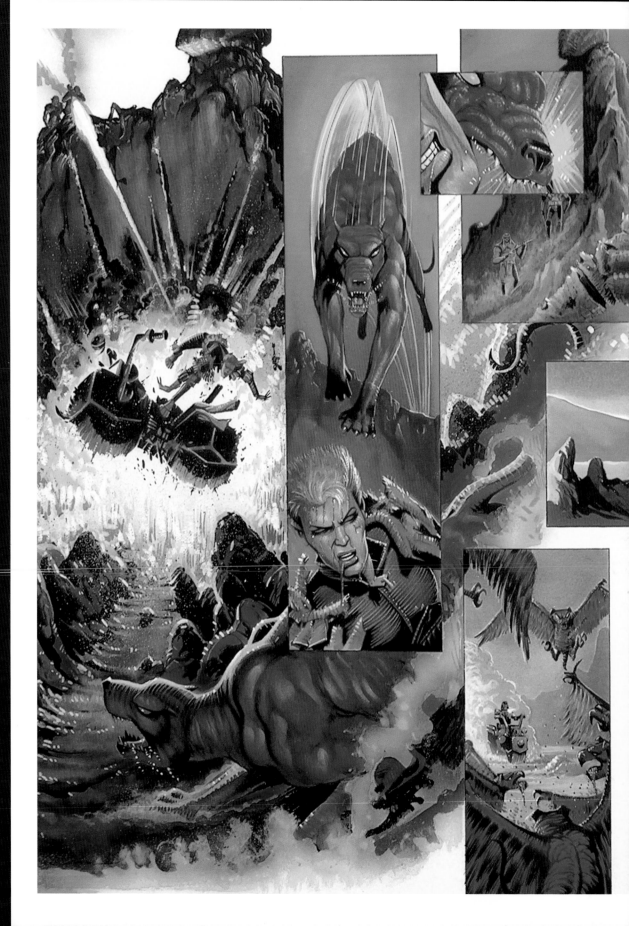

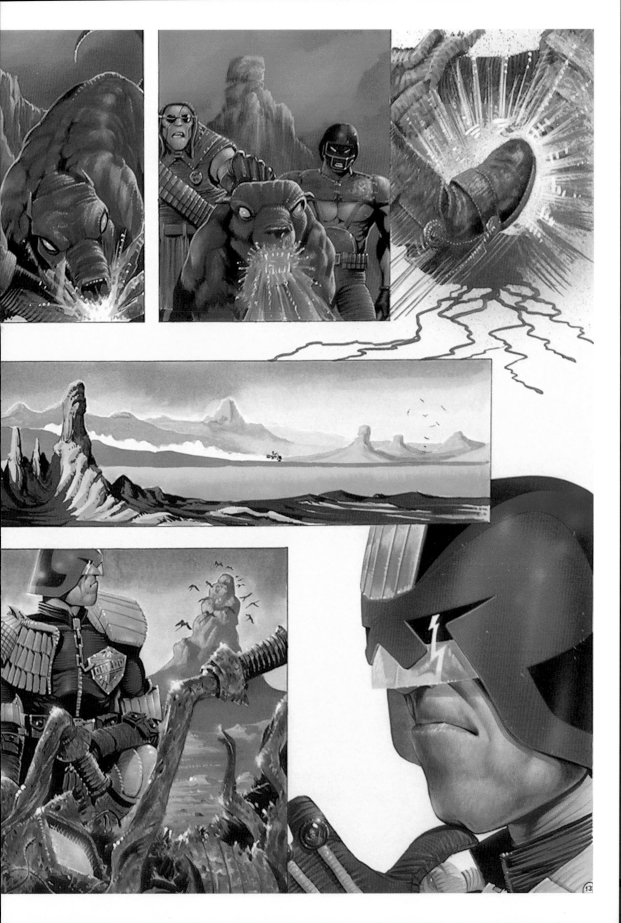

I try to use the "Easter egg" premise regularly in comic-strip work, either by making little hidden self-portraits, or fun detail that is as much for my enjoyment as for any other reason.

Here is a mini-self-portrait holding a paintbrush reflected in Dredd's knuckle stud. In *Razorjack* I dropped quotes in the text from my favourite movies.

This DPS from "Last of the Bad Guys" was an hilarious pain in the butt to illustrate. Against deadline an artist can use "professional" short cuts to save time (mist or dust to obscure parts, recognisable silhouettes of the characters, and so on). Here John Wagner decided to write in and introduce by name every single character in the Bad Guys' gang!

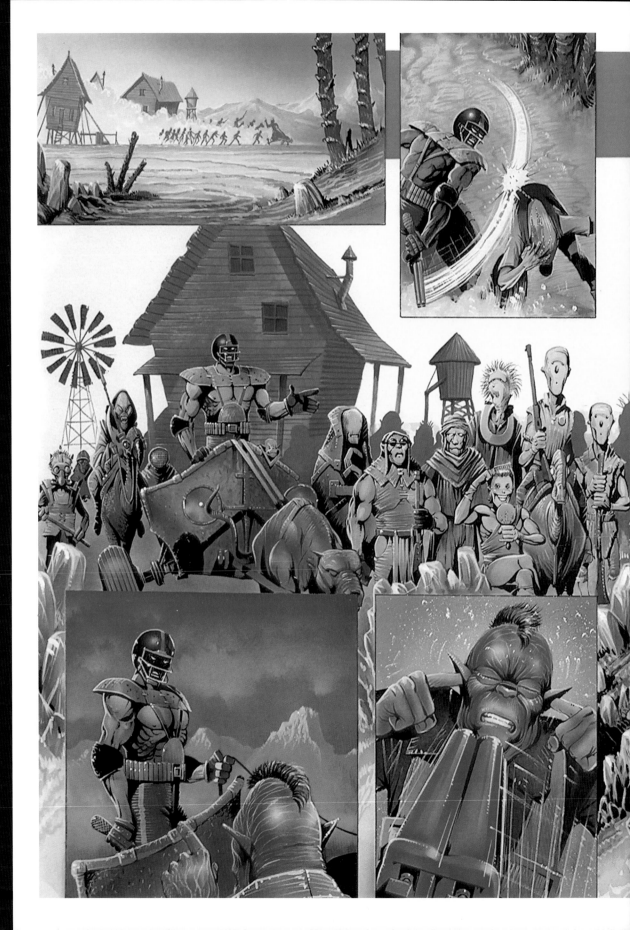

Including Smelly Guy
standing on a hill by himself
in the distance.

Cover for *2000AD,* for when I was illustrating the "Democracy" series. Writer John Wagner. 1986.

From the collection of Eddie Deighton.

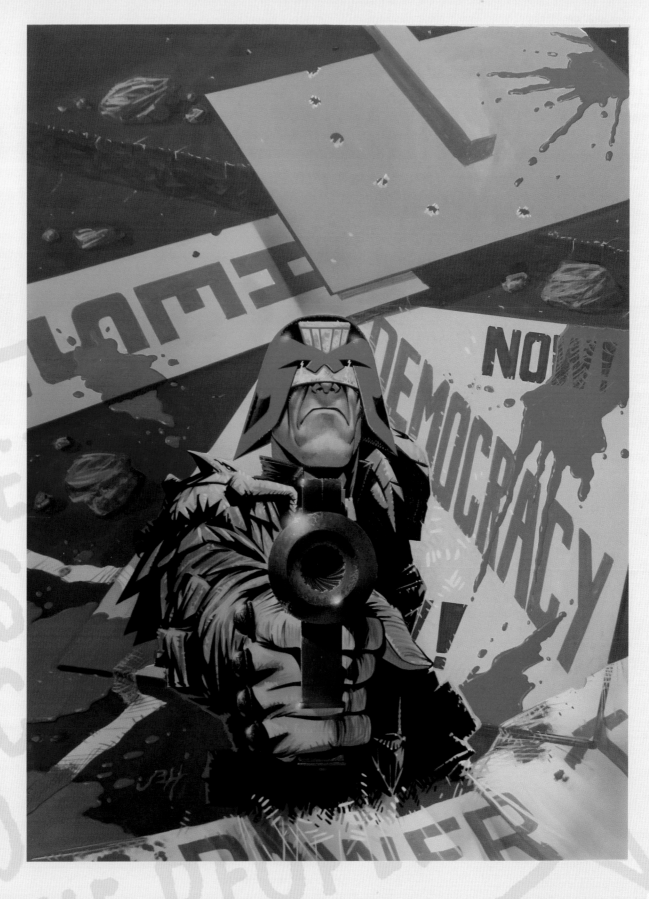

Second cover for *2000AD*, from when I was illustrating the "Democracy" series. Writer John Wagner. 1986.

From the collection of Eddie Deighton.

2000AD cover with Motor Head, a character I had written into "Scales of Justice" set in the Cursed Earth, my favourite setting.

From the collection of Ken Jones.

The original *2000AD* creators, writers and artists had set up a wonderful, weird, fucked-up world where you had the freedom to do this type of character and it had an internal logic for his existence.

My little "Easter egg" in "Scales of
Justice" was to be the red balloon in
homage to *Le Ballon rouge* – a classic
1956 French fantasy comedy-drama.
I was going to use it as a signature
element in a series of further stories
I was intending to do. At that time,
2000AD were selling subliminal
advertising spots within the comic story
pages, and used the balloon for one of
those spots, which sort of precluded me
carrying on with that idea.

John Tomlinson (editor 1994 to 1996,
writer, *Knights of Pendragon*, *Armoured
Gideon*) rewrote parts of the story for
some reason I couldn't quite fathom.

I was aiming for a *Lord of the Flies*
sensibility.

In 1995 I was approached by Guild Entertainment to work with Feref Design to illustrate the poster for the Stallone *Judge Dredd* movie. These are my first three poster designs.

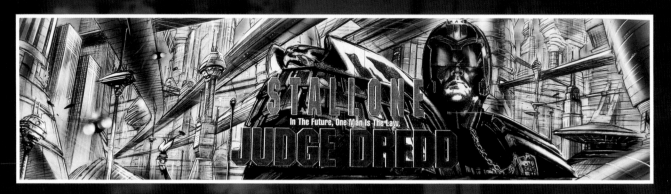

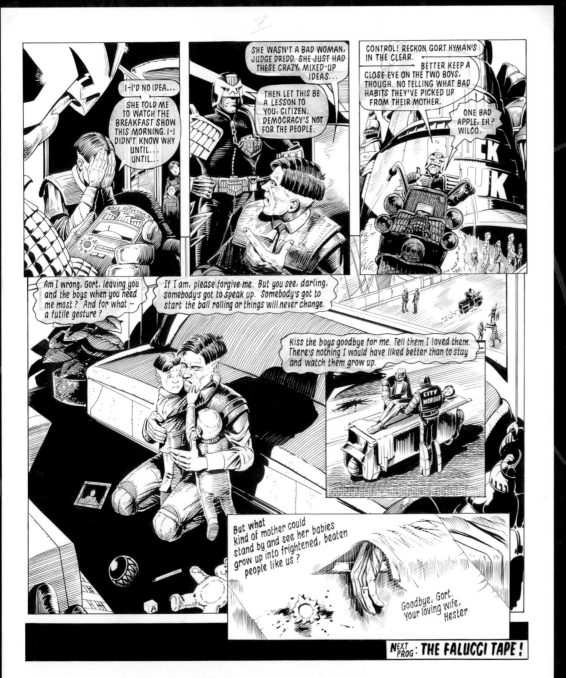

The final page in "Letter from a Democrat", written by John Wagner with my favourite Judge Dredd quote of all time.

THEN LET THIS BE A LESSON TO YOU, CITIZEN. DEMOCRACY'S NOT FOR THE PEOPLE.

z.

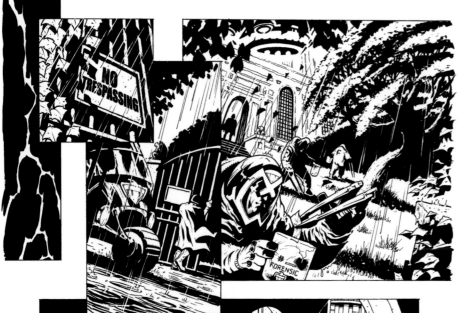

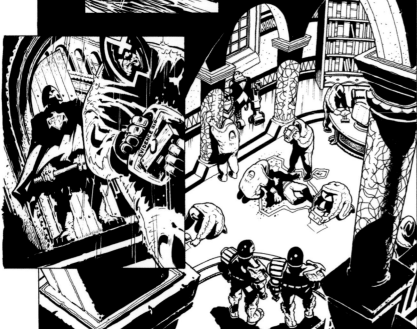

2000AD was a great training ground for me.

I tried many different black-line styles; here I wanted a more stylised characterisation and panel design.

Otto Sump. *Judge Dredd Megazine*, writer John Wagner. 2001.

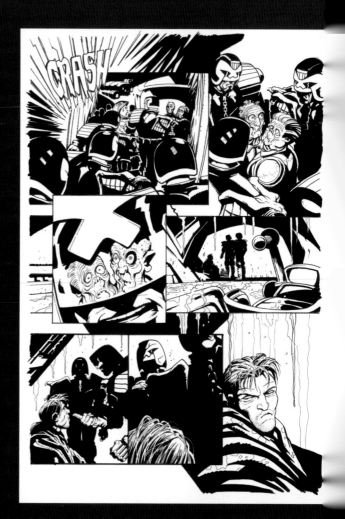

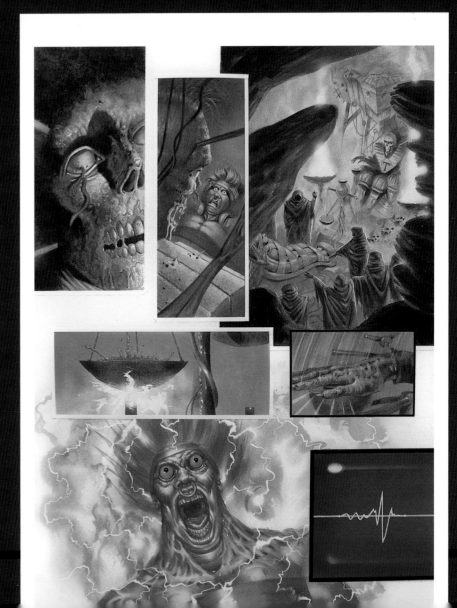

on the big-chinned superstar of this universe, Judge Dredd. At this time – the mid-1980s – IPC (International Publishing Corporation) was based in King's Reach Tower in London's South Bank area. They had a thriving juvenile group with many children's comics and young-reader magazines, all produced on the same floors as *2000AD*. I'd delivered a cover for *Big K* (a computer games magazine) and took the opportunity to pay a visit to Steve McManus.

I went in to say hello, sitting down opposite him as he pondered the line-up for the coming story arcs. His eyes seemed to come into focus, and – talk about being in the right place at the right time – he said, "Hurm! Do you want to do a Dredd story?" I almost fell off the chair. It was the last thing in my mind. I think I had almost given up on ever getting on to Dredd. That was "Beggar's Banquet" and the start of an association with Judge Dredd that has continued up until this day. I still can't wait to receive a new Dredd script.

The cover I delivered to *Big K* magazine the day Steve McManus gave me my first *Judge Dredd* commission.

From the collection of Richard Burton.

A colour page from "Scales of Justice" showing the mechanics of how the scales would be used. I like to keep a logic within all I do, including how to make a dead Judge slap an execution button.

Doing the odd *Future Shock* for *2000AD* in the early years was a great learning curve before I became a member of the two hundred (a full-time comic artist) in 1986. Finding the best pens, inking using Winsor & Newton brushes … long bristle or short bristle? Felt-tip or dip-pen? All were tried and all had different strengths, but which worked best for me? That was what I learned along the way.

I honed my skills working with writers such as Alan Moore, Peter Milligan and Kelvin Gosnell, each job proving to the Mighty Tharg (*2000AD*'s alien editor, AKA Steve McManus, in those days) that I was almost ready to cut the mustard

TEETH AND CLAW
WHY MONSTERS?

I like monsters! I wouldn't want to meet one, but I like to create them.

Why is it so fulfilling to create something misshapen and twisted? For me it is depicting something only I can imagine. It is my creation, it is mine alone – no one else thought of it. The creation of a monster image works the same way as when you draw a representation of a beautiful figure: my technical approach to both is the same. You start in the same way, measuring proportions, setting form against function, composing elements in a setting. There has to be a sense of balance, even with a misshapen thing.

I think our reaction to a beauty or a beast is similar; there is a fascination in seeing something beyond the norm and in an artist's representation of such.

Film-makers do not differentiate greatly in how they approach a scene in a comedy or horror movie: there is set-up, anticipation and pay-off. The reaction to both ends in an explosive exhalation – a laugh or a scream – the same physical reaction.

Beauty is an easy form to depict and to respond to. It is hard-wired into the human psyche to appreciate all that is attractive, in exactly the same way that we respond to children. When Walt Disney first started in the late 1920s his cartoon characters leaned towards the ungainly and were almost downright ugly. Once he and his artists refined the proportions of his animated cartoons to the most pleasing shapes, it became clear that they all distil down to the shape of young children: big head in proportion to the body, large expressive features, little pot-bellies.

Facial symmetry has been proven to make a subject more attractive and appealing to the viewer. The more symmetrical a face, the more we appreciate it and the closer it is to what we consider to be beautiful. Many studies have been done trying to map human features and analyse what makes beauty.

The term "Uncanny Valley" refers to the perceived drop in attraction and relatability of a man-made object the closer it comes to mimicking the human face. Japanese robotics professor Masahiro Mori mapped human faces and discovered that once a face started to score above 85% on the life-like chart its attractiveness plummeted. Humans need to see *life*, not just *life-like*. The valley is the point between the extremes of likeability. On one side of the valley are cartoons, cuddly toys, puppies. On the other side of the valley are fit, healthy, attractive humans. And in the depths of the valley – no matter how beautiful – we find the lifeless representations of "perfection".

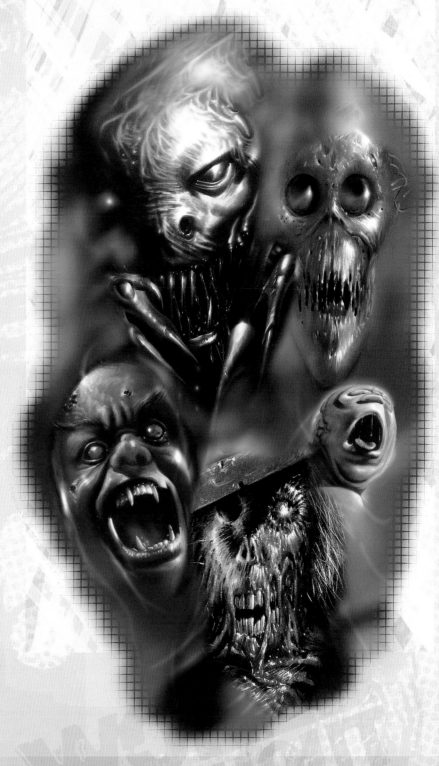

Ah, my favourite: monsters!

The actress Joan Collins – known as much for her beauty as for appearing in the *Star Trek* episode "City on the Edge of Forever" (written by Harlan Ellison, my Teflon man!) – has had a long and successful career in TV and in movies but is also known for her quips. My favourite is "The problem with beauty is it's like being born rich. As you grow older you become poorer."

Ageing is a natural process, and some people age well (Joan Collins again). But age, injury and illness change the body. The point at which we depart from the norm is a good place for you to start creating your "monster". Freak shows in the early twentieth century were an accepted part of entertainment in travelling circuses. Before that, public hangings and torture were commonplace, as was the deluxe version; hanging, drawing and quartering. Victims were fastened to a wooden panel and dragged by a horse to the place of execution, where they were hanged almost to the point of death then disembowelled, beheaded and chopped into four pieces. Perfect entertainment for everyone – well, except for *one* person, of course – back in the days when there was no TV.

Also (I'm on a roll now) rather popular was the practice of certain gentlemen and gentlewomen paying to watch a doctor perform an operation. This was before effective anaesthetics were discovered, with the patients writhing and screaming as the surgeon amputated a limb or sectioned a bowel. The best surgeons could have a leg off in thirty seconds, cutting through the thigh and sawing the bone, tying off the arteries and veins. Where do you think the name "Operating Theatre" comes from? It's all entertainment, folks!

Brother Bones.

Pre-production designs for *World Without End*. I got the opportunity to do as many monsters as I could possibly imagine, courtesy of my collaborator, writer Jamie Delano.

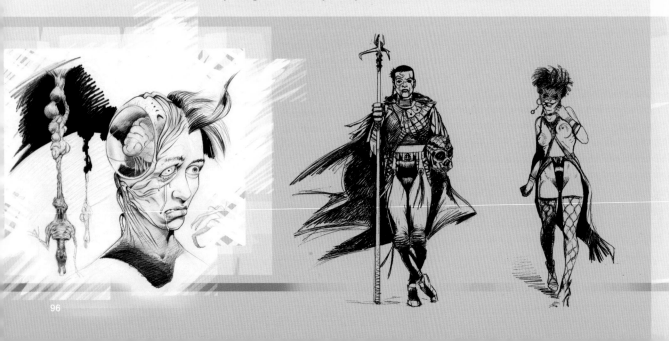

We have a macabre fascination with the suffering of others, with things that are different, with "freaks" and monsters. What I am leading to is this: when an artist depicts a monster, it should have a recognisable, relatable reference point for the viewer – even if they do not perceive it as such. Start with any form – humanoid, animal or both combined – and twist it into a monster. The horror aspect is created by having something in the picture with which the audience can empathise or identify, even when the picture becomes something only imagined in nightmares. Sharp teeth, slime, scales, burns, scars, tentacles, tumours … Just like your Kiddie-mix candy in supermarkets: you have more fun when you mix and match.

Otto Sump, a character from *Judge Dredd* in *2000AD*, opens Ugly Clinics when an ugly fashion fad happens in Mega-City One. A satirical story written by John Wagner, aimed at the vacuous fashion industry of the modern day, it was fun for the artists to draw beautiful characters and then add blemishes. A delicious counterpoint to the usual perfection expected in comic stereotypes. This was achieved by the characters in the story using unguents and creams to create warts and other blemishes, a reversal of all we might do to look better and feel more attractive.

The most classic monster is the one created by Victor Frankenstein in Mary Shelley's classic (arguably the world's first science fiction novel). Frankenstein had intended to create a beautiful creature, but he got it wrong. Victor describes the monster:

"By the glimmer of the half-extinguished light, I saw the dull yellow eye of the creature open; it breathed hard, and a convulsive motion agitated its limbs.

"How can I describe my emotions at this catastrophe, or how delineate the wretch whom with such infinite pains and care I had endeavoured to form? His limbs were in proportion, and I had selected his features as beautiful. Beautiful! Great God! His yellow skin scarcely covered the work of muscles and arteries beneath; his hair was of a lustrous black, and flowing; his teeth of a pearly whiteness; but these luxuriances only formed a more horrid contrast with his watery eyes, that seemed almost of the same colour as the dun-white sockets in which they were set, his shrivelled complexion and straight black lips."

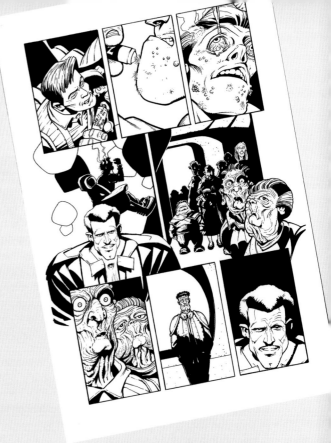

Characters in the story using unguents and creams to create warts and other blemishes … from the Otto Sump story.

Pre-production designs for *World Without End*: more twisted creatures.

I designed the world from the foundations up. Creating a landscape to set the action in was important for me. I needed to know where it was set even if none of this design appeared in the book.

The cover for the Dover Publishing collected edition. 2016.

WORLD WITHOUT E·N·D

The original six issue covers from DC comics. 1990.

A mood page from *World Without End* #1. I love exploring alien landscapes probably more than any other aspect of SF illustration.

My favourite minor character, Wingman Url, an ordinary Joe (but who could fly). Poor bastard happened to be in the wrong place at the wrong time. I would have loved to explore more of his life and adventures.

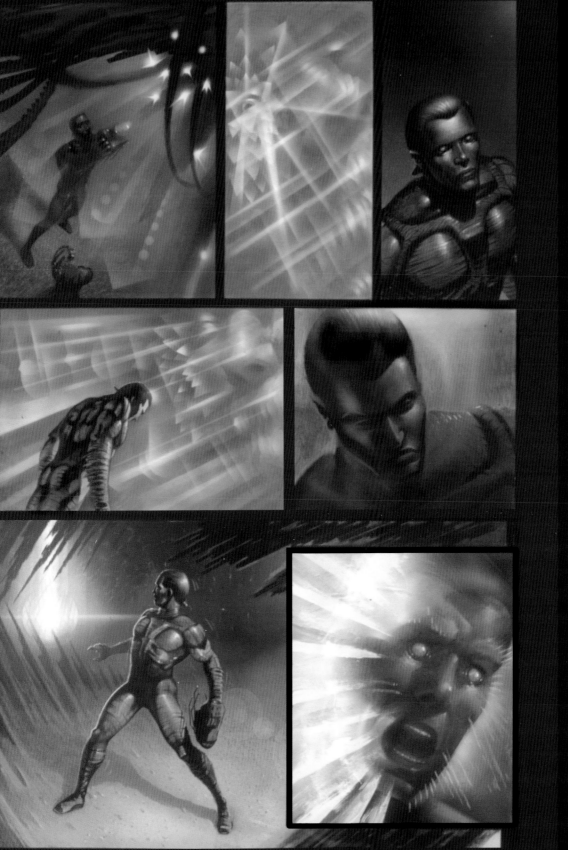

This was the first style-guide page I completed for Karen Berger, the editor for this book at that time.

Superman, Batman, Spider-Man, Captain America ... these are all superhero stereotypes. Or maybe they *became* stereotypes because they were so successful. So many variations of these prime superhero tropes now exist and elements of all of them can be traced back to the very first Greek heroes, Achilles and Hercules. And just look at Wonder Woman – a direct appropriation of Greek mythology! Other mythologies are likewise plundered for superheroes, and they mix and match between them. Secret identities, hidden lairs, unassuming "normal" friends (at least one of whom is afflicted with the "constantly being kidnapped" gene), that one arch-enemy who just keeps coming back ...

For me, the most original takes on new heroes are such characters as Hellboy, Concrete, Hitgirl and Frame from my own book *Razorjack*. This type of character has taken a step away from the stereotype. Sometimes even if the character is completely derivative (and if you don't get sued by the big companies), you can deconstruct it in the writing, in the same way as *Watchmen* did.

The use of stereotypes can trigger a thought-process that takes the reader in a specific direction: I remember first reading *A Game of Thrones* by George R.R. Martin and feeling confident in a certain character whom I saw as a heroic stereotype. I felt that I would follow this hero through many trials and tribulations of the story, knowing he would win through in the end – and he didn't survive the first book! Expectations confounded expertly!

Stereotypes exist for a reason: the readers know what they are getting, and that's comfortable. But it can also be boring and repetitive. As a creator you should strive to blind-side readers (not all the time, because then readers will come to expect it, and such expectation immediately renders the blind-siding pointless), to make them *un*comfortable, and then the story is yours to do with as you wish. In comics we probably deal in the stereotype template more than any other medium except maybe young adult prose fiction.

The first depiction of Wingman Url, who appeared on the first cover. The black-line illustration was for the UKCAK convention booklet 1990.

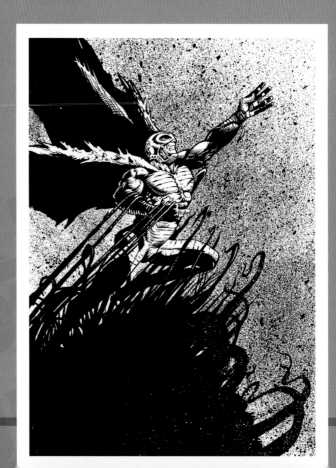

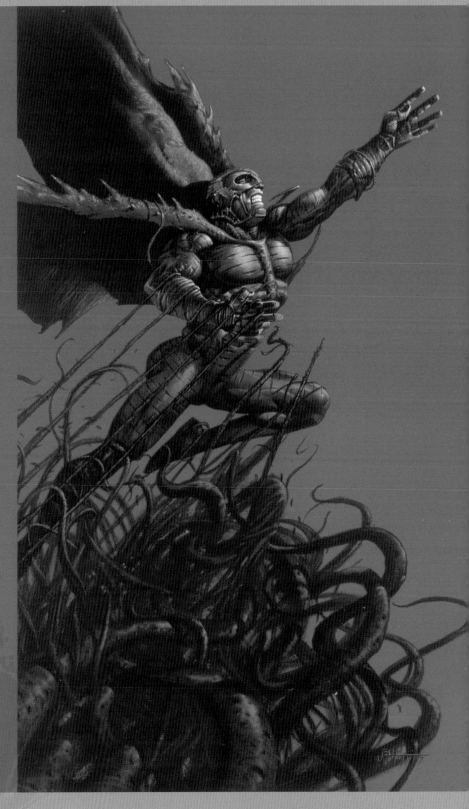

OK, back to monsters! Monsters such as Frankenstein's creature have a form that is *not* bestial and monstrous. His *mind* was monstrous, twisted in a thirst for revenge on Victor. You could understand the reason for his murderous intent. A sympathetic note gives depth to this perceived monster. In the early Hollywood depiction of the creature, Boris Karloff gave it a more horrific appearance which ended up as a recognised classic Frankenstein's monster form. This is not strictly what Mary Shelley had written, but Karloff depicted him as a dead lumbering thing, which I suppose made the blind man scene in the movie a more tense situation by our assumptions created by his appearance.

On seeing any form we make assumptions: beautiful = they must be good because they look like an angel. Quasimodo, the Hunchback of Notre Dame = ugly, therefore he must be evil. Throwing assumptions on their head is a good way of being original. But, of course, readers come to expect that, so to subvert their expectations it's necessary to add a new twist … or go back to an old one. Why *not* have the villain ugly, the heroine beautiful?

If I am brought in as the artist after the story has been written and finalised then my job is to make this world three-dimensional and depict the characters in a way that complements the story. But if I'm involved from the beginning – meeting with the writer, throwing ideas in, throwing them back out, throwing them in again but from a different angle, sketching character ideas, etc. – then such a partnership is a pleasure.

On both types of collaboration, the job of the artist is to construct the world from the ground up. But when you have an investment as a co-creator such as I had on *World Without End*, it involves you differently than just being a work-for-hire artist.

The cover for the first issue of *World Without End*. I used the colour psychology that IPC magazines had researched and proved to work. Used red on the cover – just a bit.

From the collection of Les Minney.

I remember spending weeks drawing character designs and creating the landscape before I started, talking to Jamie about what we were going to do. He frequently saw designs that sparked new story ideas, or shone a new light on old ones. This is particularly important when creating a fully realised fantasy world, and it's great fun!

When I started to paint *World Without End* the first couple of issues were fully painted on white art board with Liquitex acylic paint and probably took fourteen weeks an issue, so I reckon with the preparation and then painting the first two issues probably took nine months to complete, three to four days a page. The series was scheduled while I was working on issue three, and that triggered "deadline focus", so each issue subsequently was created a little faster. Issues three to six would average out to eight weeks per issue. So now I had that dilemma of having created a standard of art below which I could not drop, so I had to find ways of speeding up. To do that the later issues were done predominantly on coloured art paper using mixed media of cut-out collage, acrylic paint, water colour, magi-colour transparent inks, pastels and coloured pencils.

The second issue I went for cool blue as a counterpoint to the first issue. The pencil sketch was faxed over to Karen Berger to get her approval for the cover design.

Issue #3 cover. As the story was unfolding I wanted to show the characters on the cover. Rumour had now been shown not to be a monster and her real appearance I put on the cover: a beautiful young woman. I always tend to depict real strong women as opposed to balloon-breasted super vixens ... I know I should try harder.

Early in your career every new job is a voyage of discovery. They do say you can only learn from your mistakes. The problem with that is that in comics publishing you are not officially "allowed" to make mistakes, particularly once the book has been scheduled, and the number one sin is to miss a deadline. That costs the publisher money, and that will cost you your job.

Hang on, I hear you cry, what about those great artists who are notoriously slow? You will notice that they do not draw many regular books. And the publisher will not use them for titles on a regular schedule. Publishers tend to give open-ended deadlines if a desired artist is slow. The artist gets the same page-rate as everyone else and if they want to spend two weeks on a page rather than your regular artist spending two days, then that is their choice. But the artist has to be particularly good – or in particularly strong demand from readers, which is not necessarily the same thing as being good – to receive that sort of leeway from a publisher.

If you are a slow artist and cannot speed up without completely compromising the art, then the options you have are to self-publish and to approach a company that publishes creator-owned properties. This has many advantages, but also has disadvantages. The company will only start to pay you once the project gets into profit, and I am sorry to say that this happens to very few titles … but if you hit the jackpot and it becomes a success, it can lead on to the real money-making media, movies, TV and so on. Then it will have made all your hard work well worthwhile without compromising your artistic vision on the comic book.

J.M.W. Turner, a great classical artist who used colour to scintillating effect, influenced me greatly.

Death on a Pale Horse, J.M.W. Turner. 1825.

The first three pages were painted with light and tone to create a mood with Jamie's voiceover words, giving an evocative poetic balance to the pictures.

World Without End #1 page 1.

However, once you tuck the Hollywood dollar into your pocket then it is not *your* artistic vision any more. We all know Alan Moore – the most successful of all comics writers – who has had to date five movie adaptations of his comic books. Alan hates what happens to his creations once they are swallowed by the Hollywood creative mincing machine to the extent that he refuses any monies he would receive for the production of those films. I respect that: he is a man of deep integrity whose position has changed very little since he first fell out with DC Comics in the 1980s due to the machinations of the company's money-making men.

I suppose the most successful comics writer in Hollywood must be Mark Millar. He has had eight movies made from his comic books, and a number of Marvel films have been somewhat based on his storylines. Mark plays the Hollywood game better than any comic creator I can think of.

The bottom line is that you always have the comic book and its original idea untouched, and one of the most positive aspects of any movie made of your creation is that you get so many new comic book sales due to the movie being a two-hour advert for your book: people go back to the source. But it's important to remember that a poor adaptation can sometimes *hurt* the source. Remember, more people will see a bad movie than will read a good book.

So as a creative artist/writer you do have options, but you have to make choices that are dictated by whether or not you make a living being a professional comic artist. A large number of comic creators have a full-time job and comics are just a passion … but sometimes the passion can be *turned* into a full-time job.

The intention was to draw you into this twisted world in an almost abstract way, using tone and colour to create emotion and movement.

World Without End #1 page 2.

Ulysses Deriding Polyphemus,
J.M.W. Turner. 1829.

THEY GRUB THROUGH A HUNDRED-THOUSAND TUNNELLED MILES, OCCASIONALLY EMERGING TO SCAVENGE *MOLD-FLOWERS* FROM THE *DERMBRELLA'S* WEARY FOLDS.

THEY SHIVER IN THE SHADOWED STAGGERING OF FLACCID WALLS, WHICH BOW TO THE SUBSIDING WEIGHT OF AGE-- FOLLOWING RANDOM LIVES TO RANDOM DEATHS; DEAF TO THE PULSE OF DUTY.

IT IS DUTY WHOSE URGENT RHYTHMS DECREE SOUND, FORM AND STRUCTURE IN THE HINTERLANDS THAT CLUSTER ROUND THE VIRILE CORE--

WHOSE PUMPING VIGOR ENGORGES THE VEINED SLOPES THAT RISE TO MEET THE TUMESCENT SPLENDOR OF THAT HALLOWED LAND.

THAT SKY-RAPING SACRED GROVE-- HOST OF LIFE THAT *GESS* CALL--

Using colour with small forms and shapes in the distance to lead your eye ever inward.

World Without End #1 page 3, leading you on to the DPS money-shot of the cityscape. The appearance of the moon and sun in the sky at the same time creates a sense of disquiet for the world of Bedlam. This starts the story off proper.

The character with the creature on a lead appears later on in the book as just as a passer-by on the streets.

From the collection of Les Minney.

THE SHORTEST
F STORY
OW TO TELL A LONG TALE

"The last man on earth sat in his room. There was a knock on the door…"

I first read that short-short-story in the anthology *Best Science Fiction Stories* in my SF-addicted youth. It was written by Fredric Brown. It is a perfect short story. Who? The last man. Where? His room. And then the drama of the knock.

That is also the plot of *The Thing from Another World*, the original movie filmed in the 1950s, along with the remake *The Thing* in 1982, directed by John Carpenter, this being one of my all-time favourite SF movies.

Tolstoy said there are only two plots in literature: "A person leaves town. A stranger arrives in town."

I love the simplicity of all starting points. Whatever creates a story or plot has all been done before and is usually associated with a giant of world culture and literature … Aesop, Tolstoy, Dickens. So there is nothing completely original to be discovered in the context of plot, but that does not mean you cannot put a fresh spin on it and make it your own original story.

Telling a story is the whole point of working in comics, for me the most exciting and efficient storytelling medium in print – the marriage of words and sequential pictures.

For a story we need characters. They do not need to be the first thing you think of but characters – after a certain point – start to create themselves once you have set off on your story, and they become more interesting, almost outside of your control, as they grow and develop in their own way. This is as true in the drawing of them as it is in the writing. A number of artists have ways of breaking into characters, and yes, starting with all your different stereotypes and developing them from there is completely valid.

Psst! Magazine. A collaborative illustration. Angus McKie did the metal, I did the hand. A dummy cover to see if there was a market in the UK for a European-style comic magazine.

Privately financed by Serge and Henriette Boissevain. The creative team was brought together by Mal Burns, a great fixture of British underground publishing in the 1970s and 1980s. (Artpool Publications) 1981.

Star Trek Winter Special cover. (Marvel UK) 1985.

So many people ask, "Where do you get your ideas from?" Well, the more ideas I have, the easier I find it to develop *further* ideas: each idea gives birth to at least one new one.

If we look at the Tolstoy premise:

1. Situation – a person going on a journey … arrives.

2. Conflict – a stranger knocks on the door. Good … bad … human?

3. Protagonists – how do the inhabitants of the room react?

4. Resolution – they all die except one!

5. Denouement – a person leaves town.

Each choice you make at stages 1 to 5 creates a new and separate storyline, and each new variation creates new options.

Not only is that the plot of *The Thing* but also of *Blade Runner*, my number one SF movie of all time. The only difference between the stories are the details that lead from the arrival to the departure. This is the fun part where the storyteller brings to life the What, Where, Who, How and Why.

My favourite quote from *The Thing*, spoken by Palmer (played by actor David Clennon): "You've gotta be fuckin' kidding me!" Taken out of context it doesn't really stand up as great SF dialogue, but imagine a detached head, upside down, sprouting bug-eyed antennas and six spider legs, scuttling off down the corridor. See, *now* the line works!

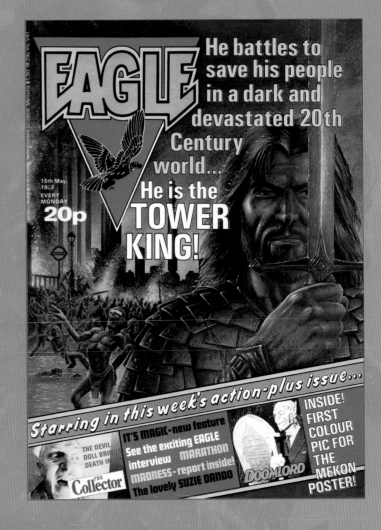

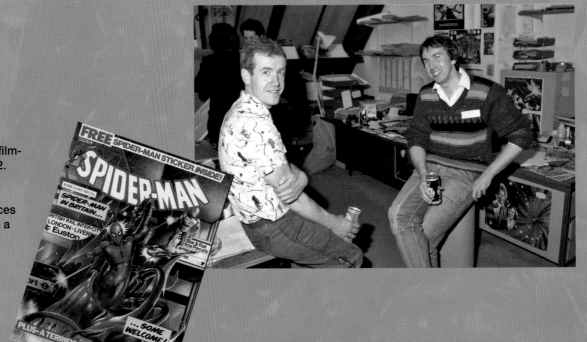

Eagle cover. I was asked to paint a film-poster style for the cover. (IPC) 1982.

Spider-man. (Marvel UK) 1984.

Barry Kitson and I in the Marvel offices in Kentish Town, London. Looks like a Christmas party, early 1980s.

Photo: Steve Cook.

This quote from *Blade Runner*, even out of context, does stand up as great SF dialogue: "I've seen things you people wouldn't believe. Attack ships on fire off the shoulder of Orion. I watched C-beams glitter in the dark near the Tannhäuser Gate. All those moments will be lost in time, like tears … in … rain. Time to die." When you know it is spoken by Roy Batty, a replicant android played by Rutger Hauer, who is dying due to a built-in mortality date, it becomes a poignant and evocative scene that gives his character depth beyond the initial premise setting up him up as an unstoppable killing machine. Apparently this was part script and partly ad-libbed by Hauer.

The most important thing you need to do as a storyteller is to entertain your audience. If you get bored with what you are doing then your audience will be bored too, so being surprised constantly by what you are creating, and what your characters do, has to be the pinnacle of achievement for a storyteller. Many writers say they know the story is working when the characters surprise them and take the story in ways the writer did not plan in advance. You could say Roy Batty did that.

From very simple starting points great things can occur. *2000AD* was an idea conceived by its first editor Kelvin Gosnell while working for IPC magazines, to appeal to the potential SF enthusiasm that he saw would be ignited by a movie that was in production at that time and would be hitting the multiplexes in the coming year: *Star Wars*. For an SF addict it was the start of a incredibly exciting period when some of the most stylish and intelligent movies of any period were being produced … *Alien*, *Terminator*, *Blade Runner*. SF film was starting to reach a level of maturity with the content but also the design and special effects, starting for me with H.R. Giger's *Alien* designs and of course the fully realised world of *Blade Runner*.

A selection of covers, *Mutatis* for Epic Magazines.

Terminator covers (Dark Horse)

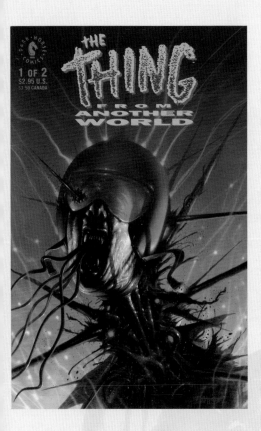

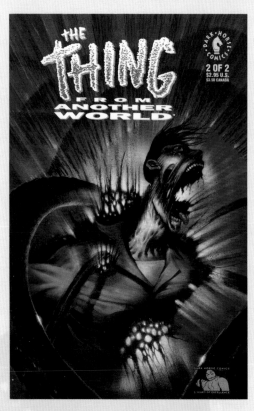

The Thing from Another World, covers for the two-issue mini-series. (Dark Horse) 1988.

Terminator cover art.

The idea of producing a cheap children's newsprint comic to exploit an SF fad had grown and evolved under Kelvin and subsequent editors into a mature quality comic that reflected broader changing attitudes towards SF, and proved (if it needed to be proven) that one should never "write down" to the audience. Mature stories with mature ideas can work for any age, but you do have a responsibility in your depiction and presentation for a young audience. Age-specific titles are not possible or needed in these days of instant media in the way that comics used to be age-banded, but if you want to aim at a pre-school or pre-teen audience then you have to be considerate of that audience.

The audience I prefer writing for are eighteen-plus. I feel comfortable writing and drawing for this group and feel there are no outside considerations I need to take into account. They are more or less me, so I can write about anything. Some younger readers can read and enjoy subject matter beyond what society might say they should: I know that as a young reader *I* could. I do not believe in censorship outside of self-censorship, but you have to ensure your audience knows who it is aimed at if you are tackling mature subjects.

As a creator, when you are employed by a company to produce work for a certain type of audience then you accept whatever strictures you sign on for, but this does not mean you cannot still produce a book with intelligence and depth that might stretch your audience. I discovered many science facts reading SF literature – I knew what a Moebius strip and a geostationary orbit were before anyone else in my class at school.

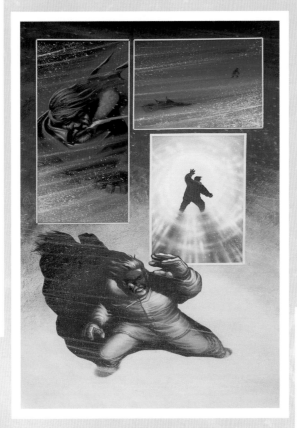

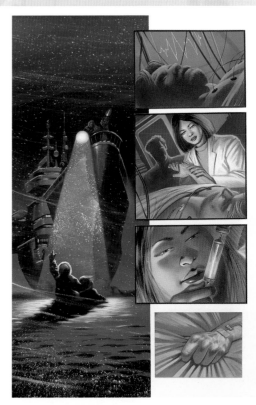

The first three-page sequence for *The Thing from Another World*. I enjoy the opening scene-setting pages in most comics. You usually have time and space to set the template for what comes next, no deadline breathing down your neck … yet.

Teeth, slime and tentacles always works for me, plenty of them in *The Thing from Another World*.

Have you ever noticed how close a smile and a snarl are?

Watchmen has a readership that starts well below what its mature advisory label might suggest. This I have seen in all the ages who come to see me at conventions, starting with a 12-year-old, the youngest I have met, with his dad. There is a great difference between "gratuitous sex and violence" and the use of adult themes contained within a considered intelligent storyline. *2000AD* has continued to publish mature science fiction and has kept a solid hardcore audience with its striving to constantly entertain with quality SF, with the best British writers and artists, and it is still gathering new readers to this day.

Allowing for the odd exception such as *Dan Dare*, most British comics up to the 1970s – if they had any SF stories at all – tended to be simplistic; monsters ripping heads off innocent victims. Nothing wrong with that, except that it does get boring very quickly. In those days the producers of juvenile comic books treated an audience of comics readers as changing every five years as they grew up and out of short pants and went on to other pursuits. They did not feel they had to change and develop their comics to suit an older audience, and so in the end they lost that audience to other media.

The first *Thing from Another World* cover was a mix of gouache and magi-colour, a technique that I really enjoy, airbrush glazes made the glistening red blood on his exploding neck bloody and vibrant.

The cover for *The Thing from Another World* #1.

A cover for the
follow-up series.
*The Thing from
Another World #5.*

In the USA, mainstream comics became a blander product due to the Comics Code Authority introduced in the mid-1950s. This saw the final nail driven into the coffin of one of the great horror and SF publishers of all time, EC Comics. If you get the opportunity to read reprints of this great comic line you will see how the best comic literature can still amaze, delight and shock. As explored in an earlier chapter, the underground comics movement in the 1960s did cheerfully undermine the code: they avoided the mainstream distribution networks and regulated retailers, and so did not offer a financial lever that a censor could use on them to enforce any form of censorship.

I see *2000AD* as having a direct link to the great EC Comics tradition, which you can simplify down to the inversion of the aforementioned "beautiful = good, ugly = bad" approach. EC Comics became known for delivering an unexpected twist on any assumption the reader might make based on the initial premise for the story. This form of story is perfectly suited for horror and SF genres, where shock and surprise is the perfect partner for tales of the extraordinary.

After most independent comic publishers in the UK had been bought out by big international publishers, comics became relegated to one small juvenile section, and the money-making publications with these big companies were the glossy women's magazines – some selling close to 500,000 copies every week. Comics tended to be a very poor relation and were produced as cheaply as possible. There *was* money to be made in kids comics but on quite tight margins; a 10-cent comic against $4.95 for a magazine.

Dark Horse was the first publisher to create an entertaining alternative narrative in their comics to the universe of the film titles and to be creative beyond what had been set up within the movies.

These big publishing companies had publishing down to a fine quantifiable art, particularly in the UK, or so they thought. They produced so many titles on so many subjects that they could do focus groups, pay for professional research, create pie charts and graphs that told you what would sell. These experts knew that if a cover was predominantly red, it would sell more copies than one with less red. A purple and green combination could only be used on horror titles, pink for women's magazines. Free gifts on a cover would give the first issue additional sales, and when sales were down they were used again to boost sales.

Once sales figures went below a certain number, IPC would close the title or merge it with a better-selling one. This would increase that lucky title's sales by a certain amount and it would usually retain a percentage of the new readership. The cut-off point was at 70,000 copies of a juvenile weekly, a figure we can only dream of achieving today – once it fell below that it was "good night Vienna".

The company accountants might only be working on margins and percentages. The big companies had overheads, distribution networks, advertising costs and many more expenses that contributed to the cut-off point – I do understand that. But when the editors, writers and artists cared deeply about the subject matter, the quality showed – they were creating for themselves. They were the SF readers of that type of book, and it did make a difference in sales figures: at the height of *2000AD*'s success it was selling close to 250,000 copies a week, which settled down to over 100,000 copies in the 1980s – when every other comic weekly was losing readers. There are reasons why a title will be an initial success – timing such as *2000AD*'s inception, or free gifts – but readers are *retained* only through the quality of the book.

This *Thing from Another World* cover, was a great exercise in freehand airbrush control.

A cover for the ongoing series. *The Thing from Another World* #7.

120

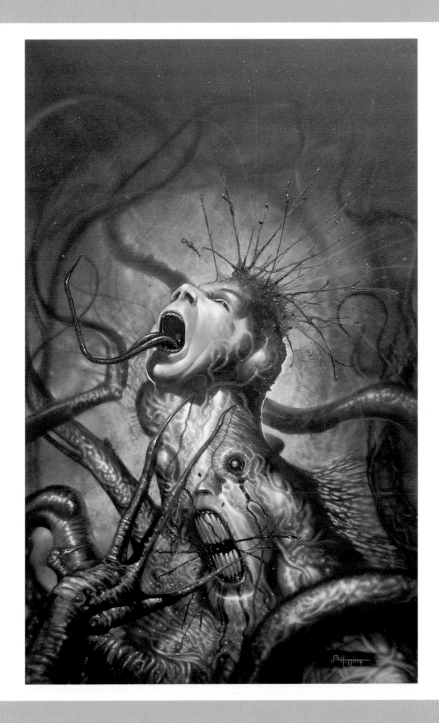

A cover for the ongoing series. *The Thing from Another World* #8.

The artist-for-hire part of me feels like I should bite my tongue on this topic, but the writing *is* the most important part of a comic book. No matter how incredible the art is, it has to have a solid foundation of ideas and writing to build on. Look at what had happened in SF literature since its first recognised "modern" inception, which I consider to be the nineteenth-century authors Jules Verne and H.G. Wells, when science became an integral part of the story and could in some cases dictate a storyline and plot that could only conceivably happen in science fiction. To see this happening in comics in the 1980s was inspirational and to be part of it as an artist with *Judge Dredd* and *Watchmen* was mind-blowing.

Dave Gibbons had moved publishers subsequent to *Watchmen* – hey ho, the life of a freelancer – and was working with Frank Miller on *Martha Washington* for Dark Horse Comics. *Watchmen* gave all the contributors a platform to go on to bigger and better things – let's just reread that sentence: I am not sure there *is* anything bigger and better than *Watchmen* – but we all went on to other things. For Dave it was this Dark Horse comics project. He then introduced me to Mike Richardson, the publisher, and Randy Stradley, the senior editor, who were looking for an artist on a new mini-series to be a companion series to go along with their "reinventions" of the *Alien* and *Terminator* comic franchises by adding *The Thing* to this innovative line-up. I had proven I could handle a fully painted series on *World Without End*, so I had portfolio work that gave them confidence in my ability to produce the goods.

The Thing had begged for a sequel since the final shot of MacReady and Childs in the 1982 movie, and that's what we ended up doing in the two-issue mini-series in 1992.

Dark Horse was the first publisher to create an entertaining alternative narrative in their comics to the universe of the film titles and to be creative beyond what had been set up within the movies. *The Thing* had begged for a sequel since the final shot of MacReady and Childs in the 1982 movie, and that's what we ended up doing in the two-issue mini-series in 1992. Chuck Pfarrer, the writer I'd been partnered with, had written many movies before and after his foray into the comics medium. Knowing what money could be earned in writing for Hollywood, I had to ask what he was doing in such a low-paid industry. He said, "Artistic freedom." In Hollywood he had to please the producers, the directors, the actors, the accountants and on and on and on. You can't put a price on artistic freedom!

Ah, committees! I have a total aversion to committees. I have heard it said that "A committee is where a good idea is taken and strangled at birth!" and having dealt with committees outside of comics on a number of highly paid jobs in the past, I totally agree. The money you earn is usually directly proportional to the amount of shit you have to swallow to complete your part of the job.

So I knew where Chuck was coming from. His real-life background was as exciting as his scripts: he was an ex-US Navy SEAL, one of the elite of the US armed forces. I remember speaking to the editor Randy Stradley, asking for a plot point to be clarified, and he told me that Chuck was unavailable at the moment, but he wasn't sure why. It turned out that Chuck had decided to take a short trip in his boat to look at a volcano erupting in the Philippines! I think it was six weeks later I got the clarification.

A fully painted colour cover is the best gig on a comic, a cherry-on-top job if you also did the interior art.

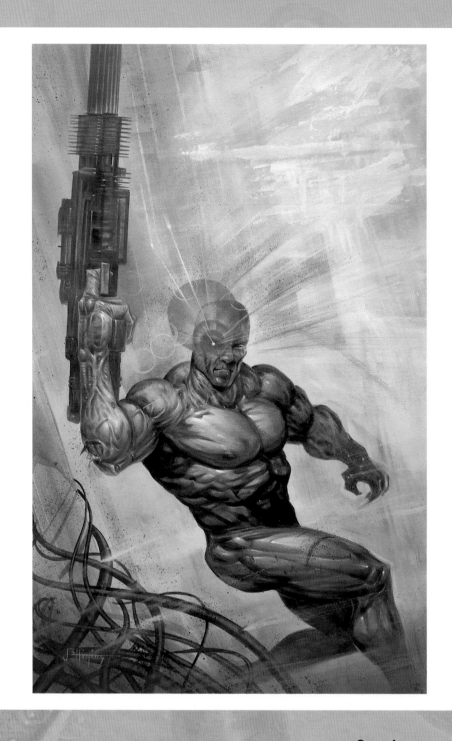

Cover for
Terminator
the comic.
(Dark Horse)
1990.

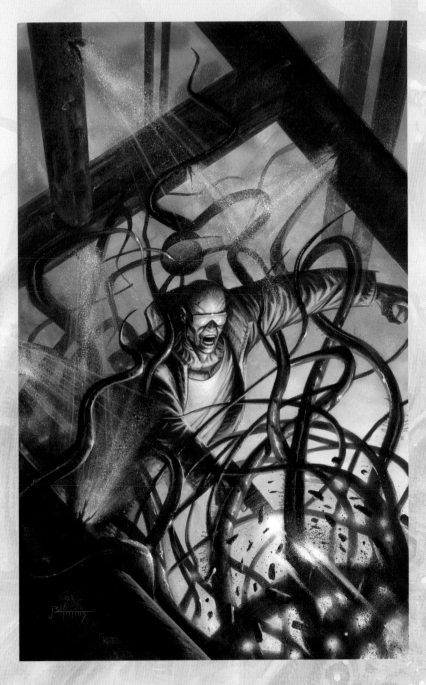

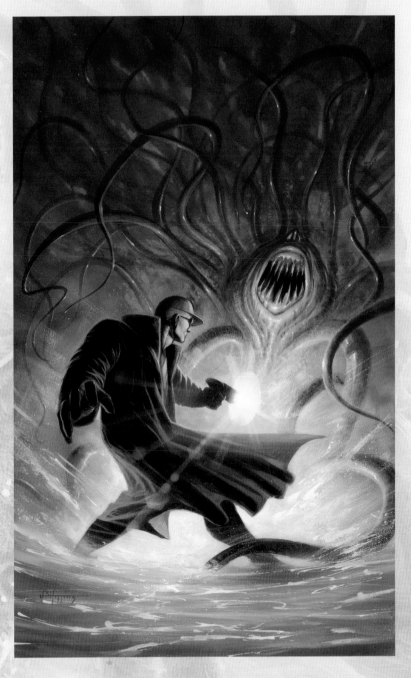

Cover paintings for *Mutatis*, a mini-series for
Epic comic magazine. Writers Dan Abnett and
Andy Lanning. (Marvel) 1989.

I seemed to be typecast as the artist to
go to with my tentacled monsters.

I had no problem with that.

123

Covers for the monthly *Swamp Thing* (DC). I was the regular monthly cover artist for over a year on this series in the 1990s.

I was finding at this stage in my career that I was getting, at last, all these opportunities to do my dream job, painting in full-colour science fiction comics. To be a full-colour illustrator is to be at the apex of the illustration field in publishing. So why the fuck was I broke all the time? Short answer: I was spending too long on each page. No matter how fast a full-colour artist is, he or she can never be fast enough. Go too fast and it's a case of diminishing returns. There is always a cut-off point for quality and the cut-off point for me as a painter was way beyond my profit-earning point. You are *never* paid enough, or given enough time to do the job you want to. That's just a fact of life for comic artists.

A guide for page-rates … Let's pick a year – say 1996, the year of *Pride & Joy* (writer Garth Ennis) for DC Comics, a six-issue mini-series. This was a relatively new form of comic series, designed to be collected as a graphic novel or, if it was successful enough, to continue in other six-issue story arcs. It was black-line interior art with digital colour.

The fee for a fully painted colour cover was $1900. This is always the best gig on a comic, a cherry-on-top job if you also did the interior art. A page of interior art breaks down like this: digital colour $102, pencils $160 and inks $102. At this time it was the same rate as I received for a page of fully painted interior art: $364. To paint a comic page takes at least 25–50 per cent longer than to pencil, ink and digitally colour a page. See the maths there? So I decided to do fewer painted comic strips. What I love about comics is telling the story, so leaving fully painted comic work behind was not too much of a wrench. Plus computers had finally come of age and with the Power Mac 7100 on the market at a near affordable price that was the way to go.

This was all a few years in the future, so not too helpful for *The Thing from Another World* for Dark Horse Comics. *The Thing from Another World* was the last fully painted series I did. Painting SF was my dream come true and I could not completely stop that aspect of my career any more than I could stop having nightmares after eating cheese late at night. I was more than happy when asked to do the regular covers for the *Swamp Thing* monthly comic by editor Stuart Moore, and trading cards were pretty popular at that time and paid between $800 and $1200 per card. So even though the storytelling aspect of my career was taking over I would never stop painting: when a technique is so hard won you cannot let it lie fallow.

I used a variety of approaches for the covers, trying to keep each month distinctive in colour or compositional content. The regular writer for most of my run was Nancy A Collins a horror fiction writer. She brought a neat Southern Gothic sensibilities to her run on *Swamp Thing*.

This was my first *Swamp Thing* commission for a special.

I wanted to try something different; the viewer is looking up at Swamp Thing from beneath the surface of the Louisiana swamp.

From the collection of Eddie Deighton.

A hellfire and damnation mad southern preacher for a *Swamp Thing* cover. Snakes and reanimated corpses!

The starting point for any artist's education (next to this book) is looking at great art. The learning process is trying to discover how an artist created that effect. Richard Corben introduced me to the airbrush, which I subsequently saw in other artists' work: the great Frank Hampson used it (sparingly) on *Dan Dare*.

Oil paint, used by the old masters and Frank Frazetta, is a beautiful medium. Its only disadvantage is an incredibly long drying time, even with drying agents. I met Garry Leach (artist on *The V.C.s*, *Marvelman* etc.) right at the start of our careers. We were both learning as we went along, and one of the lessons I learned from Garry concerned a book cover he had painted in oils; a lovely picture of a woman looking pensive and moody for a Romantic novel. Under tight deadline pressure, he set off to deliver it the day after he had finished, still not quite dry, try as he might to speed it up with a hairdryer. Holding it carefully so as not to put fingerprints on it or scuff it, he climbing on the early train into London, placed the precious painting on the seat opposite as he turned away for a second to put his coat in the overhead rack, and turned back just as a schoolboy sat on it! A scratched, fluff-covered artwork delivered to the publishers with the imprint of a schoolboy's backside on it – and still slightly tacky to the touch. I learned from this never to use oil paints if you need to deliver it tight to deadline, and as *all* deadlines end up tight …

Gouache paint I enjoyed a lot. It's very good for drying and the colours are vibrant. The downside: when doing colour-glaze washes you could reactivate the lower paint surface and it would create a colour bleed up through the glaze rather than a smooth glazed depth. And if you spilled water on it? That was the end, as *all* the paint reactivated and bled together.

Acrylic became the paint of choice for speed of drying, and glazing was no problem as each wash layer dried within seconds so there was no reactivation of a lower colour layer. And if you did spill water drops on a finished painting you just wiped it off – once acrylic dried it was waterproof … and schoolboy-bottom proof.

With digital colour you have none of these drawbacks, but you don't have any lucky accidents either (see Chapter 12).

Trading cards became a big source of work for me in the mid-1990s, and I used Photoshop to accentuate parts of some of the illustrations.

Restraint is the watch-word in computer effects: I learned this early on when mixing traditional and digital illustration.

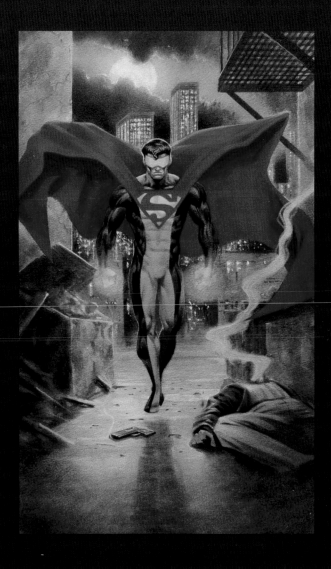

The Son of Krypton – mid-1990s costume designs.

In the Monarch painting, the background was airbrush with a repeat pattern masking, painted traditionally.

Mongul and Brimstone. Artwork size for all trading cards is approximately 8.25 x 10.75 inches. These were painted small as they were reduced quite a bit when printed.

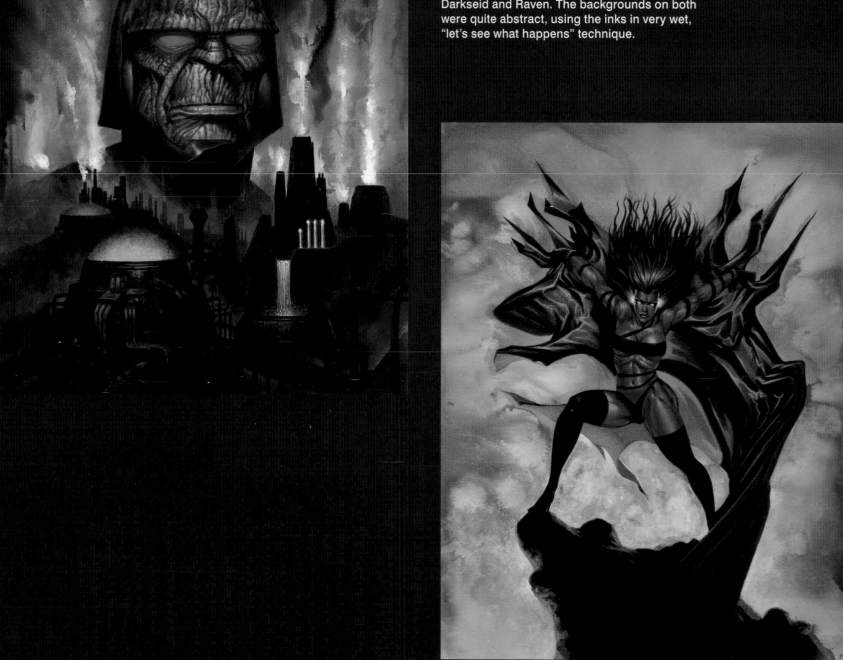

Darkseid and Raven. The backgrounds on both were quite abstract, using the inks in very wet, "let's see what happens" technique.

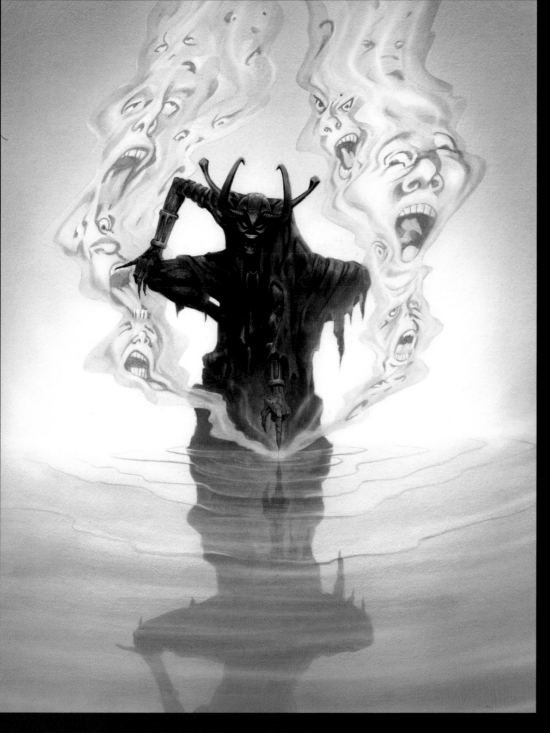

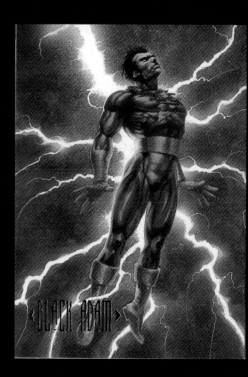

Blaze artwork, Black Adam and Emp printed cards.

TURMOIL, TOIL AND TROUBLE
CHANGING DIRECTION

When you become a freelance artist, a home studio – also known as the bedroom – is usually the first place you start in. Then as you get more commissions and it appears to be a proper job you need a dedicated work space: there is nothing worse than having to clear up all the work every night and put it all out again in the morning. From there the next step is usually the spare room. You need to create a professional space and also to create a psychological distance between your living space and your work space, and – when possible – to be able to close the door at the end of a working day and forget about it. You do have to be a workaholic to be a self-employed artist but you also need to organise your hours at the drawing board or you will suffer a burn-out.

We all have individual ways of working. Some freelancers prefer working late and through the night, no distractions, no ringing phones. Not for me; my usual working day is start at 7 a.m. and finish at 7 p.m. with breaks spread throughout the day. When I had a young family I tried *not* to work seven days a week, not always successfully. The number of times my wife and daughter, Selina and Jenna, went off on holiday without me are legion. One asset you need as a freelancer is a supportive partner: they have to put up with mad hours and missed holidays, a pretty stressful way of life for any household that has regular bills to pay. If deadlines start to bite your ass then longer days and seven-day weeks become the norm, but you need to get back to your usual work schedule as soon as possible once you meet that deadline.

When my daughter had grown and the business side was going well, I decided to move into my first away-from-home studio. This was in Courtney House, Luton, England. Working in a professional studio has a number of positives that far outweigh the commuting and expense. The first is just that: working away from home. It is also a more professional appearance for any visiting clients, and neighbours can't just pop around for a cup of tea. If you can afford it, then I would recommend it. Cheap rent options can be found, either studio-sharing or artist cooperatives – most cities have these. My first studio in 1992 was shared with Lee Gibbons, a successful SF cover artist and a great collaborator at various times over the years.

The first digital illustration I did, 1994. A technique I used later to great effect on the *Pride & Joy* series. I painted Judge Dredd in black and grey tones, scanned it into the computer and added colour and background effects digitally. The colour was over-saturated and printed badly, a lesson I learned early.

The TCS logo was created digitally, one of the more successful early digital images. 1994.

The main eye-opener was seeing how professional the group of artists and designers in Courtney House were. They worked in a more commercial field, advertising and design, which had a different approach to illustration and artwork. It could all be costed and financially quantified. That was something I had never thought about before, I was just happy to get the work. These guys quoted fees and hourly rates, and negotiated. They actually talked about money, a subject I was always slightly embarrassed about for some reason. Advertising was a business and paid the designers and artists working in that field handsomely, more than in any comparable job in publishing.

Books, magazines and comics … these all work on a flat page-rate which you are offered on a take-it-or-leave-it basis. When I first noticed this disparity in fees, it took me a while to understand how I was making a comparable living. It came down to the amount of comic art pages I did compared to the number of pages the designers did. I might get a job such as *The Thing from Another World*, 52 pages of colour art that took me nine months. The designers would be working on jobs that might last six weeks or less and then have a break of a couple of weeks before the next job came in. During the downtime they went around touting for work.

Most large design companies have full-time account handlers to keep the flow of work coming in. Small companies and individuals can't afford an exclusive account handler so take on this role themselves, which means days when no income was made as they visited potential clients – not always bringing a job back either. There was a Courtney House league table at this time of who was the highest earner in fees and hourly rates. I thought it was commercial, crass and beneath me … until I got to the top of it!

My last home studio before I moved into Courtney House, 1991. The page on the drawing boards looks like I was working on page 6, issue #1 of *The Thing from Another World*.

Kingmaker – mid-1990s musical group. Vinyl record covers, LP, EP and single cover art.

Every now and then a double "cherry on top" job came along. You can't plan for it – it just works out that way. I have always lived by the principle "be nice to people on the way up, as they will be the same people you will meet on your way down". I gave a talk at an art college in London in 1989 and one of the students kept in touch. He was a very talented designer and within a couple of years of his graduation he was working as a senior designer at Chrysalis Records. He asked me to illustrate a set of designs he had created for a group called Kingmaker. It wasn't a big job (only a couple of hours' work) but my hourly rate on it somehow worked out to $1800 an hour.

The Chrysalis designer was Eddie Deighton who went on in 2000 to co-create Com.x, a successful comic publisher based in London. A man of many talents, he also helped with the right word for my first studio name that I was struggling to find. During one of our conversations he said he was in constant turmoil, which sounded perfect for me as a word to slap before "Colour Studios".

The high-earners' league lasted just a little while longer until Steve Dillon (*Preacher*, *Punisher* etc.) blew the top off it with one advertising job for which he earned $25,000 for three hours of work! Steve had moved in when he came back to his home town of Luton after spending time living in Dublin, Ireland. Even though Steve has now been at Courtney House for twenty years he is still known as "New Bloke"! It was brilliant to get more comic artists in and Courtney House became a bit of a stop-over for comics freelancers over the years, with artists and writers on collaborative projects. Andy Lanning (comics writer, inker) and I worked on *Mutatis* for Marvel together, as well as *Dinosaurs: A Celebration*, a three-issue mini-series. With Simon Furman I worked on *Transformers*.

One of my favourite stories about Steve Dillon, who is not only a consummate comics professional but one of the fastest comic artists around: Jimmy Palmiotti (inker and writer of many comics titles) came over to work in Steve's studio for a week, inking over Steve's pencils for the *Punisher* series they were doing for Marvel. Steve was laying out and pencilling pages of art faster than Jimmy could ink them. *That* is fast!

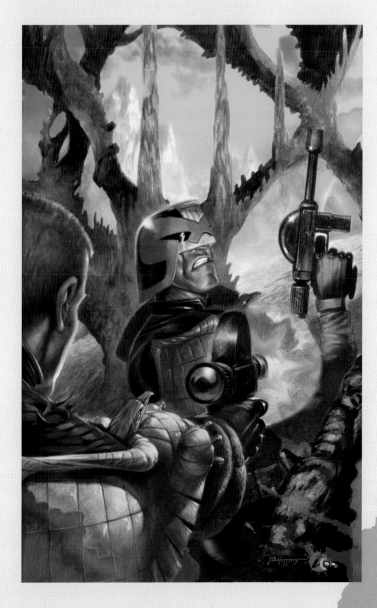

A 3D render TCS logo, took about six hours to render a 2MB file. Bryce 3D software. 1996.

Digital cover for DC comics short-lived *Judge Dredd* monthly.

Turmoil Colour Studios (TCS) came into being in 1994 when I started to get more work than I could handle, and finally a near-affordable personal computer in the form of the Power Mac 7100 came on to the market. Lee Gibbons and I bought one together, with all the peripherals – monitor, scanner and printer. The price equalled that of two – yes *two* – brand-new small family cars, and it still did not have enough memory to have more than one hi-res file open at the same time. We needed to upgrade on all aspects included additional RAM, pumping it up to a now-miniscule 120 megabytes. RAM chips at this time were selling for astronomical prices – a pound weight of RAM chips would sell for more than a pound weight of gold. Criminals were raiding business offices for computers to smash open for their RAM. A company in our street in Luton had just been burgled for their computers. We did get paranoid on security, chaining the computer to the desk at one stage. We were in a rough area of Luton, prostitutes walked the street and at least one drug-related shooting took place on the pavement outside Courtney House.

A little while after I had moved in I was watching an undercover TV news report on violence and drugs in the High Town area of Luton. The policeman driving the car said to the reporter, "And this is the worst area in High Town!" just as the car drove past Courtney House. I am sure it was a slight exaggeration … but then again Courtney House had originally been a brothel. But inside now it was a clean dream factory. There were some odd smells every now and then, but they tended to be the morning after Mick Ashpool (landlord and designer) had been on a beer-and-curry night out.

The Power Mac 7100 was clunky, slow and unwieldy but it showed me the possibilities of digital art. As far as I know I was only the third person in the whole of the UK at that time to use computers to create digital images for comic books, along with Dave Gibbons and Angus McKie (SF artist, comic artist and colour artist). Both were incredibly helpful in offering computing advice, along with Eddie Deighton who came in and gave Lee and me a tour around the Power Mac, showing what buttons to push.

Art by Courtney House studio buddies.

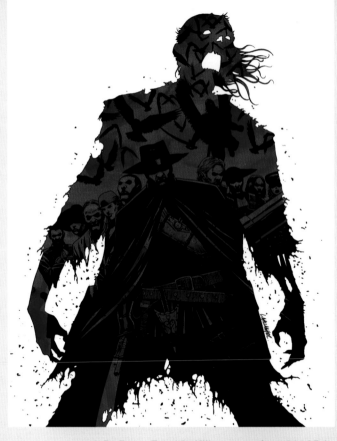

A *DeFoe – Zombie Killer*, cover for *2000AD* by Leigh Gallagher. (Rebellion) 2015.

Artist: Lee Gibbons.

An early digital portfolio piece. 1998. And a modern digital cover: *Twilight of the Dragons*, **writer Andy Remic. (Angry Robot Books) 2015**

I discovered that my attention span was pretty limited: I never read one of the manuals and to this day my eyes glaze over if I see anything bigger than an instruction leaflet. Press a button and see what happened was my rule. Lee approached it in a completely different and scientific way and also got involved in 3D software that came along a few years later, to great effect. I had no patience for that. Bugger me, but waiting for the simplest 3D image to render was a killer! I felt myself age as it ticked line-by-slow-line down the screen … and then it would usually crash and you had to start again.

Sending a small jpeg image through a modem was a brain-numbingly slow process. Angus had seen the potential for the computer early on in so many ways: he was one of the first people to digitally produce a hand-lettered typeface. He also saw how computers would make desktop publishing possible for individuals, something I would get stuck into a couple of years later with Jack Publishing (more on that later). At this time Angus was colouring for Tekno Comics which was situated in Florida, USA. Angus being based in the north of England, he suggested the innovative idea of sending the digital files of the comic book he was colouring over the internet. This would avoid the very expensive international express post that would take up to a couple of days. The editor agreed, Angus started the process around 18:00 UK time … and over twenty-four hours later the last file finally digitally dribbled into the Tekno receiving computer. The phone bill ended up being a lot more than the express post would have cost. But a worthy experiment in my opinion.

This was the time when home computers were an exception. We learned as we went along. It was a completely new education, trying to get your mind around such simple facts as "You do not lose the digital images when you switch it off!" The technical helplines were good, but knowing *what* to ask as a novice owner was a fog of nomenclature. We did laugh at other owners who called in and were reported to have said something particularly stupid.

Stupid: "Why won't my computer work?"
Tech: "Is it switched on and plugged in?"
Stupid: "I can't see."
Tech: "Why not?"
Stupid: "It's dark."
Tech: "Why?"
Stupid: "There's a power cut!"

The tech people's first question was always, "Is it switched on?" I am not admitting that it was one of our first big technical leaps knowing how to switch it on, but … there was a lot of technical stuff to remember in those days.

I saw many creative possibilities for me in digital imagery. I felt it would change the way comics were produced and published. I also felt I had found a tool that would allow me to produce high-quality colour art and to speed up the whole process without lowering my standards. Plus it was a digital adventure. Having produced traditional comic pages for close to ten years now, I felt I needed a shake-up and Apple gave it to me.

Excalibur: The Legend of King Arthur cover. (Walker Books) 2011.

Artist: Sam Hart.

Where The Poppies Now Grow:
© Hilary Robinson & Martin Impey
(Strauss House Productions) 2014

Artist Martin Impey.

I decided I needed a overarching name to indicate that this was work produced with the aid of the computer. I used the TCS imprint in the credits on any comic book or cover I worked on that used the computer extensively. Being one of the first illustration studios using computers and offering digital files was a great marketing tool, and we became a much sought-after provider of artwork, but within a few years the processing power of computers had doubled and the price had halved, which brought in many new studios offering comparable digital services.

I have no problem with competition. In comics the editor and the readers will like one artist for their style over another artist, and that will be the main consideration when you are commissioned for a project. We are a broad church welcoming many styles of illustration and storytelling, which I believe makes comics one of the most vibrant and continually evolving art forms around. The downside of competition is that when it is based solely on a technical service, other factors drive down the price. Within a short while large computer colouring studios – along with individuals who had few or no overheads (working from their bedroom) – appeared on the scene, and they offered incredibly low prices, which of course the publisher would go for.

Initially it appeared that anyone coming in off the street who knew computers could colour a comic page: everything digital looked classy and slick. The publishers appeared to have learned nothing from the colouring on *Watchmen* or *The Killing Joke*. It was weird that they became blinded by the digital medium, and had slipped very easily back to the thought "just colour between the lines". I remember receiving a directive from Marvel Comics in the late 1990s that said, "Make all black line artwork an open style, with no line rendering or black shadow, let the computer do all the modelling."

A digital image featuring The Spectre.
(Portfolio piece)

Video game cover, digital illustration. (SCI) 1998. Another good first lesson on the disadvantages of doing purely digital artwork: the managing director of the company rang me soon after I completed the image to buy the original painting to hang in his office.

No painting to sell.

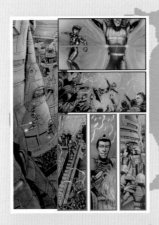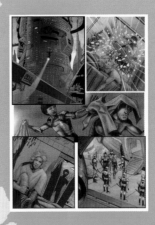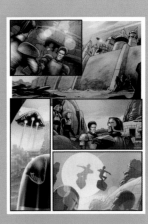

An complete episode from *Chopper – Super Surf 13*, writer Alan McKenzie. TCS was in full swing at this stage, producing digital colour for *2000AD*. It was a steep learning curve: all computer studios supplying digital art at this time were trying to get all the specifications right for the best reproduction.

It was a constant battle fighting with the equipment, processing large files agonisingly slowly; then the computer would crash at the final stage, losing a day's work! Frustrating, but it happened regularly.

However, before all of this came to pass, TCS was producing a great deal more work than I could ever have done as an individual. We worked on colouring *The Mulkon Empire* drawn by John Watkiss (*Kiss of Death*, *Sandman* etc.) for Tekno Comics and *Chopper: Supersurf 13* written by Alan McKenzie for *2000AD*; those – along with editorial illustrations and advertising jobs – were going through my computer. At one stage I had around 14 freelance artists supplying work, inks and grey-wash paintings over my pencils, which I then turned into colour art on the computer.

Let's talk about money a bit. For *The Mulkon Empire* in 1995 the studio was receiving $7167 per issue. That's $255 for a page of digital colour – pretty healthy by any standards, even today – but just a couple of years later on, for *Pride & Joy* it was $2880 an issue, or $102 a page. The market had settled down in a way that fundamentally changed how comics were produced on all levels, from supplying large-size digital files over the internet in seconds to how they were lettered and then sent on to the printers. When the finished colour art leaves the artist now, it usually only exists digitally.

Money did become a factor, but more than that I found it a very frustrating way of producing comics. I was doing less actual artwork and becoming more a managing facilitator and digital colourist with less artistic involvement in what the TCS imprint was producing. I decided to change direction and take on less work, and more personal and creator-owned projects. This started with *Pride & Joy* written by Garth Ennis in 1995. Garth and I had previously worked on a number of jobs for *2000AD*. He was one of my favourite writer collaborators even then. He had a singular, stylish approach to

storytelling with impeccable characterisations and some of the most authentic written dialogue that I had ever read in comics. One of Garth's many talents was to slip smoothly and believably between horror, pathos and comedy, sometimes in the same scene.

I now had a Power Macintosh 9600 to go along with the 7100. This had a great deal more processing speed and all the RAM I could fit into it, which made it feasible to produce high-quality colour digital files without the limitations that the slow processing speed of the 7100 had imposed. The TCS colour artists now worked in Courtney House full time, and on *Pride & Joy* they were Danielle Hunt and Sam Hart. I added the final finish and any modelling needed on an effective and creative production line. Danielle and Sam were skilled on the computer and also talented artists. The studio was still taking on other lower-profile projects for which I used a small talent pool of freelance artists who included Martin Griffith and Lee Townsend.

Pride & Joy became a watershed for me. I felt I had discovered all I had wanted to with digital art and decided to wind up TCS as a full-time employer and go back to what I loved: drawing and telling stories. Sam went off to São Paulo, Brazil, and Danielle went back to college in Milton Keynes, England.

Networking: I cannot emphasise how important this is. A larger studio set-up such as Courtney House creates a dynamic and growing network of different client types who come in regularly, and comic art can feature in all types of advertising and product campaigns. Jon Goode, a neighbour in the studios, was a stunning airbrush artist, doing stylish and hyper-realistic covers for *Scalextric*, *Action Man* and … *My Little Pony*. I worked with Jon on a number of occasions.

The cover for *Pride & Joy* #1. (DC) 1996

I finally got the specifications right for the best printing reproduction, and the combination of traditional grey tone-painted art scanned and then digitally coloured.

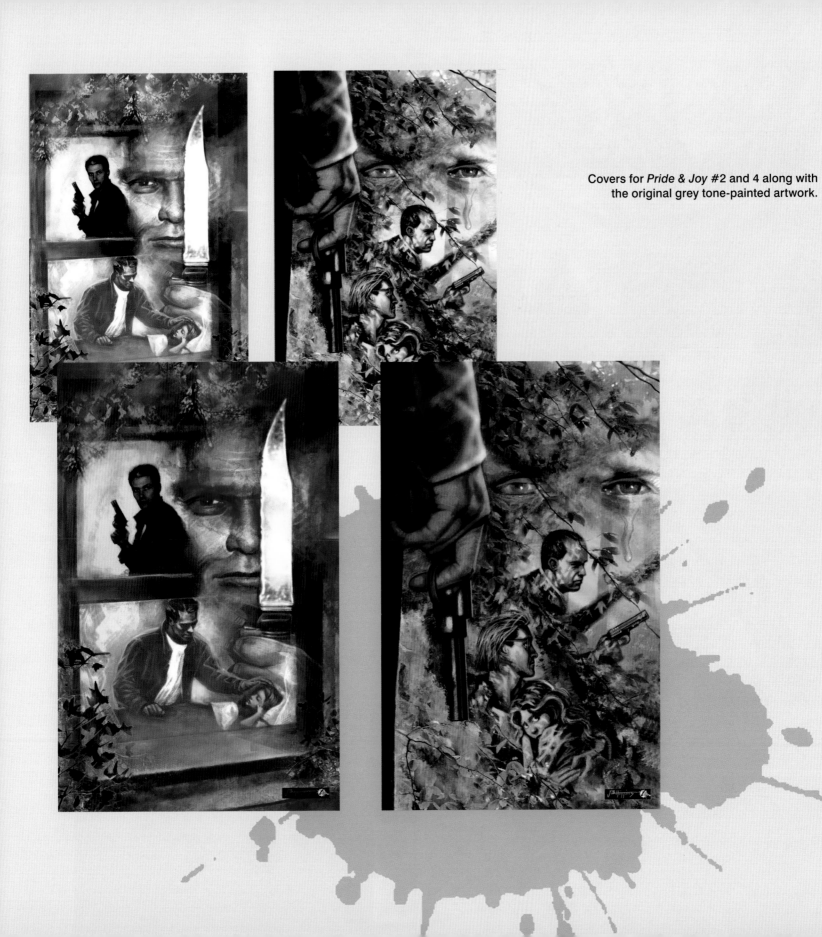

Covers for *Pride & Joy* #2 and 4 along with the original grey tone-painted artwork.

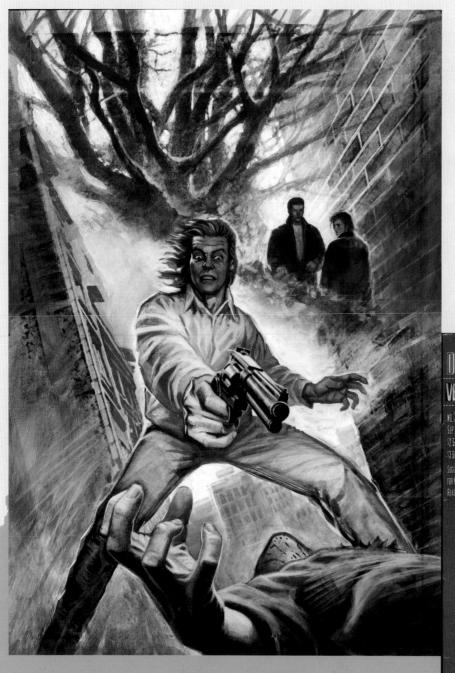

The cover for *Pride & Joy* #3 with the
original grey tone-painted artwork.

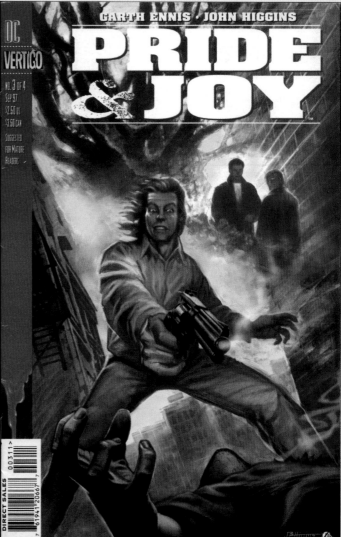

I loved the way Garth started the book on page 1 with an image from the final scene. You know someone gets it bad but you never find out who until the final scene. A sense of foreboding to the story starts from page one, building tension throughout the book as you get to know the characters and come to like them.

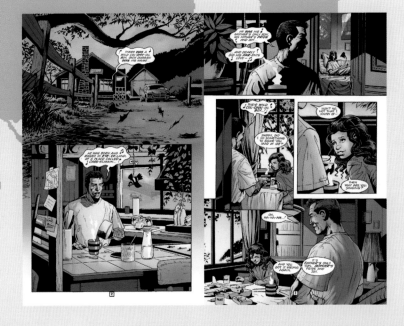

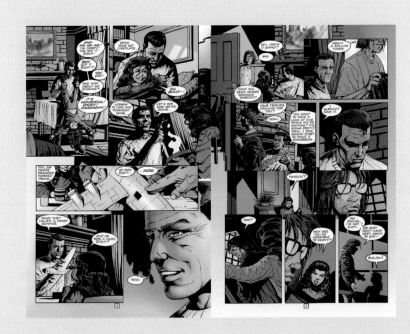

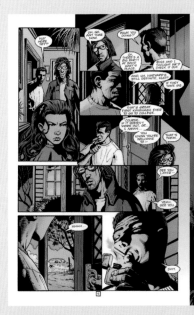

BATTLETANX

This was a great project. A mini-comic commissioned by Third Planet International. A free comic magazine to insert with the computer game of the same name. Written, pencilled, inked and coloured by yours truly.

Published in 2000, it came just after my financial fallout from self-publishing *Razorjack*. I needed something like this to get back into the swing of working for clients again, and I needed to fill the financial black hole it had left me in.

The most positive aspect of having computer power at your fingertips with all the desktop publishing aspects was that now, for the first time, an individual artist could produce all the work needed to get art to a print-ready stage. All the design, colour, lettering and formatting could now be done by one person. After *Razorjack* I was completely confident in what I could do as an art and design studio.

BABES
ZOMBIES
WARLORDS

DEATH IN THE 21st CENTURY

Pages from *BattleTanx*; the concept came from TPI. I worked closely with the design group, who gave me complete artistic freedom with TPI's distant overview. They ensured it was closely related to the design and story direction of the game itself.

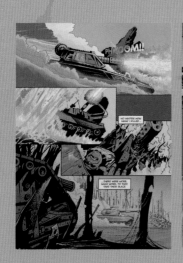
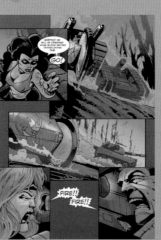
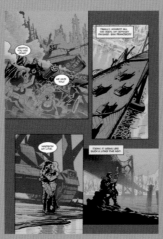

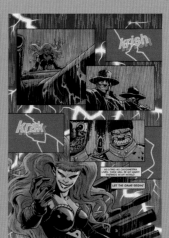

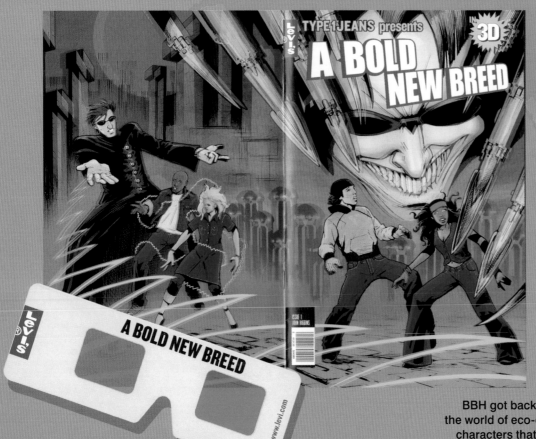

A commission from BBH, an award-winning international advertising and design group, to promote a new line of Levi's fashion products. A 22-page 3D comic magazine. Pencilled, inked and coloured with invaluable help from Leigh Gallagher.

From initial commission to print-ready art, we turned this 22-page book around in record time, working very closely with the company at all stages from initial designs to revisions, and also incorporating the client's fashion directions – and we still hit the print deadline. Published 2003.

BBH got back in touch in 2005. They were considering entering the world of eco-education publishing. The idea was to have super characters that could be packaged and promoted in comic form, leading on to other aspects of merchandising.

I designed the characters on the right based on their briefs. I rather liked them, but they were not developed any further.

The network of fellow freelancers was a great asset ready to be tapped at short notice when too much work came in. Even though TCS was not actively sourcing multiple revenue streams, sometimes jobs came in that I just could not turn away. Gary Gravat, a Courtney House designer, helped on the first issue of *Razorjack,* providing proofreading and design suggestions.

One of the lessons I learned early on in my career was to invest time in future projects. No matter how busy I was at the time, I always looked for the next job, and the job after that. You cannot be passive, waiting for work to come in – you have to be proactive in looking at as many projects as you can.

Collaboration is another key word. Writers and artists should work together on many different projects with different people. Writers do have an advantage as they can work with many artists at once. I found that working with more than two writers became a logistic nightmare. My preferred situation was to be working on a regular book and to be in talks with a writer or editor about future job possibilities, and also to have a project in the desk drawer ready to present. This was a juggling act which sometimes came to a head when you got all three jobs overlapping: *that* is when you need your network of fellow freelancers.

Leigh Gallagher (comic artist, *2000AD*, *DeFoe* etc.) worked with me a number of times at Courtney House. Always a versatile and enthusiastic artist ready to take on any challenge set him, he has continued to grow in ability and into a singular talent. One particular job came at the worst time and the best time: *Levi's: A Bold New Breed* 3D comic. I was in the process of moving to the USA permanently, having found a partner in comics and life at that time: Mindy Newell, a talented comics editor and writer (*Catwoman*, *Her Sister's Keeper* etc.). I was trying to balance travel, personal life and work all at the same time. This job would not have worked out so well if Leigh had not been available at short notice to come down to Luton. He was right at the starting line of his career – well actually he was still in the dressing room – so he had the freedom to decamp down to Luton from Liverpool for weeks at a time. He took over my house and studio for two months while I was working in Bayonne, NJ.

The old "cherry on the cake" metaphor makes an appearance again. Thirty thousand dollars for three months' work. We turned around a 22-page colour comic ready for print in six weeks: preparatory meetings with writers and BBH advertising and design took up the rest of the time. You do have a lot of people to please on this type of high-profile job. I might have have complained earlier – just a little – about committees, but if you get an effective facilitator who is the filter between you and the committees, as I had in project manager Stephanie Jardine of BBH, then that type of job cannot get any sweeter. You get the money you can only dream about in comic publishing, but without the usual committee pain.

I know a number of comic artists who, after experiencing advertising commissions and their committee decision-making processes, refuse to do any more no matter what the fee. The artistic freedom you get in comics has no price on it.

Who doesn't like dinosaurs? This was a lovely job to do, a six-page comic strip for an anthology comic magazine. *Dinosaurs, A Celebration* – a four-issue series for Epic comic magazine.

Pushed by dinosaur enthusiast Steve White, editor at Marvel UK at the time, now artist, writer and editor. Epic was an imprint of Marvel comics that gave creator-owned rights to the artists and writers. Writer, John Freeman. (Marvel) 1992.

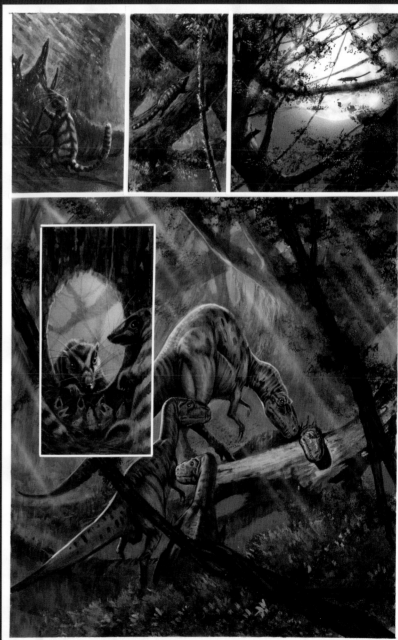

SELF-PUBLISHING
HOW TO LOSE YOUR HOUSE IN ONE EASY LESSON

I'm all right, Jack – on my Jack – Jack of all trades – and then *Razorjack*. Jack features in a lot of phrases and expressions. Jack is one of my favourite names. It was the name of my father, and is a variant of John; *his* father's name.

Jack Publishing was one of those light-bulb moments when an idea seems to manifest at just the right time. I was at the point in my career when a number of strands of experience converged. I had experience of writing, all aspects of producing comic art, and any other type of illustration that I'd been called upon to do, and – probably more important than all of that – by 1998 I had learned how to produce art digitally, which gave me an understanding of what computers could do for the individual creator. This opened up wide horizons.

"Jack of all trades and master of none!" I have heard this used as a self-deprecating comment or a criticism, depending on who uses it. It is a saying that I thought suited my first self-publishing venture, which went along with the phrase "all on my Jack", meaning that I intended to do all of the many tasks needed to bring my vision to fruition. A number of them I had not done before. I felt confident in writing and producing the art, but all other aspects of publishing, such as pagination, layout, making print-ready art, advertising and promotion, arranging distribution … all of these were completely new to me.

I had spent the first fifteen years of my career desperate to get inside comic publishing and to make a living doing it. You know how it goes: you see in the distance the mountain you want to climb, you know it's high but you have the energy and the ambition to get to the top – every journey starts with the first step – so you put one foot in front of the other and start to climb. You climb and climb, wiping away sweat as further up the mountain you go. You can see the top not too far above you

There are many tasks in self-publishing, from designing the cover logos to walking into comic shops to promote the book itself.

Razorjack as realised by master sculptor Nigel Booth. 2009.

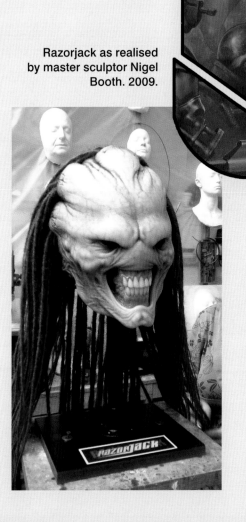

now. Gasping for breath, hand stretching up, you grab at the last outcrop of rock and pull yourself to the top and … you see towering over you the *rest* of the mountain, looking like the same distance you have just climbed. That is the way most people's careers tend to unfold. One more ridge to climb and then you will reach the top, but the top always seems to be as far away again, and with someone else's flag happily waving from it.

At the Jack Publishing stage in my career I could look back down the mountain and see how far I had come. I had arrived somewhere, editors knew my name, I was getting interesting jobs, and working with some of the best creators around, so it would be sensible to carry on up to the next ridge, and then on to the next.

But no one had ever accused me of being sensible. It seemed like a good time to do my own project. I had seen the possibilities of what could be done with creator-owned properties within a big company structure, and also the disadvantages. Hindsight has 20-20 vision, but even then, just twelve years after *Watchmen* first appeared, the contract that Dave and Alan had signed with DC that had seemed to give them a lot of control over their intellectual property (IP) was shown to be, as always, biased towards the big company. There are many arguments for and against DC Comics having control of the *Watchmen* IP and I do not have the expertise or time to list the pros and cons. But I knew even then that one's creative life in relationship to one's IP was so much simpler if one had total control over it. No one could tell you what to do or how to use it, or any images related to it.

In an almost perfect case of synchronicity as I sit here writing this – being halfway through preparing this book, and dealing in this section with self-publishing and copyrights – I am waiting on DC's licensing department to get back to me to give me permission to reproduce, in this book, a small selection of artwork featuring DC's characters that I had drawn for them over the years. Many arguments can be looked at here, but to keep it simple: of all the companies and clients from whom I have asked permission, all but DC have said, "Congratulations, go for it John, well done." They appreciated the opportunity to promote comics across the board in a positive way for every client by whom I had been employed.

But DC licensing asked me for a fee of $3500 *to use my own artwork*. They subsequently dropped that demand when I pointed out how inconsiderate and insulting this was for someone who

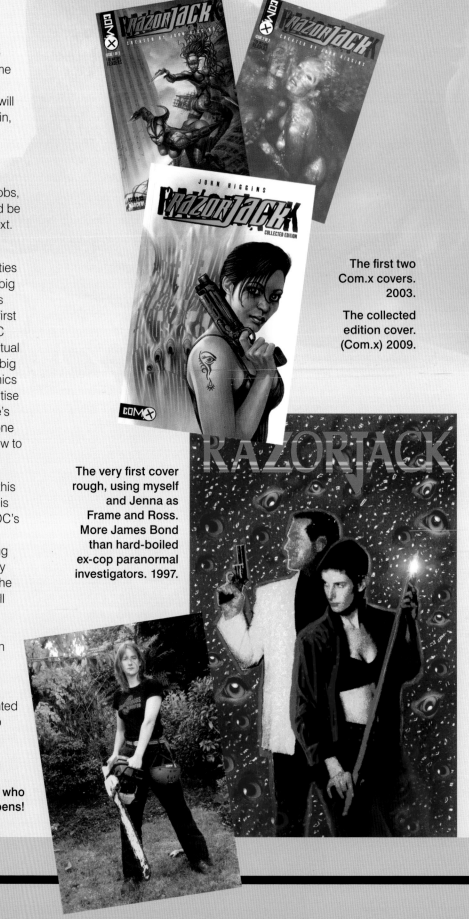

The first two Com.x covers. 2003.

The collected edition cover. (Com.x) 2009.

The very first cover rough, using myself and Jenna as Frame and Ross. More James Bond than hard-boiled ex-cop paranormal investigators. 1997.

Jenna as super chainsaw-wielding arborist, 2003. I know who I'll have with me when the zombie apocalypse happens!

had worked consistently for them for over thirty years. Then they wrote into their rights contract how, when and to whom I could sell the book. This is akin to being in a 100-metre race with your right arm tied to your left leg. I have sent *that* contract back too. Bear in mind that all these demands are for a tiny 15 per cent content of a book that they are not contributing to in any other way. I am waiting to see what they come back with, and that waiting started over eighteen months ago from the date of my first request for their permission … I am just pleased I am a slow writer.

All of this is nothing to do with the creative people who understand comics on the publishing side of DC and with whom I have had a long and friendly relationship. DC Comics are a small part of one of those massive media corporations I mentioned in the first part of the book. It is profit margins and bottom lines, run from the top by accountants, lawyers and pen-pushers who send dictates down to the creatives at the bottom of an inverse pyramid.

With creator-owned material, I think the attraction is not so much the commercial possibilities for one's own copyrighted creations as the creative freedom you have. We just need to look historically at all the creators who have lost the rights to their characters and watched as publishers exploited them with very little regard or reward for the original artists and writers. Compare that to the example of those creators who produced their own books outside of the big companies. In 1992 a number of major artists broke away from the mainstream companies and started their own company, Image Comics, an incredible success story at that time. There were also a number of successful independent black-and-white comics around: Dave Sim and the incredible *Cerebus*, *Bone* by Jeff Smith and *Elf Quest* by Wendy and Richard Pini. The underground comix of the 1960s had shown the way to produce and publish an alternative to the output of the mainstream comics publishers, that being mainly superhero comics (which continues to this day).

Razorjack. Photo: Will White. (model Jessica) 2010.

Promo advert for Razorjack. (Jack) 1999.

The first *Razorjack* was an anthology magazine with many creative strands, articles, a number of different comic strips and cartoons, such as this set of innocent characters an attempt at a Lil Annie Fanny, Wicked Wanda cartoon pastiche.

" RAZORJACK is exactly the sort of thing I've been talking about; doing things new is the point. John Higgins is an innovative and driven artist, constantly looking for the next level, constantly expanding his capabilities."

WARREN ELLIS

RAZORJACK

Check out our website on www.turmoil.co.uk
email us at jack@turmoilcolour.demon.co.uk

FULL COLOUR ADVENTURES IN AN 84 PAGE SQUARE BOUND GRAPHIC NOVEL FORMAT

" Our biggest selling independent comic to date! RAZORJACK outsold Preacher in it's first week! It will continue to sell off of the shelves long after other comics have passed their sell-by date! "

CHAOS CITY COMICS

TO ORDER RAZORJACK: send a cheque or money order made payable to: TURMOIL COLOUR STUDIOS, FOR £7.95 (UK) or $11.95 (US) To: *Jack Publishing. Courtney House. 12 Dudley St. Luton. Beds. LU2 0NT. UK* Allow thirty days for delivery. **RETAIL,** Enquire to the above address for special offers and retail discounts.

As she sat on her favourite nob rock, she couldn't understand why he never walked around the puffer fish pond!

Dark Inspirations

Interior cover from *Razorjack – Dark Inspirations* sketchbook.

Sketches from *Dark Inspirations*.

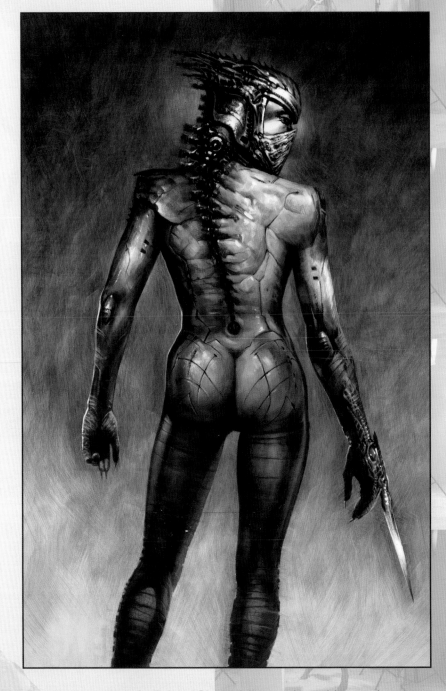

A tone illustration of a Twisted Sister; these are the maiden warriors. Their bodies and minds have been twisted and corrupted to Razorjack's ways. They are not evil the way she is, but handmaidens of violent death and destruction carried out at her bidding.

I have always been interested in the cyborg or biomechanical mix of flesh and metal. This Twisted Sister is an unstoppable killing machine, a synthesis of power, cruelty and sexual allure.

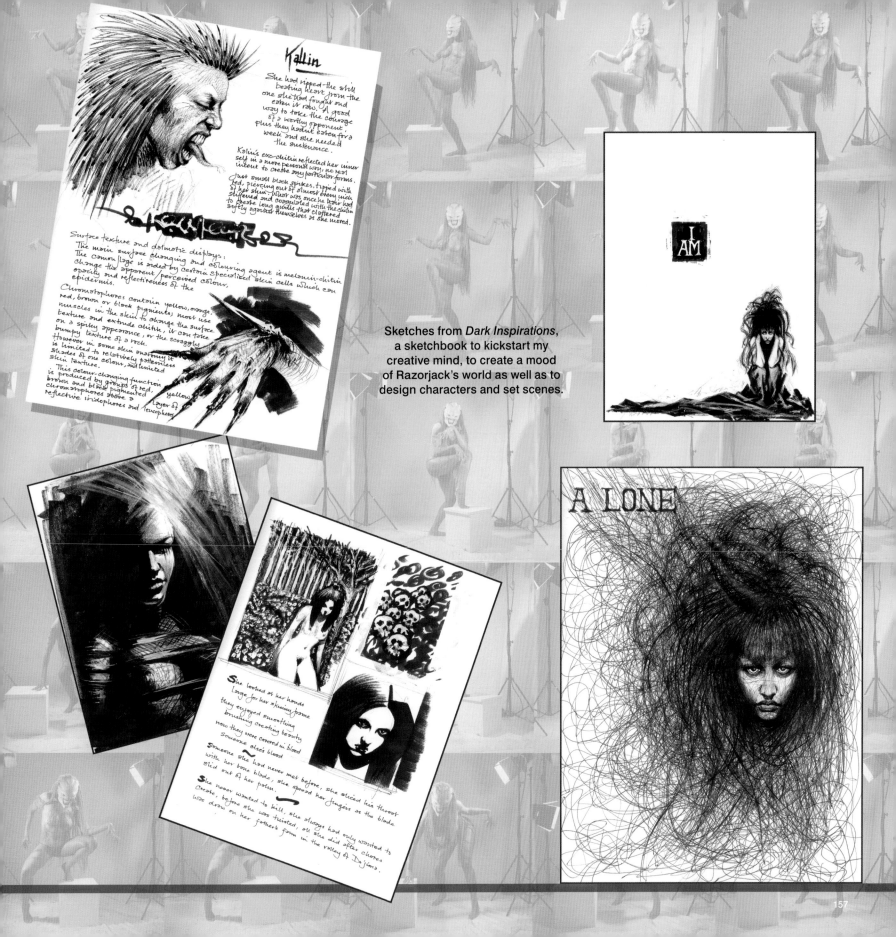

Kallin

I AM

A LONE

Sketches from *Dark Inspirations*, a sketchbook to kickstart my creative mind, to create a mood of Razorjack's world as well as to design characters and set scenes.

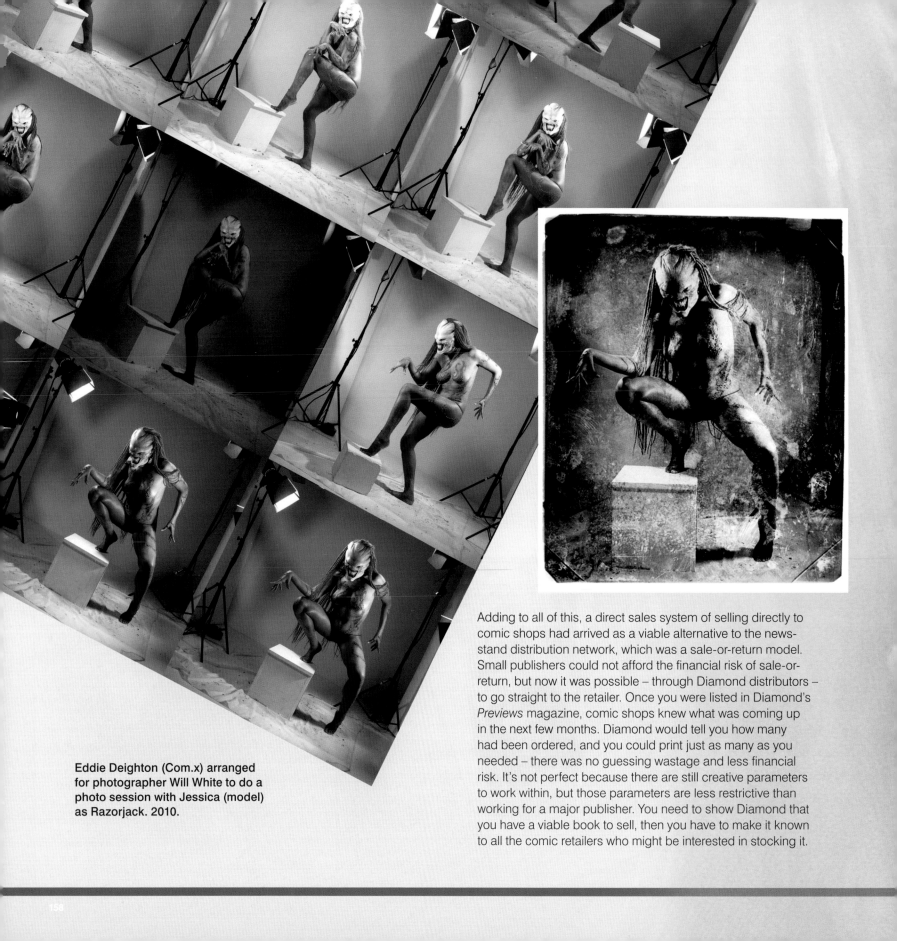

Eddie Deighton (Com.x) arranged for photographer Will White to do a photo session with Jessica (model) as Razorjack. 2010.

Adding to all of this, a direct sales system of selling directly to comic shops had arrived as a viable alternative to the news-stand distribution network, which was a sale-or-return model. Small publishers could not afford the financial risk of sale-or-return, but now it was possible – through Diamond distributors – to go straight to the retailer. Once you were listed in Diamond's *Previews* magazine, comic shops knew what was coming up in the next few months. Diamond would tell you how many had been ordered, and you could print just as many as you needed – there was no guessing wastage and less financial risk. It's not perfect because there are still creative parameters to work within, but those parameters are less restrictive than working for a major publisher. You need to show Diamond that you have a viable book to sell, then you have to make it known to all the comic retailers who might be interested in stocking it.

Cover for the collected edition.
(Com.x) 2009.

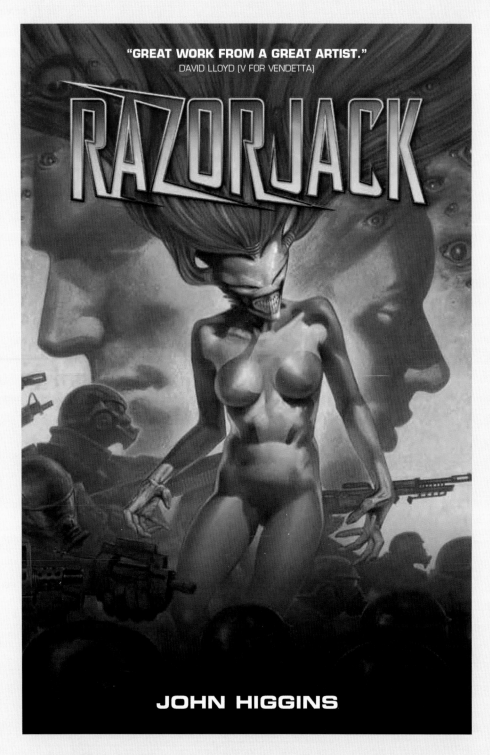

"GREAT WORK FROM A GREAT ARTIST."
DAVID LLOYD (V FOR VENDETTA)

RAZORJACK

JOHN HIGGINS

Titan Comics. 2013.

Una 1999.

I have had a small number of Razorjack models who have channelled this alien life-force with impeccable poise and scary grace. Una Fricker was the first in 1999, her hands being particularly expressive.

Jessica from the 2010 photo session, another fine pair of expressive hands.

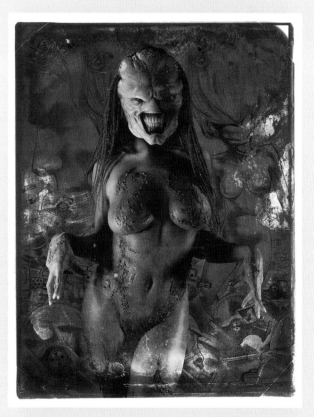

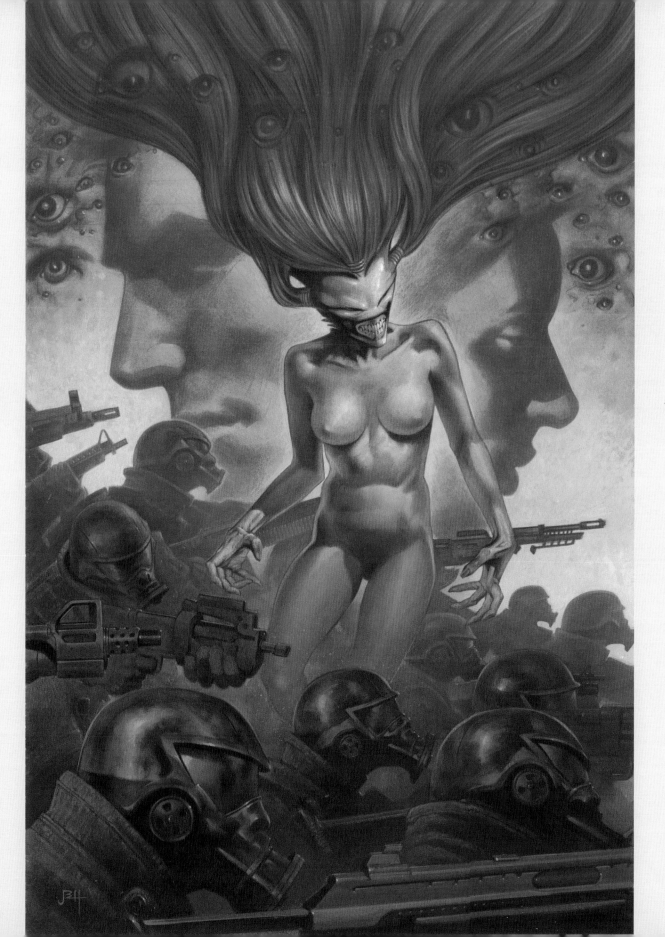

The original cover
without the bikini
cover up.

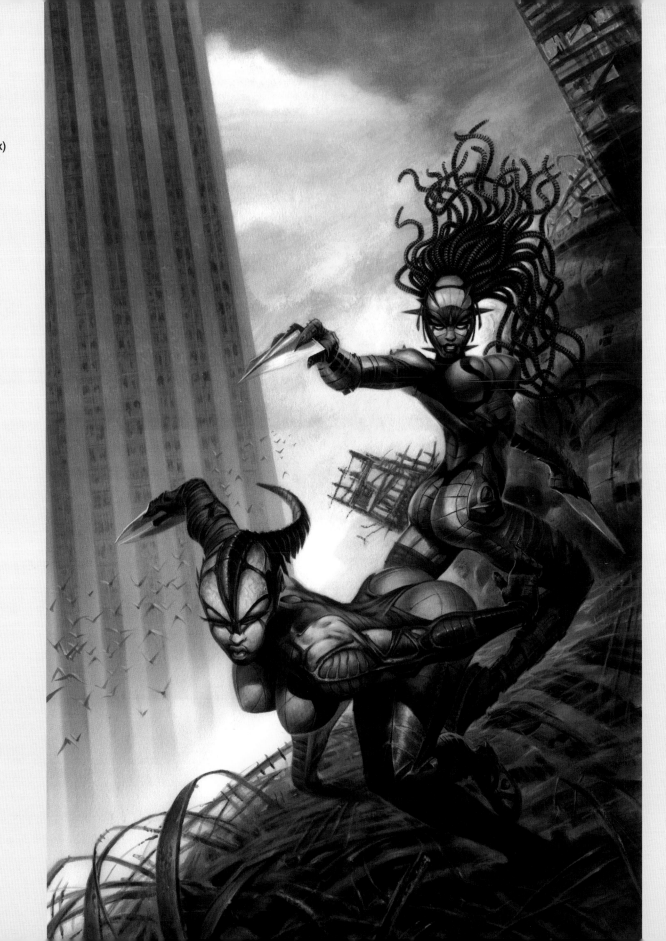

Cover to *Razorjack* #1 (Com.x) 2001.

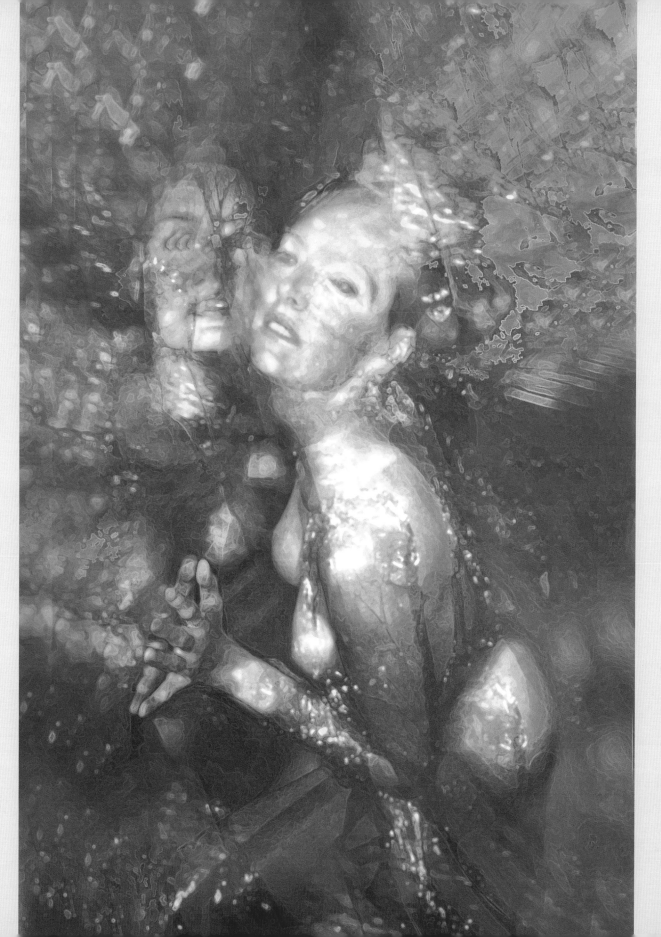

Cover to
Razorjack #2
(Com.x) 2001.

Una –
photographed,
scanned and
tweaked in
Photoshop
(see Chapter
12 for technical
details).

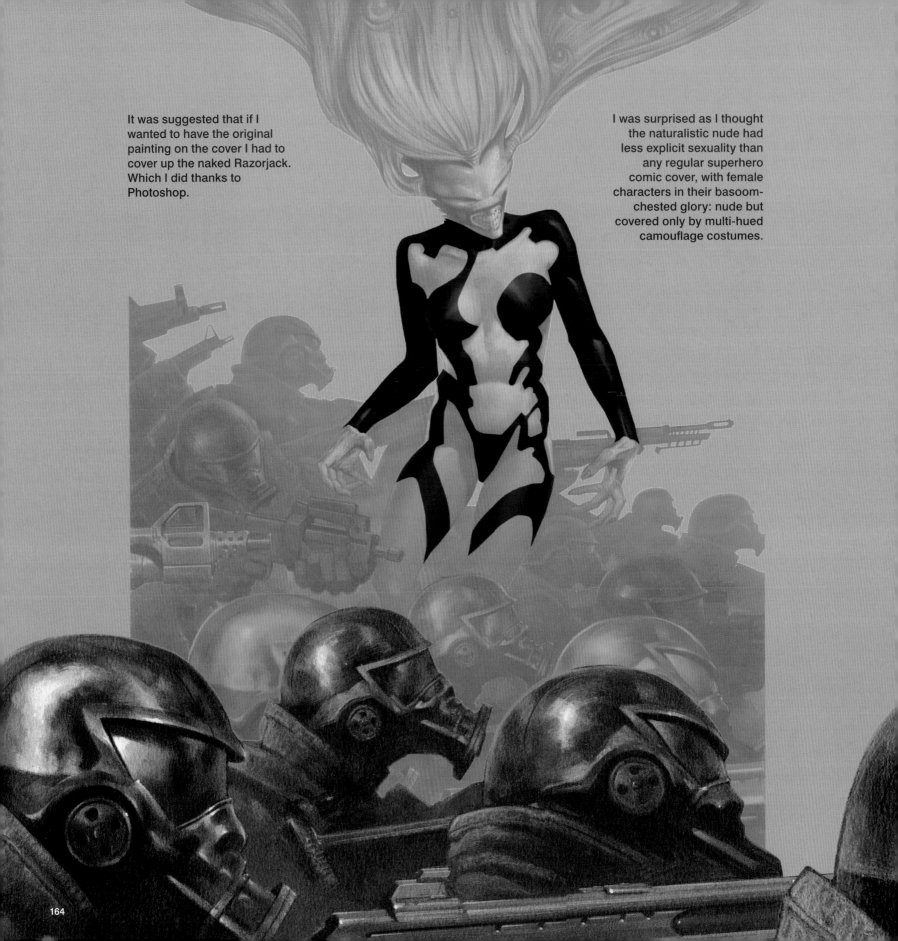

It was suggested that if I wanted to have the original painting on the cover I had to cover up the naked Razorjack. Which I did thanks to Photoshop.

I was surprised as I thought the naturalistic nude had less explicit sexuality than any regular superhero comic cover, with female characters in their basoom-chested glory: nude but covered only by multi-hued camouflage costumes.

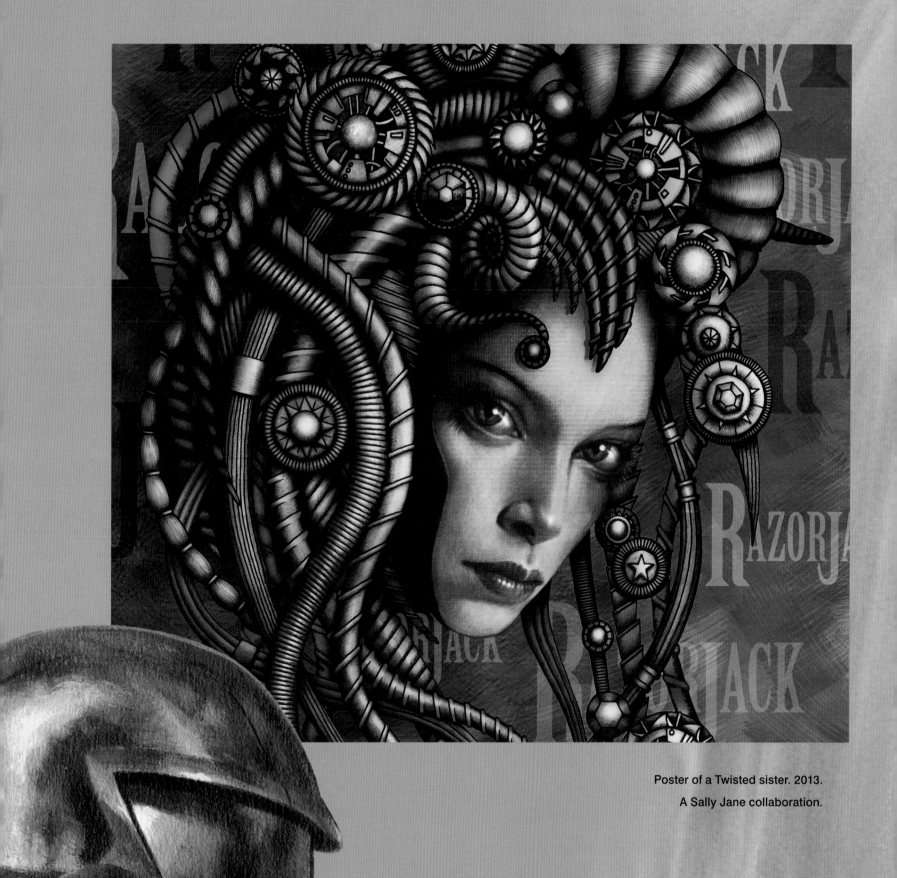

Poster of a Twisted sister. 2013.

A Sally Jane collaboration.

Book cover, Michael Carroll writer. (Com.x) 2010. Photo: Will White, design Eddie Deighton.

eBook cover, Michael Carroll writer. (Quantum) 2015.

This is harder than you might think with just the basic listing, so you either spend a lot more money for a bigger advertising space in *Previews* or pay for adverts in other trade magazines. Getting good reviews in comic fanzines and SF- and comic-friendly magazines is a good way to promote your book. I had many positive reviews in print and online – some have been incredibly perceptive and helped when I came to add more detail to the world of *Razorjack* in future issues. The internet is a great shop window, but your book can get lost in all the other comic book news and static that saturates the digital airwaves.

Profit margins are always tight even for the big companies, and they get favourable deals with Diamond with different percentages and services. This is completely understandable: they produce 90 per cent of all the titles that go through Diamond, so the small 10 per cent of independent publishers are not really going to make a lot of difference to Diamond's turnover. I had a very friendly contact at Diamond who helped with advice, and the fact that he liked *Razorjack* was a bonus: he recommended it for a "Gem of the Month" spot along with an interview and art preview in the magazine.

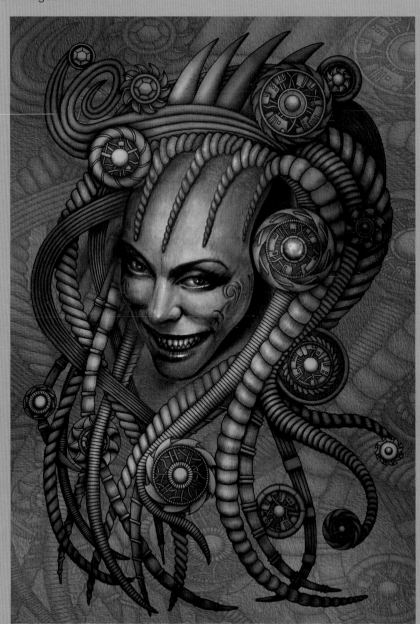

Twisted sister poster. 2014.

A Sally Jane collaboration.

An approximate breakdown for publishing a book goes something like this. The cover price is split, with the retailer receiving 47 per cent, the distributor 16 per cent and the remaining 37 per cent coming to me as the publisher. Out of that I need to pay for printing. Then the grey area of costing for the production of the pages, writing, pencilling, inking, lettering, etc. If you bring in other talent then you need to pay them and that is reflected in the overheads.

I did all of those tasks, and as the publisher I considered that cost as my investment. The other myriad costs involved in producing a comic book are art materials, studio equipment, the choice of whether to pay for more advertising, interest on loans and overdrafts. This all has to be taken into account when looking at the viability of self-publishing and making the figures balance. So keeping costs down is imperative right from the off. There is no guarantee of how successful a book will be. I knew I wanted to publish it to the highest possible standard, comparable to the books I had been working on for the major publishers; it was important to me that the readers got the best production values.

The first issue was done as an 84-page colour anthology magazine on quality paper. I always enjoyed that type of publication as a fan. Networking came to my rescue yet again and I called in favours from Charlie Adlard (*Walking Dead* etc.) and Robbie Morrison (*Nikolai Dante* etc.), whose award-winning short story *White Death* appeared, along with Robbie Morrison and Colin MacNeil's (*Judge Dredd* etc.) *Demon for Hire* strip, with annotated pages from Robbie talking about concepts and ideas on collaborating.

I now know that it would have been more realistic and a safer option to publish it with half the page count, black and white on cheap paper and with a superhero story. The *Razorjack* story I had strong ideas for. It was a mash-up of all my influences and not something that would sit comfortably in one genre. It was horror, sure, it had some superhero tropes, a touch of SF which is a broad church for almost any type of story, and a murder mystery. I described it in one interview at the time as "hard-boiled SF noir". Never heard of that? No, neither had I until I finished *Razorjack* and tried to describe such a melting-pot of genres. Since then I have discovered it was already a real genre and not something I had made up. Thank you, Google!

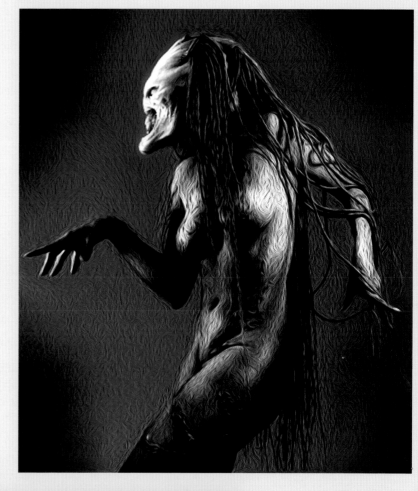

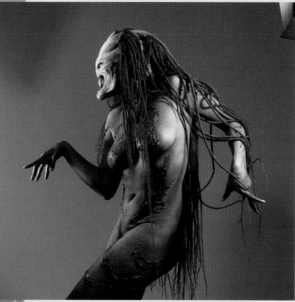

A convention Razorjack print: a Will White photograph processed through Photoshop.

The internet is a great resource for finding the best printing costs and the other services you need to self-publish, even when I first produced *Razorjack* in 1998 and the internet was not as intuitive as it is now (Larry Page and Sergey Brin had just founded Google as a new search engine to compete with Yahoo and Alta-Vista, and "Google" had not yet become a verb). I checked with a number of printers in other countries such as Canada and Spain to find the best price for printing my small print run, 1200 copies. Quebecor Printers, Canada, gave me the best quote, but I went with a local printer that was more expensive but where I could pop in and check the production. You find out very soon that the financial see-saw of printing costs and distribution is a strange world of balances and checks. To print 1200 copies of an 84-page anthology title of original scintillating colour art cost $1740, which comes to $1.45 a unit. For an extra $800 I could get 3000 copies, which was a bargain at $0.84 a unit. Once the printer has the book set up and on the press, which is the major cost, printing more copies brings down the individual unit cost.

So, the cover price was $11.90
Distributor = $1.92
Retailer = $5.64
Me = $4.44

It took approximately fourteen months from the first pencil marks on the blank page to sending the finished digital print-ready PDF document to the printers. So for fourteen months' work I received the grand total of $5,328 on the initial orders. As I did everything myself, all of that money came directly to me – "Wahoo!"

Now, of course, we have print-on-demand services that allow the creator to print single copies of a comic and send it directly to an individual buyer, or to create digital-only comics that have no printing costs at all. Print-on-demand has potential for profit, but it is the same as the equation above for normal printing: the more you print the cheaper it gets. If I were publishing *Razorjack* now I would first approach a company such as Image, but at the time it was not the umbrella imprint it has now become, which accepts many viable comic projects. In its early days Image concentrated on their core books.

But was it worth it? Too effing right it was! Not financially at that moment, but creatively. Maybe not for all the sleepless nights on sweat-soaked sheets that I went through worrying about money, deadlines and quality, but it was worth it for every moment that I had total creative freedom, and I owned all the rights to my blood-stained baby.

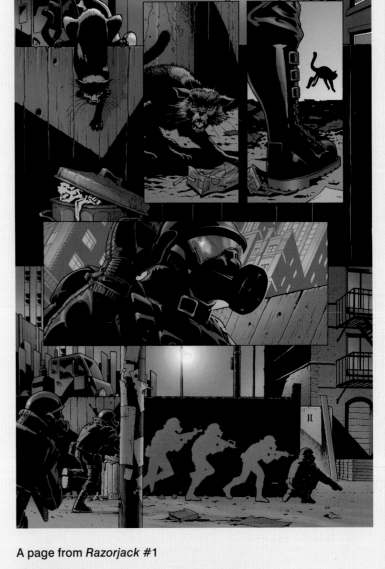

A page from *Razorjack* #1

The SWAT team setting off a chain of events that create a trans-dimensional nexus, a gateway for Razorjack to cross over into our world.

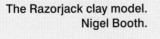
The Razorjack clay model.
Nigel Booth.

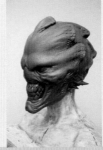
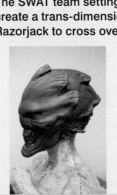
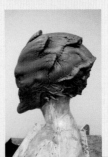

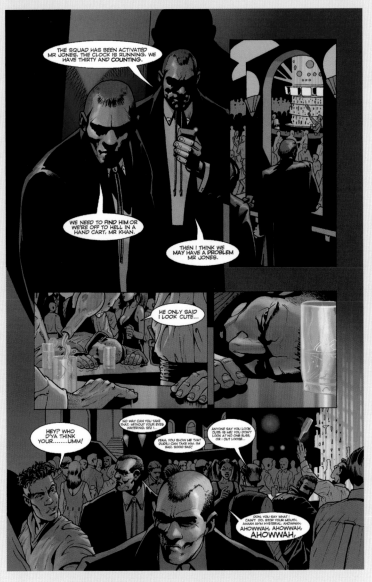

A page from *Razorjack* #1

Featuring the first appearance of my favourite dead assassins, Mister Kahn and Mister Jones.

My first marriage had just ended amicably: we'd sold the house and split the proceeds. With my half and a $10,000 overdraft I financed the whole process myself. Selina went and invested her half in part of a mountain in Wales.

Those are the cold, hard facts of self-publishing for most creators. We all have in our minds the possibility of success, but for every *Teenage Mutant Ninja Turtles* there are a thousand *Geriatric Mutant Samurai Tortoises* that no one has ever heard of. The driving force is *not* the prospect of big money (and at the start not even the idea of breaking even). That is a vague thought in the distance! The drive is to create the best possible comic book you can. When you start, it is thinking of your best story ideas, putting them on to paper, moulding the plot, adding characters, getting to know them and to know how they would react to situations, planning all the story steps and dreaming of the potential of your creation. That is the great thing about the planning stage of any project: it is the excitement of possibilities, no costs yet. That lovely amorphic, unshaped nebulous fog of creativity. Nothing joins up, everything is just little islands of separate ideas glowing like pearls on a black velvet cloth that you polish one by one, waiting for the thread that will join them all together … Then you commit, and it becomes hard work as you start joining all those individual pearls into one carefully balanced story.

The hardest job in any storytelling is editing. You lose some of your beautifully crafted phrases, situations that you thought were necessary to the plot become redundant, and you have to make other elements balance against a new idea you have to put in to compensate for the gap that just appeared.

I had many ideas and storylines for an ongoing *Razorjack* comic if the sales had warranted it, and I had intended to publish *Razorjack* as a three-issue story arc, but at that time I could not afford to spend another fourteen months working for an hourly rate below the national minimum wage. Fortunately Eddie Deighton – along with Russell Uttley and Neil Goodge – had created Com.x in 2000, for whom I'd been a sort of informal adviser and drinking buddy. I'd also illustrated a couple of early Com.x stories for them. At this stage I had decided I could not afford to continue to self-publish *Razorjack*. I had bills to pay and a daughter to put through college. But I jumped at the chance to co-publish the next two issues with them when they suggested it. I accepted for two reasons: the idea of *Razorjack* as an unfinished story would have haunted me for the rest of my career, and I had made a promise to myself for all the fans of the first book. I felt they had shown loyalty and belief in my weird fucked-up fantasy world, and I wanted to tell them the full story.

With Com.x giving me an advance on royalties and paying for production and printing, a lot of the mundane but important tasks were taken over, freeing me to spend more time on the story and art. Sam Hart (that's Sam from Courtney House) helped on the colour with another person from his Brazilian art network, Rod Reis (now a master colourist for Marvel and DC Comics). For the first time I got a sense of the freedom of just being the storyteller without the pressure to do it all. With Com.x production values of the highest standard things looked good for *Razorjack* continuing, and we got two additional 32-page Com.x editions out. This completed the origin story.

The Com.x connection, along with Sam and Rod: a perfect example of networking. Eddie, once a student of the college for which I did a talk, who then employed me. Sam, who started as a student in my studio, then worked with me for Com.x, my publisher, bringing in Rod. And today, 19 September 2016, Sam sent me a cover to colour for his personal comic project called *Mega Ultra*. All relationships are made with no concept of how it will all connect again in the future, but working in a creative field it helps that all your friends tend to be very talented!

"What's *Razorjack* about?" I hear you scream.

Weeell … it is hard-boiled SF noir!

Here we go! (To get the full flavour of this, you need to imagine me hooked up to a drip-feed of pure adrenalin, eyes stitched open, tears of blood dripping down my face, teeth bared in a rictus grin as I prepare to scare the bejeezus out of you!)

Ssssh!

Hear that? That sound that has woken you from deep sleep. You lift your head up from your sweat-stained pillow, straining to hear that noise that was almost inaudible. Was it outside the door to your darkened bedroom? In the wardrobe? Hold your breath, listen in mind-numbing fear, dreading to hear the sound again, hoping it was all a bad dream. Until … you hear it again!

Razorjack **starts with** three innocent college kids who get caught up in a vortex of violence and action spanning multiple dimensions, stemming from when they inadvertently open up a gateway to a dimension ruled by the evil incarnate Razorjack. Into this plot pot we throw undead assassins, secret societies and a serial killer, along with Frame, a hard-bitten cop, and his young assistant Ross, who start out solving crimes and go on to save worlds.

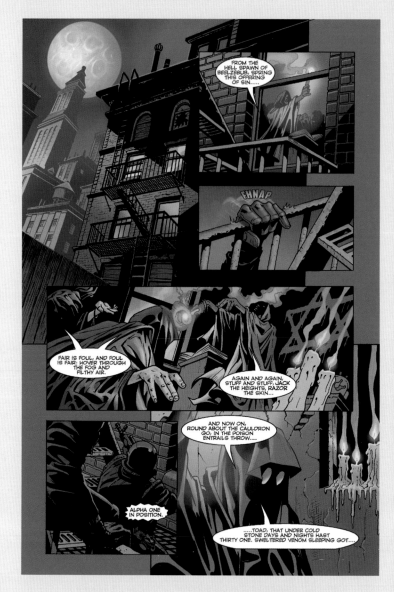

A page from *Razorjack* #1

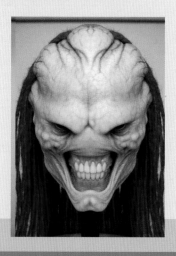

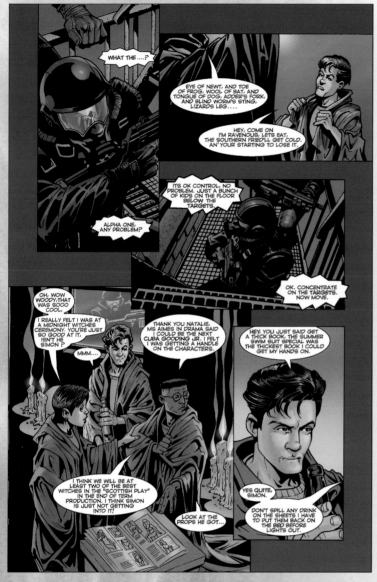

Following page from *Razorjack* #1.

Me and Jenna in 2011; all the orthodontist visits were worth every penny.

I remember reading Edgar Rice Burroughs (*Princess of Mars* – my favourite cover) and loving the fact that John Carter, ordinary Joe from the Midwest, had all these incredible adventures. I wanted it to be me. I wanted to travel to other worlds and to be a hero. This was also the appeal of the first superhero comics I read as a kid. I looked everywhere for that radioactive spider. Haven't found one yet.

This is what *Razorjack* is about: you and me, having to step up to the base and become a hero. It is the realisation that bad things do happen to nice people unless you do something about it.

I hope I have not put you off self-publishing. I do think it's a valid expression of creativity and can be viable if all the elements converge. Image is still around with the same principle of the creators owning the copyright to their work, and they have published such titles as *Spawn*, *Witchblade* and *The Walking Dead*, which became successful comic series and then crossed over into other media, TV and movies.

Razorjack is still going eighteen years after it first appeared. It became a collected edition with Com.x in 2009 with new material. Titan Comics published their hardback edition in 2013 with even more new material. It has spawned two novels written by Michael Carroll (*The New Heroes*, *Judge Dredd* etc.) and Al Ewing (*Zombo*, *Damnation Station* etc.); a full musical suite has been composed by a number of musicians including the talented artist, colourist and musician Sally Jane Hurst and Wallasey College of Art graduate Kevin Jones; and Razorjack herself has been realised as a fearsome 3D prosthetic head by Nigel Booth (sculptor on *Hellboy*, *Hellboy II*, *Captain America* etc.) ready for personal appearances and a possible movie. This disparate group of talented people saw something in my creation that excited and sparked ideas that they felt could be a valid expression of their creativity within my universe.

I still own all rights to it. It will continue to appear in print and other media, in collaboration with like-minded creators. I have so much more I want to do with *Razorjack*, but it will appear on *my* terms and no one else's.

As a satisfying postscript to the DC licensing saga, I got the permission from licensing. I am not a person who expects special treatment, but in the end I had to ask the co-publisher Dan Didio to expedite the process, which was becoming log-jammed in absurd demand creek, which he did. Thanks to Dan this is as a complete a book as I can possibly produce.

WONDERING

FREELANCING AND
SUPERHEROES

CHAPTER 8

Whoosh! "What was that?"

"That was the deadline."

"That was fast – do I get another?"

"Nope, that was it!"

There are three things in life that you cannot avoid: death, taxes and deadlines.

If you are asked how long you need to do a job, work out your best guess then double it. If you are asked to quote a price, double that too. Neither of those will ensure you get the job, but what I can guarantee is that the deadline will never be long enough and you will never get enough money to do the job you would like to do.

The worst feeling you can get after you have given a quote is when they immediately say, "Great!" That means you under-quoted. Always quote high and let them negotiate down.

Every commission for an artist is a compromise on time and money. No matter what my opinion might be about the businessmen who run the big companies, they are right when they say that "time is money". This field of dreams is a business, and it costs money to produce those dreams. By all means work for the big companies. They pay you to do what you love – telling stories – but do not give them your best ideas. Give them your best Batman and Spider-Man ideas, but keep your own completely original ideas for yourself, unless of course they make you an offer too good to refuse, which is possible. *Watchmen* was one of the first deals to give the creators options, the best contract for its time. Better ones have

A selection of foreign editions of my comic books.

been signed since and no matter what is said about the *Watchmen* IP being held by DC, who have exploited it and kept it in print since the day it was created, who is to say what would have happened if it had reverted back to its creators in 1988? (In most contracts the reversion time is stipulated as "being out of print for twelve calender months".)

I enjoy working for the big companies. No, that is not strictly true. I enjoyed worked for Steve MacManus, Karen Berger, Axel Alonso and many other editors who worked for the big companies. Those editors became friends. They gave me the opportunity to produce some of my best work, which is how a big company should function: you working with talented editors who are as focused as you on creating the best possible product. Being employed by a big company can work to your advantage – in some cases. *World Without End*, *Pride & Joy* and other creator-owned properties did revert back to me after those twelve calendar months. But if any had been my "Watchmen" and become successful beyond my wildest dreams I would be pretty happy now. None reached those giddy heights, but DC made money out of them all. The first issue of DC's *World Without End* sold over 40,000 copies. This, along with *Pride & Joy* and quite a few others I have been involved in, have been reprinted in many languages around the world. Big companies know how to exploit and make money from comic books they have control of, and that means you do also.

B/W Batman based on the cover for *Storm*, my only Dark Knight story so far. Writers: Graham Brand – Andrew Donkin. (DC) 1994.

Interior pages from *Storm*

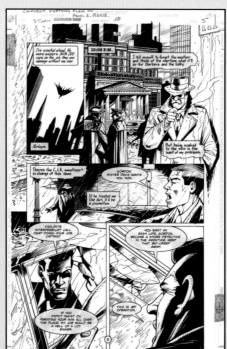
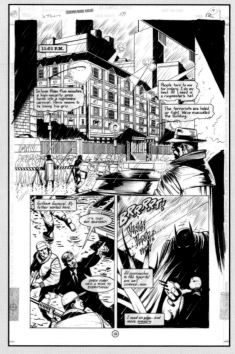

I made a conscious decision in the mid-1990s to move into the superhero genre, but my timing sucked, as the apparent publishing success of the major comics companies at that time was driven more by the variant cover boom (with "special" issues of comics being printed with multiple covers – hardcore collectors will want at least one of each different cover) than story quality, and it was all just about to implode. I had concentrated my attentions on Marvel and did a number of mini-series for them. For my last job, editor Richard Ashford commissioned me to illustrate an eight-page story – *War* – featuring *Siege*, written by Mindy Newell. Short stories are a hard medium to master, but Mindy got it just right and did an evocative, thoughtful story on conflict and innocence with plenty of superhero action. I intended to spend some time on it, for it to be a portfolio piece to show off my best superhero work, but with the publishing implosion and Marvel going into bankruptcy in 1996 everything stopped overnight. The story was never published and I did not get paid for it either. The lack of security for a freelancer is yet again underlined.

Covers to the *Scarlet Witch* mini-series. Writers: Dan Abnett – Andy Lanning. (Marvel) 1995.

An acrylic painting on canvas for a projected Western graphic novel project. Co-created with Sven Larson.

As *Razorjack* was a conscious move to give myself a creative kick in the ass, moving to Bayonne, New Jersey was the equivalent of a kick in the ass, slap in the face and a shot of adrenalin! Think of Dennis Hopper's character Frank Booth in David Lynch's *Blue Velvet* sucking in amyl nitrate, and his manic, pop-eyed, full-body clench! That was the way I felt every day for the years I lived there. Garth Ennis always described stepping out of a yellow cab on to the mean streets of New York as walking into the biggest film set ever created.

It seemed like the right time, with my move and after *Razorjack*, to try my hand at superhero comics again. The comic market had recovered and Marvel was out of bankruptcy and once again a powerhouse of publishing. Even though superhero is now a genre stream all of its own, it is still pure SF. Superhero stories have been around since storytellers told of gods smiting with thunderbolts and lightning, but in science fiction terms the pulp story *Gladiator* by Philip Wylie, published in 1930, is generally regarded as the inspiration for Superman. This was probably the first time science, rather than mythology, had been the inspiration for a new type of hero.

A series of photographs taken from my Bayonne studio with the best view ever from a studio window.

I had a home studio in Bayonne with one of the best views of New York, and within a short transit train trip I was in the middle of it all, which was a great opportunity to reintroduce myself to editors at both of the big publishers, Marvel and DC. It was said that visiting DC was akin to visiting an accountant's office, while going to Marvel was visiting a college frat house, and so it was, but outside all the editors partied hard. Garth Ennis had also moved permanently to NY and it was great to meet up with him regularly. Now, I am not saying it is a good thing, but people from our side of the Atlantic have a reputation for being serious drinkers. Garth is a great socialiser and was the initiator of most of our gatherings, and going to bars might have featured regularly in them. He had arranged one gathering in the meatpacking district of New York at a bar called the Brass Monkey. I had not been out for a couple of weeks – probably a deadline kept me in – so I was raring to go and I had a big thirst to catch up with everyone and have a couple of pints of Guinness.

Characters from the Western project that would have touched on many aspects of the history of the United States.

A small selection from the many photographs I took over a year.

A fact: New York has some of the best Irish bars in the world and the best Guinness I have ever tasted. Another pleasure of drinking in America is the "buy-back" drink, which means that when you are a good customer, the bar staff buy you a drink. I was probably a little over-excited, but the drink was going down like pints of dark, sweet, liquid night, and halfway through the evening the young lady who was serving Garth and me came over with buy-back pints for us and said "You guys are awesome!" I know, I know, it is a self-aggrandising story, but I have never been described in any way, shape or form by a young attractive woman as "awesome" before in my life, and if it was only for drinking a lot, I will accept that!

Another drinking story, if you will indulge me, concerns Steve Dillon. I was out with Stuart Moore, editor at DC, who told me that when he took Steve out for the first time when he worked for DC Comics in the late 1980s (well before *Preacher*, the highly acclaimed Vertigo series Steve did with Garth Ennis), and asked him where he would like to go for a drink, Steve said he had been in this particular bar when he first came over to New York for a holiday five years previously and had enjoyed it. They walked into the bar and the barman turned around and saw them and said, "Steve!"

Steve is a memorable guy, all around nice bloke and legendary drinker.

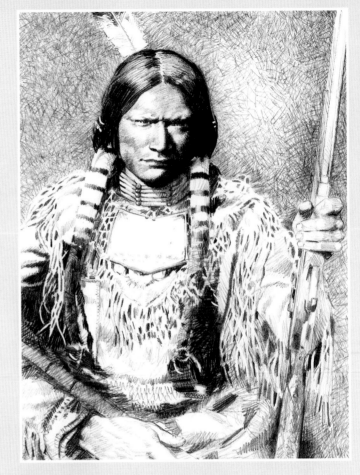

A pencil study of a Lacota Sioux warrior.

Sven and I did a great amount of research. I became steeped in American history while living in Bayonne,

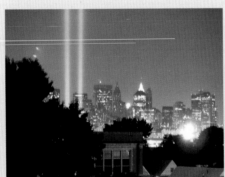

when every season and time of day created a completely different spectacular vista over New York.

I was getting a number of quality projects to get my teeth into while living in Bayonne. I did a mini-series for Marvel called *Identity Disc* (writer Robert Rodi) on which I had the pleasure of working with colour artist Chris Sotomayor, who later worked with me on *Jacked* in 2016 (on yet another crunching deadline). Working with Dave Gibbons is always a career high, which I did again when he wrote *Thunderbolt Jaxon*, a mini-series for Wildstorm, and also – most excitingly – when we revisited the colour for *Absolute Watchmen* in 2005. Being in such close proximity to DC I could drop into the production department and work alongside Alison Gill, who had moved to DC Comics. With her and her production team we turned out the best possible digital interpretation of the colour that we could, and then with a job well done we'd slope off to drink in McGee's on 55th Street, which was at the time DC's regular drinking hole. This is no longer the case, sadly, since they became all Hollywood and moved lock, stock and publishing barrel over to Burbank, California in 2015.

The power of the natural world featured high in all aspects of the daily life of the native first Americans.

"The Earth and myself are of one mind. The measure of the land and the measure of our bodies are the same …"

Hinmaton Yalatkit – Nez Perce chief (1830–1904).

With a colour palette of light and shade that only nature and the hand of God could create.

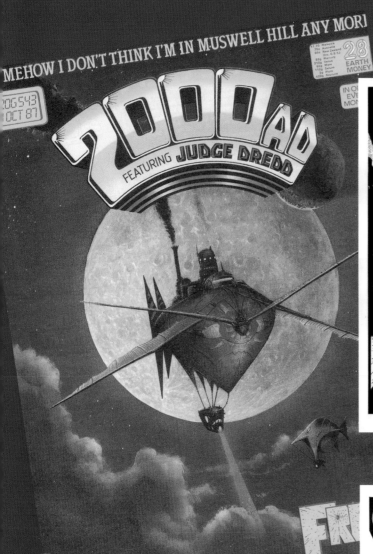

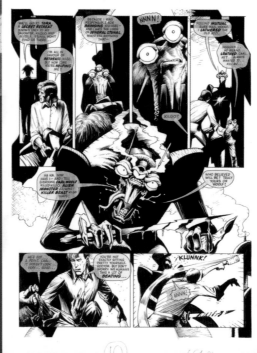

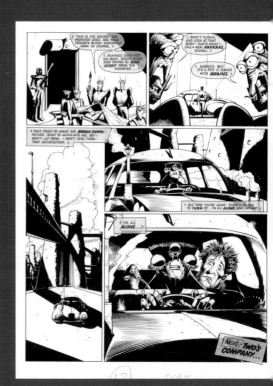

The cover for the first series of *Freaks*, writer Pete Milligan. (Rebellion) 1987.

A selection of pages from the first series of *Freaks*.

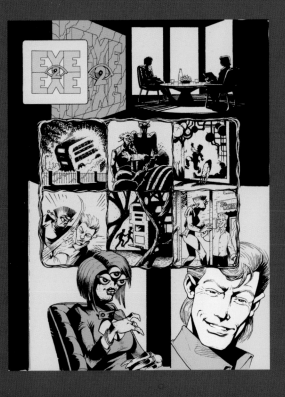

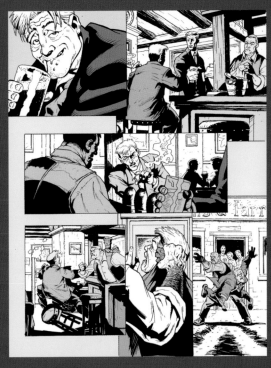

The digital cover for the second series of *Freaks*, writers: Mindy Newell and John Higgins. (Rebellion) 2005.

A selection of pages from the second series of *Freaks*.

I went a bit more cartoony on this series.

A Splendid Chaos.
Writer John Shirley
(Methuen) 1989.

Earthworks.
Writer Brian
Aldiss (Methuen)
1988.

*The Malacia
Tapestry.* Writer
Brian Aldiss
(Methuen) 1988.

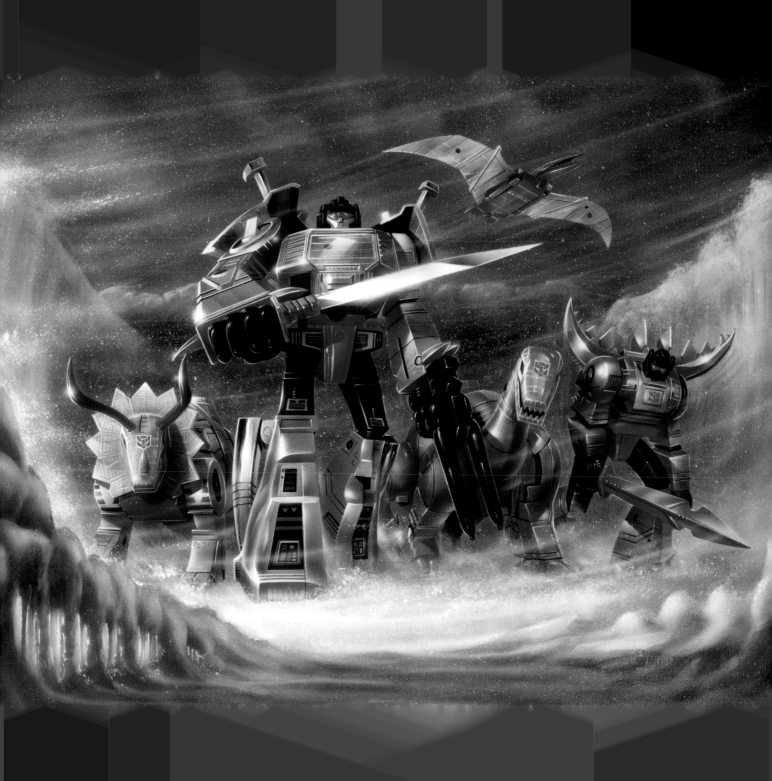

45p

MARVEL COMICS GROUP
APRIL 1983
NO. 168

STAR WARS ™

Princess Leia caught in the middle of the Slaver Wars!

Plus— Indiana Jones!

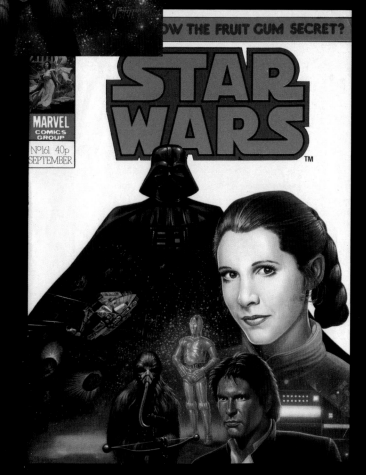

OW THE FRUIT GUM SECRET?

MARVEL COMICS GROUP
Nº161 40p
SEPTEMBER

A selection of *Star Wars* covers. (Marvel) 1983.

The internet has changed every aspect of comics publishing. One positive is that you can now work anywhere in the world for a publisher in a different town, country or continent, with no drawbacks of distance or time-keeping. I would never forget my roots in *2000AD* even while living in Bayonne, and I worked on a series for Matt Smith who had taken over from Andy Diggle as editor. This was *Faces*, a return to the world of *Freaks* (written by Pete Milligan). Mindy Newell and I co-wrote this mini-series. A more low-key revisit maybe than *Watchmen*, but great fun to show how fictional comic characters age and change.

DC and Marvel have been producing superhero comics for over seventy years now, with their core characters Superman, Batman, Spider-Man et al. They keep reinventing all their characters, using the best writers and artists around. They promote them around the world and back. Successful movies are being made: two-hour adverts that keep the comic book cyan, magenta, yellow and keyline black flashing in front of our eyes. Superheroes appeal to the child in us all. We all want to be bigger, stronger, faster and better-looking. That is why superhero comics keep going. The companies know this and pour millions into keeping them relevant for each new comic-reading generation, and they make back *billions*. Not on the sales of those flimsy paper comics that started the whole business, but through every other medium – films, computer games, collecting cards, advertising fast food and any other market you can think of.

A test page for *Swamp Thing*. (DC) 2000.

It *is* possible for creators outside the big company structure to have sky-high success. I believe there is a quantifiable tipping-point equation which involves being in the right place at the right zeitgeist moment, when all the elements come together: idea, creativity and timing – all that equals success.

Zombies? Really?

I thought they were old hat in 2003 when *The Walking Dead* was created by Robert Kirkman and Tony Moore, but it became a success. The timing was right, but Robert Kirkman is also a brilliant storyteller and it blossomed once Charlie Adlard came into the mix. No reflection on Tony Moore, but when the team is right it can be an unstoppable creative force.

To be freelance is to take risks, but it gives you freedom, and you can go where the work is. Big companies can give you a good living, but they will use you and discard you at a moment's notice when it suits them. You get no loyalty from corporations, no health insurance, you work from one job to the next, you are a commodity to be used and exploited. What the company does is to pay you – and pay you well – to produce art on their licensed characters. It might be work for hire but to work on the characters that you read as a kid is the next best thing to creating your own successful comic book.

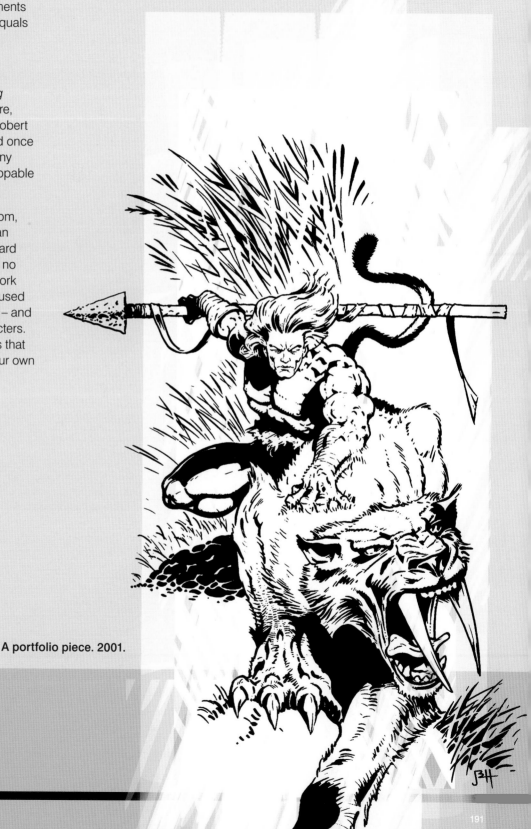

A portfolio piece. 2001.

WRITING FOR COMIC BOOKS
SCRIPT FORM AND PANEL DESCRIPTIONS

Many cultures believe that life is a circle. Returning to the UK was another fresh start in so many ways. But after the adrenalin rush of the New World shores it was as though I had gone back in time, back to an England of London bobbies, red double-decker buses, gas lamps and fog.

Oh, hang on, that's an episode of *Murder, She Wrote*.

Working in the USA I had rediscovered an enthusiasm for storytelling and felt energised by the work I was getting. Every commission you do is a learning curve, an opportunity to stretch yourself, to try different styles and techniques. When you work with good writers your job becomes so much easier. You start to find your style without struggling against story fluff, padding and – sometimes – complete misdirection. Just because a person is a writer does not mean they can write a good comic script. In the mid-1990s book publishers saw the growing success of graphic novels and thought, "We have great prose novels, let's adapt them into graphic novels." An obvious but still good idea. I received a couple of comic-script adaptations of great novels, one of which was adapted by the original writer, but had no visual hooks or pacing. It would have made the most boring graphic novel interpretation of an exciting prose novel ever. It did not get produced.

First page breakdowns, with character sketch.

A script from the fertile mind of Steve Moore, with my detail breakdowns. Steve was a regular collaborator who I had the good fortune of working with in the early days of my career. 1996.

Along with Alan Moore (no relation), Steve had one of the most detailed writing styles for script breakdowns. He had the same talent as Alan, incredible flair for evocative prose directions in his scripts that worked perfectly.

The opening page and scene of a story can be approached in many ways. Here writers Jimmy Palmiotti and Justin Grey wrote a very cinematographic opening with great brevity in panel breakdowns.

Gray-Palmiotti-Higgins

JONAH HEX—TOWNKILLER

PAGE 1

We're going to do something different with the design of this issue by working primarily in a grid. This page opens with a chase scene where one young and very handsome man HANK, is being pursued and ultimately lynched by a town of roughly thirty people—men and women some carry TORCHES.

Panel 1 gives us a look at Hank's terrified face, sweaty and dirty.

Panel 2 shows the legs and hooves of horses pounding the dust.

Panel 3 shows Hank's feet running through the dust.

Panel 4 a lasso looping around Hank's foot.

Panel 5 shows Hank YANKED backward so his face pounds the dusty ground.

Panel 6 shows Hank being dragged backward by the rope through the dust— teeth broken, mouth full of blood.

This from Garth Ennis, one panel packed with detail, using crop-in panels before and after to take you in then immediately away. A typical Garth set-up for the subsequent tour of a strange and entertaining group of dysfunctional characters he creates so well.

THE BOYS 26 GARTH ENNIS

PAGE ONE

1.
Close up. Hughie sticks his head round the bathroom door.

Hughie: FELLAS, I'M JUST GOIN' OUT FOR A —

2.
Big as poss. Chaos in the G-Wiz frathouse bathroom. All six are stark naked and laughing their asses off. Randall and Jamal seem to be trying to sit on the toilet at the same time, one behind the other, Randall wearing a WW2 aviator's helmet with goggles down, both wearing DM boots. Blowchowski is taking a piss, arcing a stream of urine across the room and into the tub, where the other three are crammed into a bubble bath together. As much piss splashes them as goes into the tub, but that just adds to the hilarity. Soapy water all over the floor and up the walls, a turd floating behind the toilet, bog roll unfurled all over the place. Hughie shuts up as he sees this further back- not shocked, just knows there's no point in talking to them. Learning to take these guys in his stride.

Blowchow: DUDE...!

Sugar: AAAAAH!!

Weezer: YOU MOTHERFUCKER--!

Rand & Jam: **BLOWCHOWSKIIIII!!!**

3.
Hughie strolls off down the hall, door closed behind him. Civvies, by the way.

Hughie: NEVER MIND...

Door: **DUDE, I'M WIZZIN' ON G-WIZ--!**

On a second comic-script adaptation from the same company, I was told to use the script as the basis for the story, to make it more visual and turn it into a comic strip. They said this as if it was an easy aspect of the job; I was the comic artist after all! That was perhaps an acknowledgement that not everyone can write a comic script. Now, I have no problem collaborating with a writer and making suggestions so we both come up with the story, visuals and words, but to take over a non-sequential script meant that I was changing a synopsis into a comic script. When I said it would be a rewrite – for which I would need a longer deadline and additional money for the extra work – I didn't get the job.

The problem many new comic-strip writers have is that they give too much direction loaded with detail.

"Hang on," I hear you say, "I saw Alan Moore's script for *Watchmen*!"

What you also saw was Dave Gibbons breaking down that mass of extraneous panel detail by colour highlighting the few words that were relevant to what worked in that panel. If you supplied a script like that now it would not be accepted. I worked on a number of Alan's scripts for *2000AD* and all were entertaining and top-quality stories, but they always had too much detail. When you are a newbie artist, as I was, it was daunting to try to determine what to put in the panel, to discover what was relevant from all that detail. Brevity in a comic script is the best discipline to learn for a new comics writer.

Other points are:

Trust the artist.

A writer should only ask the artist to draw what can be seen from one point of view. Two points of view requires two panels.

Do not *tell* the reader what is happening: *show* what is happening – it is a visual medium.

Never overload your word balloons. Keep them to a maximum of 25 words.

Consider the number of characters talking in any one panel. Too many word balloons in a panel can look bad and just confuses a story.

Trust the artist to position the characters in relationship to other elements; you need to consider placement but do not try and write down where every element is placed.

Do not ask for nine panels on every page. (Weeell, I know that *has* been done but it requires a special writer in a special collaboration who can get away with that!) Most action adventure stories average around five panels a page, with a few more or less depending on what is happening in that scene.

Usually it is left up to the artist to design and lay out a page.

Trust the artist.

There are two main ways of supplying a script that you might want to consider. The Marvel way, which involves supplying the story to the artist without it being broken down into pages and panels, just a detailed synopsis with a beginning, middle and end, with story beats. The artist then breaks this down into pages with panels. They decide how to pace and to add detail. The writer then finishes off the dialogue and story once he or she sees the artwork. This gives it a completely different dynamic and can create a smoother visual flow. The other method is a full script with descriptions, panel breakdowns and story directions with dialogue already in place.

I have been fortunate in working with the best writers, and not having to worry about story or pacing. This is the freedom good writers give you: your job is to visualise the story. They can also make demands that stretch you as an artist. They don't care that you do not like drawing horses or cars – they just write the best story they can and let you worry about the pictures. To be stretched as an artist is good, that is how you learn. If you only like drawing circles and never draw cubes, you don't learn.

A good collaboration is the best thing in the world. It is to be nurtured and cherished. When it works well it is the most fun you can possibly have with your clothes on.

These two scripts from Al Ewing and Michael Carroll. As with the previous two you can see they have a standard approach to page presentation. You supply an editor with this layout and you will make him very happy.

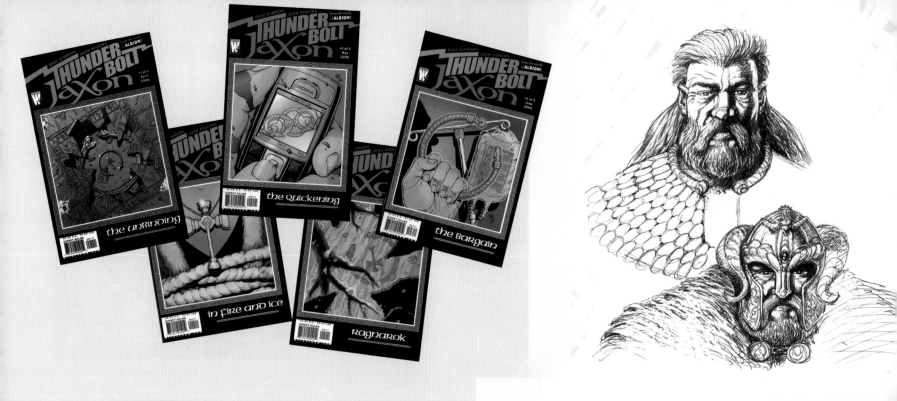

Working with Dave Gibbons on *Thunderbolt Jaxon* at this time I felt was a major step forward in my development as an artist. Dave is a safe pair of storytelling hands, so I had no worries about story pacing and drama. I wanted to try a new methodology in producing the pages of artwork. It was the culmination of every technique and method I had tried in the past. I had also settled on the equipment that was right for me: non-repro blue line to pencil the art, the right felt-tip pens for the line art. Felt-tip pens had finally reached the quality artists had been demanding in the permanence of the ink, on ink flow and the felt tip retaining its shape to the end of its use. Technically I was also spotting the blacks better, which gave a nice support to the ink outline and created a balance in the composition. (See Chapter 12 for technical details.)

One of the biggest problems for new artists is ensuring that the inking is not tentative and too light. The black line needs to be accurate to the pencils but also have the strength in line thickness to outline shapes and to support different elements within the scene. Strong accurate outlines and spotting black is the key.

I was over halfway through the five-issue run on *Thunderbolt Jaxon* when I returned to the UK. Finishing off against deadline became quite fraught, so enter Sally Jane Hurst. Fortunately Sally Jane was an artist and designer and knew her way around the computer. Maybe it is not the best way to teach someone about comic illustration by dropping them right into such a high-pressure deadline, but "sink or swim" springs to mind … and she swam majestically into my life.

Mini-series *Thunderbolt Jaxon*. Writer Dave Gibbons. (Wildstorm) 2005.

Character sketches *Thunderbolt Jaxon*.

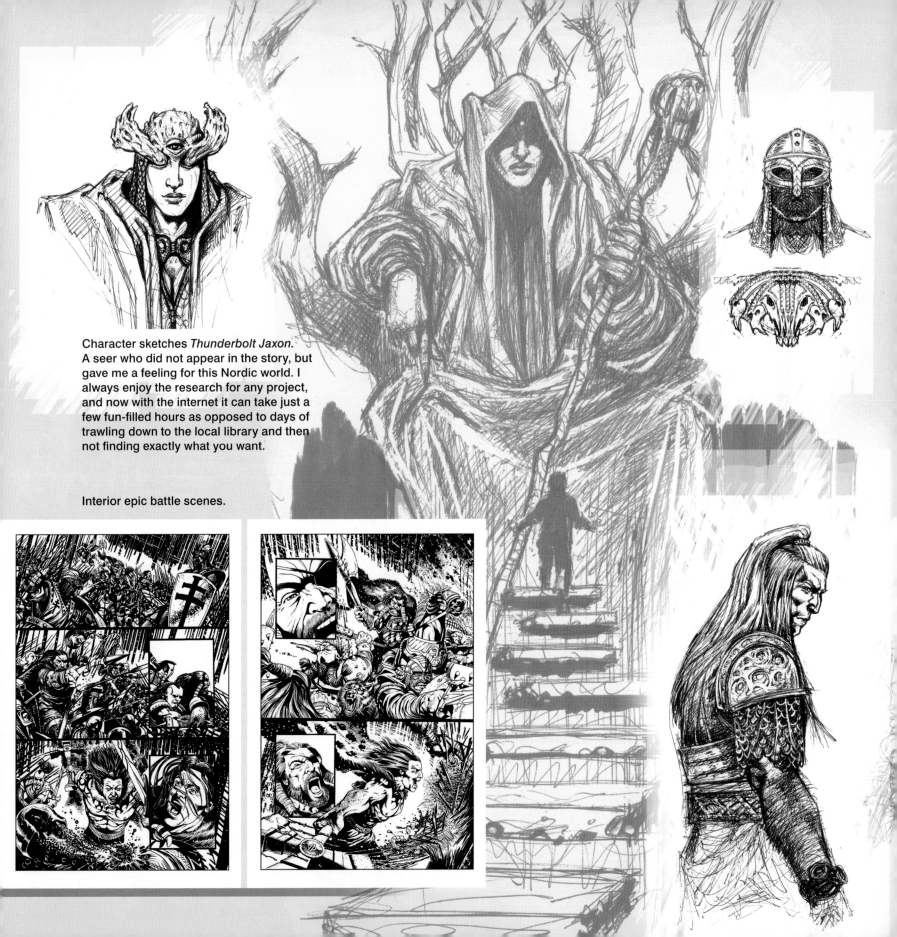

Character sketches *Thunderbolt Jaxon.*
A seer who did not appear in the story, but
gave me a feeling for this Nordic world. I
always enjoy the research for any project,
and now with the internet it can take just a
few fun-filled hours as opposed to days of
trawling down to the local library and then
not finding exactly what you want.

Interior epic battle scenes.

I have moved around a lot since I first left home at 15 to join the army, so I am used to living a hand-to-mouth existence. Working in the tiny box-room studio in the two-up, two-down terrace house in Worthing on the south coast of the UK was a comfortable, if tight, squeeze. Work was coming in thick and fast. One job was a graphic novel prequel to the movie *The Hills Have Eyes* written by Jimmy Palmiotti and Justin Grey with a deadline that was crushing – another baptism of fire for Sally Jane. We had to produce a finished page of pencilled and inked black-line art every day for close on four months. This was for Fox Atomic Comics, a short-lived publishing imprint of the genre film company Fox Atomic. You talk to any freelancer and they all have a story of receiving a job or editorial directive on Friday afternoon, with the "If we can have it back by Monday!" codicil. Even though you know the commissioning editor goes home at a realistic hour each day and takes weekends off! It still gives you a buzz and a sense of pride in your ability to produce finished pages of artwork day after day under such pressure and hit the deadline.

Once it is finished, then you crash. Living on adrenalin for so long is knackering. The flip-side of all that work you have done in such a short time is that you have earned well and can afford to take time off. You might just have earned above the minimum national average wage. Yah!

Loco-Motive Studios, named by Sally Jane with her Locomotive logo design.

The cover to *The Hills Have Eyes* by the incomparable Greg Staples.

The Hills Have Eyes – the mutant cannibal meat-store and butcher's shop.

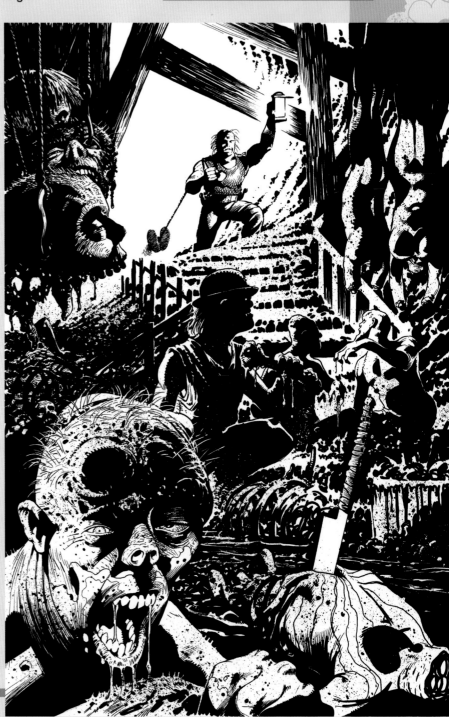

Sally and I being filmed in the Globe Pub for *The Hills Have Eyes* DVD extra. Director Keith Cox. 2009.

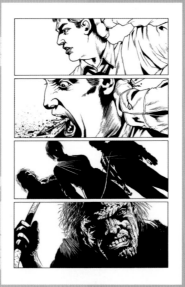

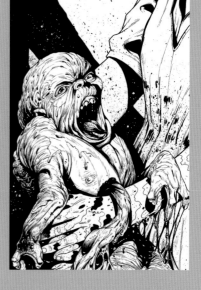

One fun highlight of *The Hills Have Eyes* prequel was that a film team recorded us working on the graphic novel as a bonus feature on the DVD. It was directed by Keith Cox, who was willing to do a guerrilla type of filming. I am not a size-matters type of guy, but studio-wise I couldn't allow us to be filmed in the box-room. It looked like a crack-house squat, without the crack. Fortunately we had a great relationship with the Ransom family who ran the best pub in Worthing twenty yards down the alleyway, The Globe (sadly now no longer a pub since Barry the landlord retired). I asked him if I could set up my studio in the bar when it was closed during the day on the Monday. So it came to be: I was filmed at my drawing board, with the gleaming beer taps and mirrors twinkling behind me, talking about producing the art for the graphic novel and pretending to draw while being served pints of Guinness by Dominic, the son. The best dream studio I could wish for!

We also started the first series of *Greysuit* for *2000AD*, written by Pat Mills. Yes, *that* Pat Mills, co-creator of *2000AD* itself and creator of so many classic characters that it's impossible to know where to start listing them. Well, forget it! This is not about Pat – it's about me!

I wanted to get Sally Jane involved on the colouring side. We hadn't done colour on the previous jobs, but she had proven that she could work under pressure and had taken to comic production without a problem. So we worked hard on getting her not only technically confident on producing colour art files but also in the theory of using colour to tell a story. After we completed the first series, talking to Dave Gibbons about her growth as a colourist, I remember saying, "I had taught her all I knew." He asked, "So what did you do for the rest of the morning?" Cheeky superstar-artist bod that he is!

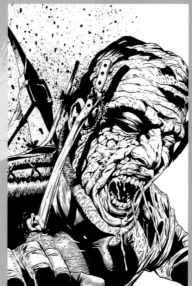

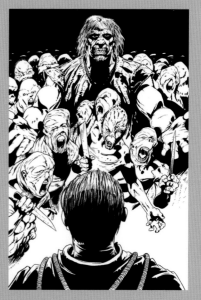

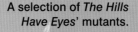

A selection of *The Hills Have Eyes*' mutants.

199

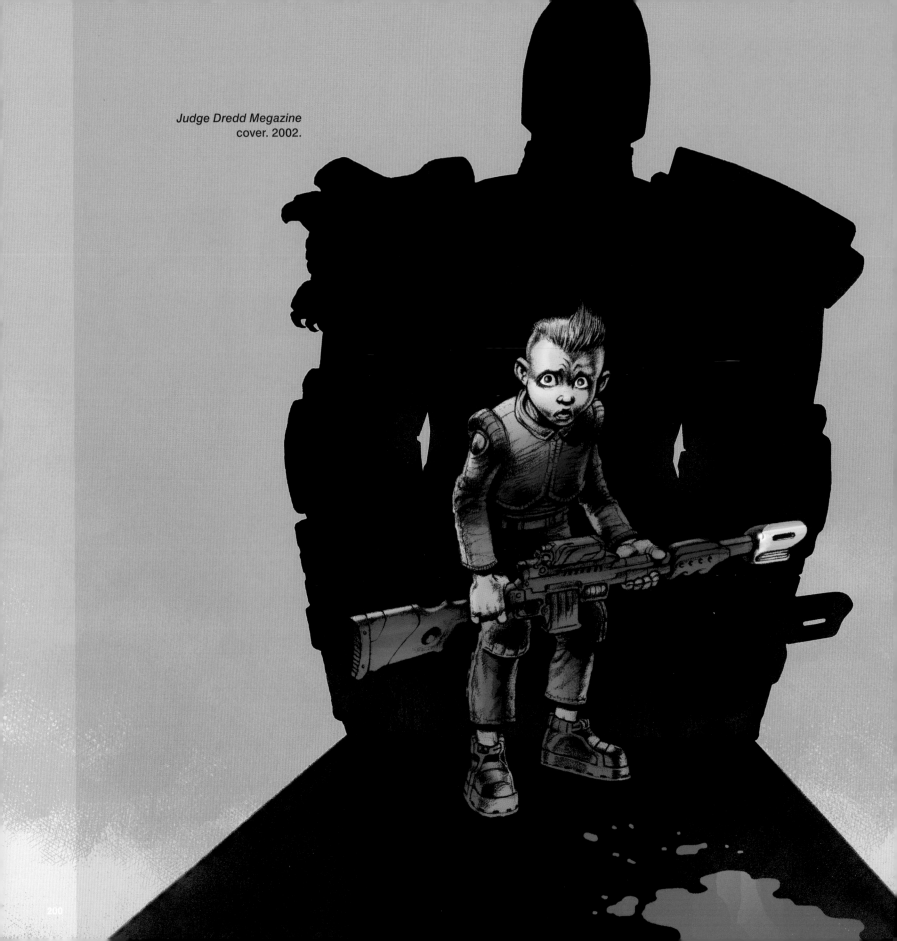

Judge Dredd Megazine
cover. 2002.

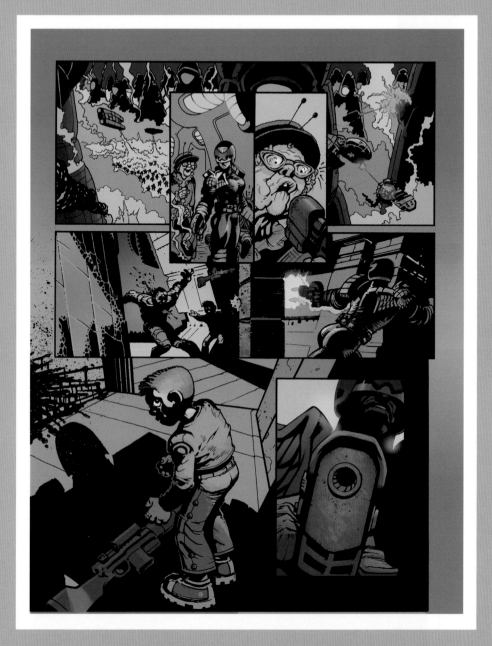

A mini-series "Monkey on my Back" for the *Judge Dredd Megazine*. Garth Ennis script from an idea by me. I love the way Garth can mix humour right next to life and death, all in one short scene. Will the kid pick up the gun?

Cover pencil art – damn, the kid picked it up!

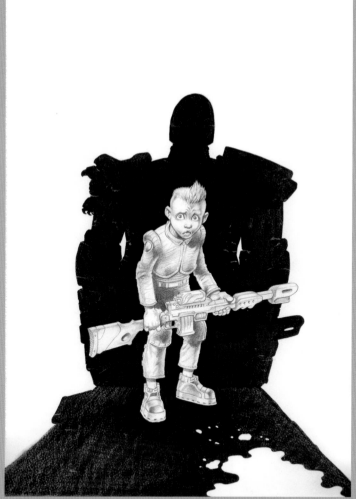

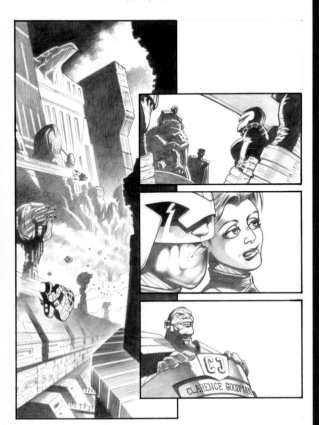

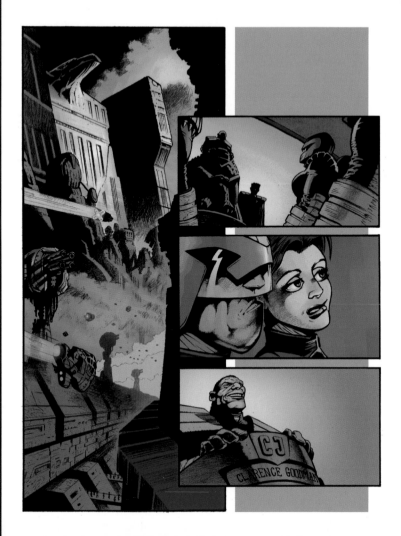

I wanted to try something new with my approach to the art for this series. This is graphite pencil converted to full colour. *2000AD* has always allowed me to try something new.

I scanned the pencils into a CMYK file, copied background on to new layer, clicked on drop menu to multiply. You can then colour away without affecting the graphite tone.

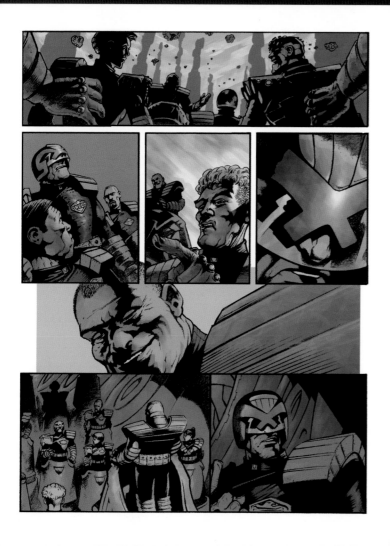

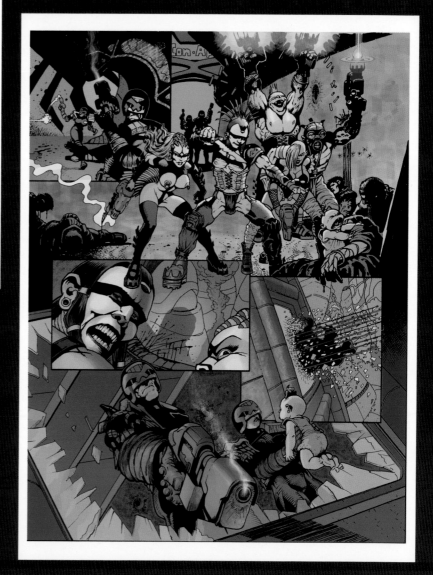

Yes, I am now getting back to my circle metaphor. Around twenty years earlier my full-time comic career had started, working on *Judge Dredd* and *Watchmen*. Learning on the job, searching to find the best way to produce the story, art and colour … Once I finished a story, then came the doubts and second guessing. Did I do a good job? If only I had done that differently! Will I be employed again?

So here I was in 2006 working on *Watchmen* and *Judge Dredd* again, but this time it was with a confidence I did not have the first time around. I was working with Dave on new *Watchmen* illustrations tied to the Zack Synder movie adaptation. Dave was having a ball, his enthusiasm was infectious, and we were paid well. We were being given another bite of the *Watchmen* cherry. Who would have thought the same art team would work together on the same characters twenty years later?

I had not illustrated a Judge Dredd story for a while, but as a fan I had always found time to check what was happening in his universe. The one constant was the high quality of art and story. John Wagner (Dredd's co-creator with Carlos Ezquerra) was still writing the most relevant stories, along with a small select group of new writers who had shown an understanding of how to write a Judge Dredd tale. I was fortunate in working with two in particular, who – along with John Wagner, who is always a pleasure to work with – gave me the opportunity to come all the way around that circle and work on stories that felt like they embodied the classic essence of Dredd: Al Ewing and Michael Carroll, who wrote with humour, pathos and surprise endings – the elements that make up the best type of SF story.

The most interesting part of a journey is not the destination, it is the travelling, the striving and failing, the struggle and the succeeding. The blisters, calluses and tears. My goal all along has been just to tell stories, and for the last thirty years I have told them, one after another, on a constant journey. Each story I have been commissioned to do has been a little way-station, a small destination that I arrived at before looking forward to the next one. Imagine the Appian Way lined with crucified slaves, six thousand bodies all leading to ancient Rome, a gleaming city, the pinnacle of a civilisation built on the blood, sweat and tears of enslaved peoples, a city of perfection. That is the peak I am constantly striving to reach. It will always be in sight but I will never reach it.

Nope … couldn't quite make that last metaphor work, but I came close!

"Have no fear of perfection, you'll never reach it" – Salvador Dali

Pencils for a three-part cover poster for
2000AD. **(Rebellion) 2012**

All of you who enjoy writing and drawing at any level know that it is as addictive as any drug. Making something out of nothing – words on a blank page, black lines on white paper – to bring something into being is an act of creation, to be in a constant state of enthusiasm and anticipation waiting to see how it turns out. Once it is complete and finished, I feel deflated, with a sense of "la petite mort" – the little death. This phrase is used to describe that feeling after an orgasm, and also describes the sense of loss you feel when you have finished an all-consuming task, something in which you have invested time, energy and emotional commitment.

The only way to feel better, to get over it, is to start all over again. Just like sex.

To be freelance is to always be an outsider, with no security other than your own ability to produce work within a budget and deadline that is imposed on you by the client. You cannot have a career plan because outside forces dictate where you go as you pinball from client to project to new client.

But it is still the best job in the world!

BEFORE AND AFTER CURSE
PIRATES, ZOMBIES AND DINOSAURS

Getting from A to here.

Watchmen has featured large in my career, and for a number of critics DC has not been the right company to have control of the IP. The current debate about using any *Watchmen* characters in a broader DCU context seems simple and straightforward. Don't! It is as near a perfectly contained graphic novel as it is possible to be. It has a beginning, middle and a satisfying end with perfectly designed pictures (with added emotionally placed colours).

For a long time it was left as just a classic graphic novel and reprinted every year (remember the twelve-month rule?), selling a few extra thousand copies, a comfortable perennial earner. It sold approximately five to ten thousand issues a year, say 200,000 copies over twenty-five years. Then came the movie and within a year it sold over one million copies, and became the biggest-selling graphic novel of all time. Once it stopped being just a graphic novel and became a movie – and then a cash cow – the money men got involved. Yes, publishing is a business, but decisions made based on projected balance sheets and not for creative reasons are short-term gains that are never going to please either the fans or the creators.

In 2013 DC produced the *Before Watchmen* series to a storm of protest from fans. I was asked to be involved and I accepted because it had a broad *Watchmen* framework set in place by the original creators and it did not deviate into a broad DCU. I was involved in an almost peripheral way, with *Curse of the Crimson Corsair*. I could see the reason for doing a pirate story in the context of *Watchmen* in a completist way, but whereas the original pirate story was a reflection of the main story and added emotional emphasis in an almost subliminal and abstract way, there was no overarching story that tied all the *Before* storylines together, other than that they were *Watchmen* characters.

Curse of the Crimson Corsair. **(DC) 2013.**

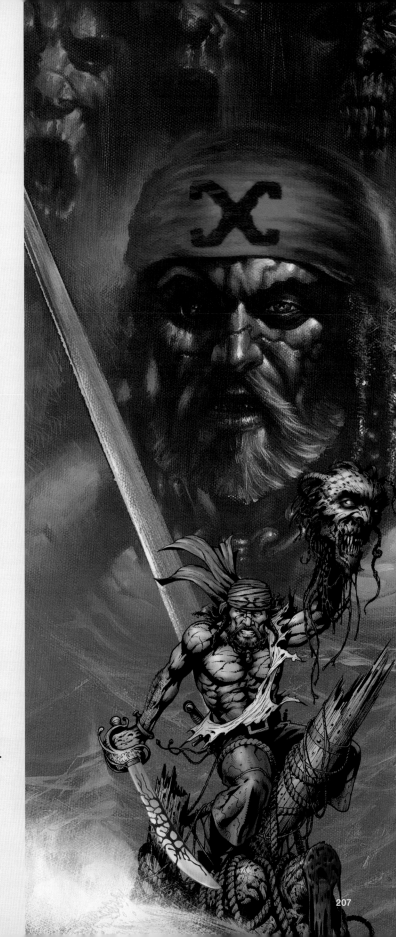

I would have preferred the original title, *Tales of the Black Freighter*, but copyright reasons would not allow that name to be used. I asked Dave if he had any objections to me working on it and he had none. "You are a freelance!" was his acknowledgement. If he had objected I would have backed off. I was very pleased I got the opportunity to do a pirate story (who *doesn't* like pirates?) and to work with Len Wein, co-creator of *Swamp Thing* and *Wolverine*, and one of the original series editors, along with Barbara Kesel. Len had approved my very first colour test page which started off my *Watchmen* association, so I was looking forward to working with him because of that connection – but also because he was a writer who had created a number of the most original comic characters in the "Bronze Age" of comics and as editor helped to bring about the "Modern Age" of comic books with *Watchmen*. Len rang me up and asked what ideas I had and what I would want to draw in the *Curse of the Crimson Corsair* series.

When I had spoken to Dan Didio initially about being involved with *Curse* he indicated that it should be associated with the rest of the *Before Watchmen* stories as a type of fable tale to give a sense of mood to the main stories, which I attempted to do. I also wanted to make it relevant in the context of the original *Watchmen* by presenting the "poisoned chalice" conclusion of a quest. So I had a full back-story to give Len with character sketches. I was having a ball. I knew what I wanted to do and felt strongly that it had to have a *Tales of the Black Freighter* sensibility. This contained a quest, murder, loss, unrequited love and zombies – all done with the brutal depictions that I have a reputation for doing quite well.

Curse was to be a two-page episodic-type of strip with cliff-hanger endings. I was excited by the possibilities after working in the short-story medium for *2000AD*. I was comfortable with how a short story could work, even within this quite bitty context, with two-page episodes spread across all the *Before Watchmen* mini-series.

Part way through, for one reason or another, I felt the direction was going away from what I considered to be the darker content of the original *Tales of the Black Freighter*. So it was decided that I should take over the full scripting chores, starting with the second episode of "The Evil that Men Do…!", with great support from series editors Mark Chiarello and Camilla Zhang. I did enjoy the discussions with Camilla on my choice of certain words as I tried to give an authentic voice to the characters from that period. Our "*Poonnany*" conversation is one that springs readily to mind.

I had enjoyed Len's writing of seventeenth-century formal English, which he had used in the dialogue and voiceover panels, and I wanted to retain that feeling. Michael Carroll was the right person to talk to for that type of literary approach and the written-form sensiblities I was trying to create: his knowledge of writing is second to none.

I also wanted to add a sense of disquiet and alienness for when the character of Gordon McClachlan entered the new world Mayan civilisation in South America. Years ago the TV mini-series *Shogun* starred Richard Chamberlain as a seventeenth-century seafarer shipwrecked on the shores of Japan. The first broadcast did not have English subtitles for the Japanese dialogue, which I thought gave an "otherworldly" feel to it and created an underlying sense of dread, as the viewers had no reference for why the shipwrecked European crew were put through such trials and deadly tribulations. That impressed me at the time and I wanted to try to engender that feeling for when our hero has dealings with the Mayan civilisation and their cult of deadly sacrifice by having the Mayans speak in their native tongue with no translation. The pictures and English dialogue would bridge any story beats if necessary. Sam (that's Sam from Turmoil Colour Studios in Luton, again) had worked at one stage as an English/Portuguese translator in Brazil and for further authenticity we brought in Sam's friend Juliano who could speak Tupi Guarani, an indigenous South American language that was close to what might have been spoken at the time of the Conquistadors. Sam translated my English script into Portuguese (Juliano did not speak English), and Juliano then translated it into Tupi Guarani.

Sally Jane and I decided to make the colour palette monochromatic (one base colour) with spots of muted colour. What I had done in the original *Watchmen* with *Tales of the Black Freighter* to differentiate it from the main body of the story was to recreate a "cheap comic print" effect, to point out that it was a comic story within the real-world story. This was particularly effective when we did the *Absolute* edition of *Watchmen*, as we added a Photoshop dot-filter on those panels. But here the variety of eight different artist styles across the *Before Watchmen* titles dictated an oblique approach. So I decided to treat *Curse of the Crimson Corsair* as "real" and not to approach it as a "fictional" comic publication within the *Before Watchmen* world. Because there was no single unifying script for the *Before Watchmen* series, we did not have the cohesive overview that Dave and Alan had with the original.

I went for the more modern "IMAX" immersive graphic style rather than a strict grid of uniform panel sizes. Panels of different sizes can alter the flow and pacing of a story: large panels catch the reader's eye first and thus can be used to highlight important or dramatic moments. Likewise, smaller panels can help create a sense of intimacy or urgency depending on their position relevant to the panels around them.

Early character sketches. Before we had started on the script, I'd worked up some ideas that did not appear in the final story. Ideas tend to arrive more easily once you can visualise the characters.

I loved playing with all the traditional pirate tropes, skulls, skeletons, zombies and costumes. I did a great amount of research, but unfortunately all the best designs I found in my research had already been plundered by the designers for *Pirates of the Caribbean*.

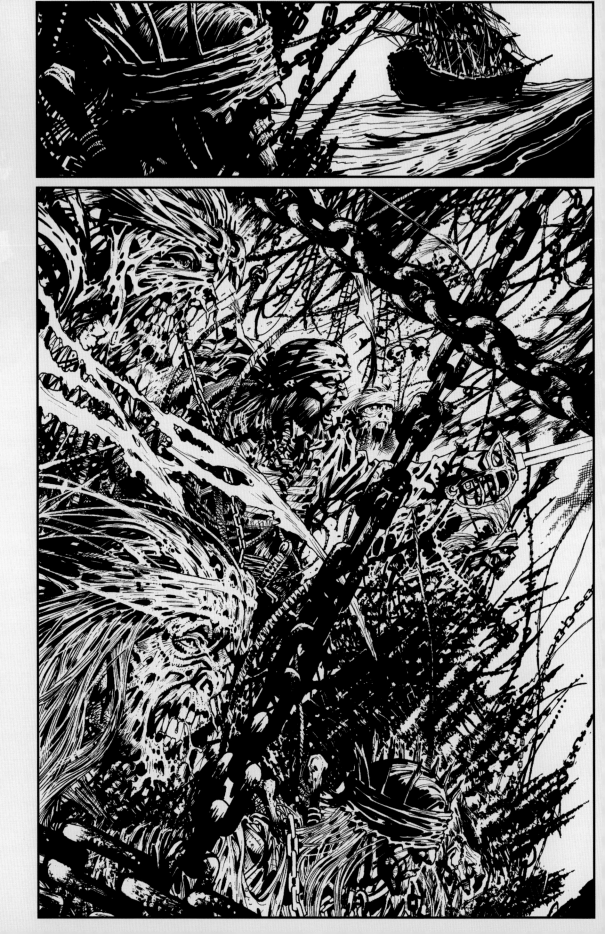

Page #1 of *Curse of the Crimson Corsair*, depicting the dead seamen of the *Flying Dutchman*. I extrapolated from normal dead and decomposing dead to wet, dead and decomposing, with puffy flesh, sloughing-off skin, and flesh nibbled away by sea creatures.

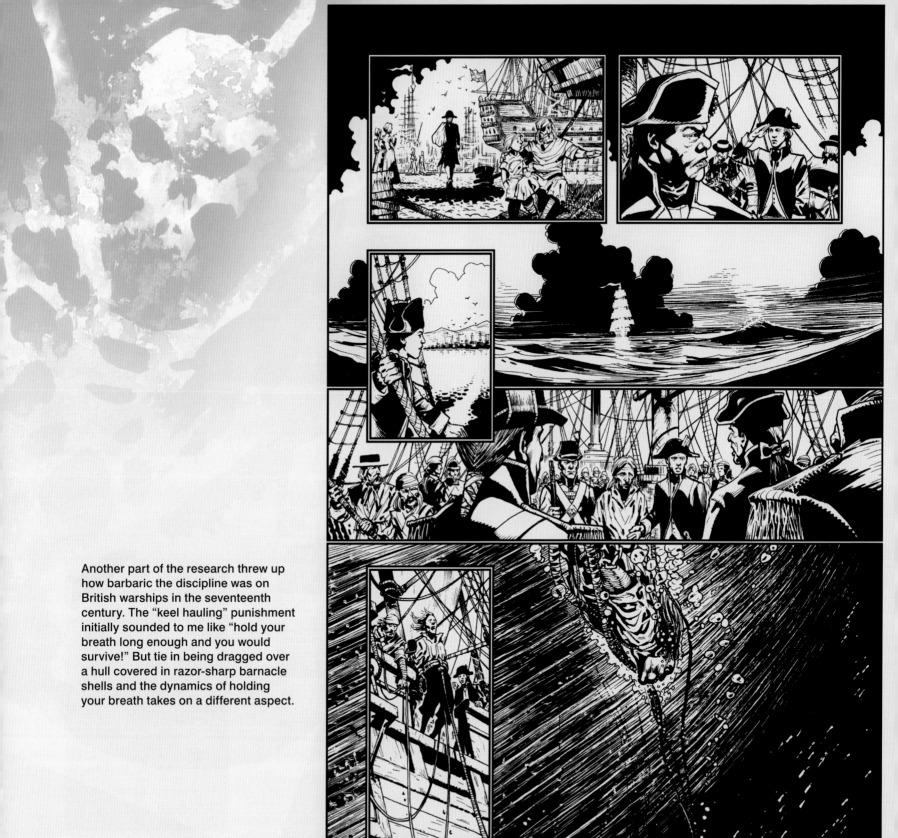

Another part of the research threw up how barbaric the discipline was on British warships in the seventeenth century. The "keel hauling" punishment initially sounded to me like "hold your breath long enough and you would survive!" But tie in being dragged over a hull covered in razor-sharp barnacle shells and the dynamics of holding your breath takes on a different aspect.

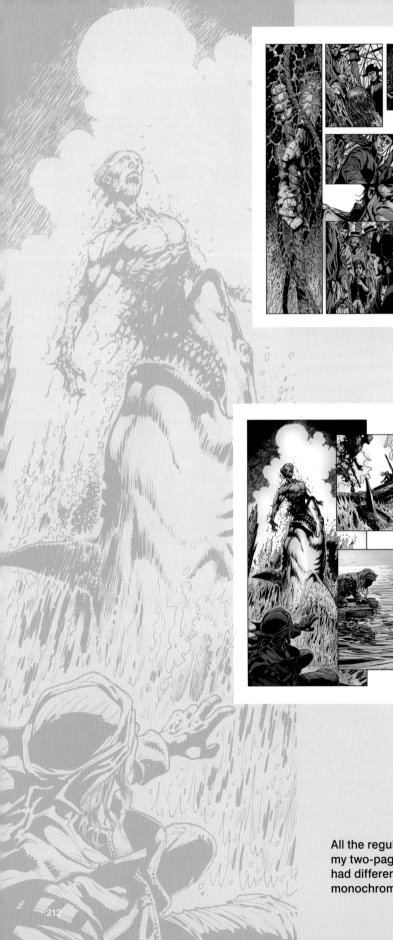

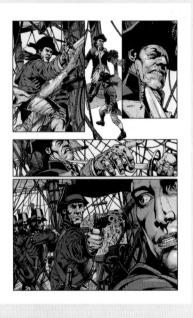

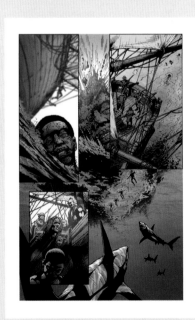

All the regular mini-series of *Before Watchmen* in which my two-page *Curse of the Crimson Corsair* appeared had different colour palettes. That led me to go monochromatic with *Corsair*.

I understood that most people would see *Curse* as superfluous to *Watchmen* even if they thought *Before Watchmen* was not – and the sales figures would suggest that a lot of people thought *Before Watchmen* was a valid prequel series of stories – but the bottom line was that I wanted to make it a modern pirate story first and foremost. Even though it had only two pages per episode, these still had a beginning, middle and a cliff-hanger ending. Thankfully, with modern publishing and comic series being collected at the end of a run I hope people will now see it as a stand-alone adventure story with added depth to the content that nods to the *Watchmen* and *Tales of the Black Freighter* with respect and creativity.

Thankfully I have not had too many quiet periods in my career, and one of the best complaints for a freelancer is to be too busy! 2015 and 2016 have been the busiest years of my career so far. Many quality jobs came in one after the other and, as much as all freelancers *hate* to turn away work, I had to. If that happens it is time to use the networking system. Passing on work to other art hands is as good for you as it is for the client. The client gets a recommended artist, you get a plus mark from the client and your fellow freelancer will reciprocate when it happens the other way around.

On the last three panels from *Curse of the Crimson Corsair* I decided to make a graphic statement and link to the original *Watchmen* printing, going from the smooth modern digital tone colouring to hand-separated dot facsimile.

I also reprised the final panels of *Tales of the Black Freighter* with the protagonist reaching out to the ghost ship.

Stamp collectors have a lot in common with comics fans, including respect for quality packaging and collectable editions.

One job that was a highlight of 2015 – and also probably one of the most prestigious of my career – was to illustrate a set of stamps to commemorate the 350th anniversary of the Great Fire of London. It was an honour to work for the Royal Mail for its reputation of excellence and world-renowned imprint, and to be part of such a traditional printed form of illustration as stamps: one of those functional forms of art that gets such a high profile that any association with it gives added cachet to the art and artist. That commission, along with *Jacked* – a DC Vertigo mini-series written by Eric Kripke (creator of the TV shows *Supernatural*, *Revolution* etc.) – kept me completely busy all through 2015, along with the work need to to facilitate the republication of *World Without End* and *Pride & Joy*; both collected editions were published in late 2016. If I could have got *Razorjack* into the mix it would have been just a perfect period in my career.

To be freelance and still to be working after thirty years in my dream job is something I celebrate every day and with each new job. However, to have such longevity is a double-edged sword: you have a proven track record and commissioning editors know the level of professionalism you bring to a job and trust you to deliver quality work every time; but you can also be taken for granted and sometimes the editor is looking for the "hot new talent", which automatically precludes you. This is completely understandable as there is always a new generation of comic artists coming on behind. When you see a job that you know you would have brought something extra to, and see it not reaching a higher standard than it got … that can be frustrating. But then sometimes it *does* reach that standard … and that is even more galling!

Initial roughs.

Finished pencils. It took a number of briefs before we finalised the shape of the panels. It was an ongoing collaboration all the way to the end with *the chase* design consultants and Royal Mail.

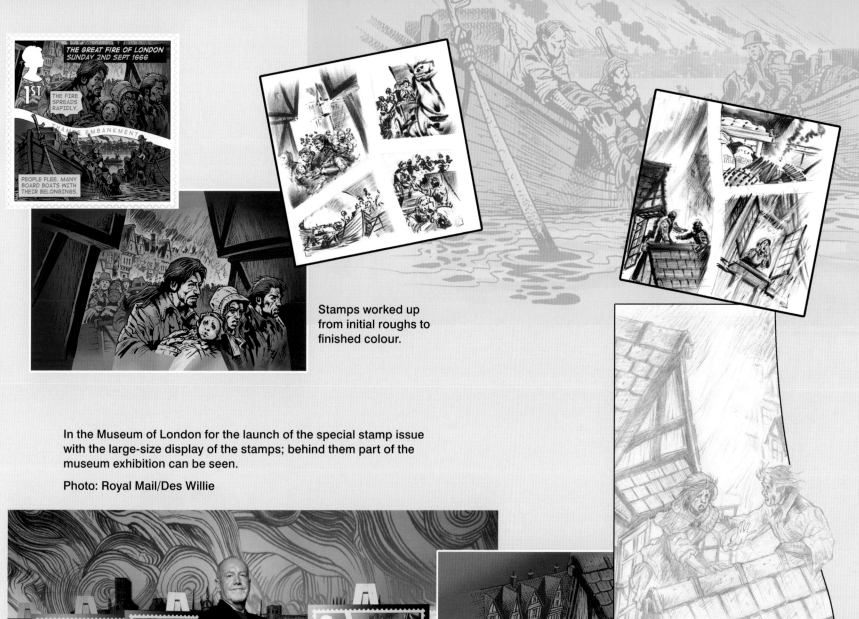

Stamps worked up from initial roughs to finished colour.

In the Museum of London for the launch of the special stamp issue with the large-size display of the stamps; behind them part of the museum exhibition can be seen.

Photo: Royal Mail/Des Willie

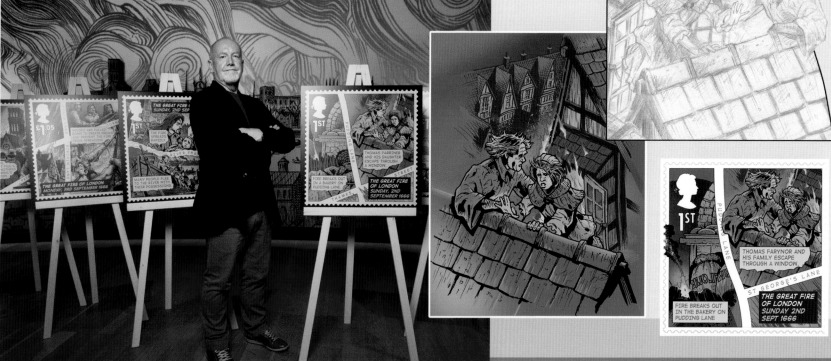

Only joking! To see any new work that impresses you as an artist always gives you an extra incentive to continue to improve and remain relevant to the modern marketplace – and *not* to be taken for granted.

One of the enjoyable aspects of longevity is that you get the opportunity to work with talented newcomers who read your work when they were young fans. This was the case with Eric Kripke. He read my mid-1990s run on *Hellblazer* while he was a student, citing *Son of Man* – written by Garth Ennis and illustrated by yours truly – as his favourite comic story. When he was asked at Vertigo which artist he would like to work with on *Jacked* he asked for me, which is a fine compliment from a fine creator and writer. I have banged on about how lucky I felt doing the "best job in the world", and it got even better with those commissions.

But if you have your best job in the world, then you too are lucky, whether you are an accountant or a zoologist (see what I did there? A to Z!) My accountant Les thinks he has the best job in the world: he loves numbers and making them all add up and meet in the right place. He might live in a baronial home on his own private estate and be a millionaire, but he still loves his job! He is also a man of impeccable taste and discernment, since he owns more of my original artwork than any other single collector.

One more tip for you, as I come towards the end of this book, is to get a good accountant very early on in your career. Les and I started around the same time, and in the early years when I could not afford to pay him he would pick a piece of my original art to cover the bill. I think I got the best out of that deal. He has kept me on the right side of profitability and kept the tax man away from my door for all these years. He has always been my cheering section, and given me the right encouragement, usually at the end of every tax year when he says, "You should be earning so much more than this!"

Covers for the mini-series *Jacked* by the art team of Glenn Fabry and Ryan Brown. (DC Vertigo)

AMPED

John Higgins

First character sketches of Josh, the "hero" of the story.

Always hit your deadlines, use sun-block and pay your taxes. Sounds simple?

When I lived in the USA I had a particularly good year and was happy (sic) to pay the IRS what they were owed, which I did at the end of that year. I then moved back to the UK, closed my US tax account, and opened my UK tax account all over again. All clear, legal and above board. A couple of years later, completely out of the blue, I started to get US tax demands, which was a bit of a shock. Worse than that, they were asking me to pay more in tax than I had earned gross for the whole year in question, which, as far as I was concerned, I had already paid in full. I thought it was a mistake as I had all the right paperwork, which I sent off with a letter explaining as much to the issuing officer and assumed it would all be sorted. Every year for a further eight years I got more demands. I can tell you which part of America has a tax office and what type of tax it deals with, as I was passed on from office to office. The frustration of trying to deal with a faceless bureaucracy as I tried to clear it up, writing and ringing and trying to talk to a real human being, was maddening. Living in the UK made everything ten times more complicated. I felt like I was in a Franz Kafka novel.

I have never been among the first passengers off an international flight in my entire life until I arrived for a San Diego Comic Convention one year. I was the second guy in the queue behind Matt Smith, British star of the Doctor Who TV show. "Brilliant!" I

thought, as people started to queue behind me, feeling smug and happy to be so fast in disembarking, until the customs officer put my name into the computer. One of the colours you don't want to see flashing over your name on an official computer is red! The customs officer had never seen a message from the IRS before, and took me to the back of the hall as passenger after passenger joined the customs queue I had just been pulled out of. I am not sure what bothered me more, seeing my place at the front disappearing or thinking I would be spending time in jail for tax evasion. Luckily this was on the west coast where customs are a bit more relaxed and helpful; they sorted it out for this particular visit and allowed me through to SDCC. That did focus my mind though, and I finally managed to talk to a human being soon after about the tax and got it all cleared up.

What had happened was that the accounts department of the company I was working for had an electronic tax-filing system and someone had inadvertently double-clicked the amount I earned that year when they had sent off my yearly income to the IRS. So it appeared that I had earned twice as much that good year as I really had. As I had received a normal paper return from the company with the correct figure on it, the two different totals were never compared for eight years until I finally talked to a tax officer in person who listened, checked and finally got it sorted out. But for those eight years, at the end of every tax year – without fail – I received a US IRS tax demand with threats of fines, seizure of goods and imprisonment. The first demand had been for $55,000, going up every year with interest until the final demand reached $143,906.43!

Working with feedback from editors Shelly Bond, Ellie Pyle and Eric Kripke, we softened Josh and made him an even less likely "hero"!

A selection of different faces for Josh.

217

This set of pages I did as portfolio examples, 1985. Subsequent to which I became busy for the next thirty years, but I always intended to complete it one day.

I was finally given that opportunity by Matt Smith when it appeared in the *2000AD Summer Special* 2015. (Rebellion)

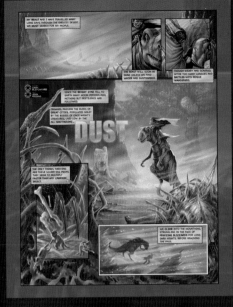

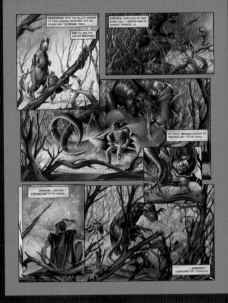

The first two pages were completed in 1985.

Writer Gary Blatchford went on to become an award-winning animator, but always dreamed of appearing in the pages of *2000AD* and finally got his wish.

This was as far as I got on the last page in 1985, alongside the finally finished page.

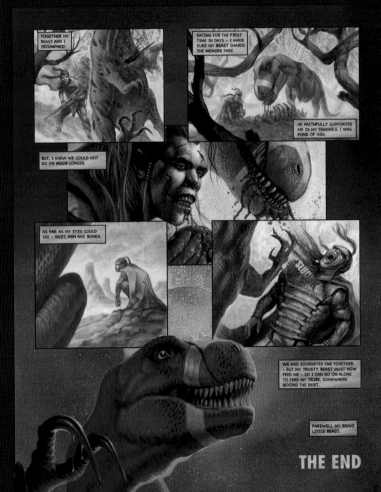

THE END

A selection of pages from *Dark Satanic Mills*, an original graphic novel for Walker Books, written by Marcus and Julian Sedgwick. Storyboards by me with finished art by Marc Olivent. It was shortlisted for the Kate Greenaway CILIP Award in 2014.

My storyboard to Marc's finished pages.

Throughout this book what I have tried to do – along with blowing my own trumpet and showing a small selection of the work I have produced over the years – is tell you how you can become a comic artist and writer. You might take a slightly different path to mine, but all it comes down to is how to tell stories, draw pictures, find ideas, entertain your audience and find clients. This was all mixed into the plot of my comic art life-story and probably just like an Alan Moore script had too much detail.

My biggest learning curve came once I knew what rules to break and what methods and materials did not suit me. That is the moment you become your own artist or writer. Look at all I have said and take what you need to develop and leave the rest.

To produce a comic strip is the sharp end of writing and art. It may not be recognised as such by the wider literary and arts world, but you have to be more than just good in comics: you cannot fudge and *pretend* you can do it. You have to be able to write a story and you need to be able to draw one … it's as

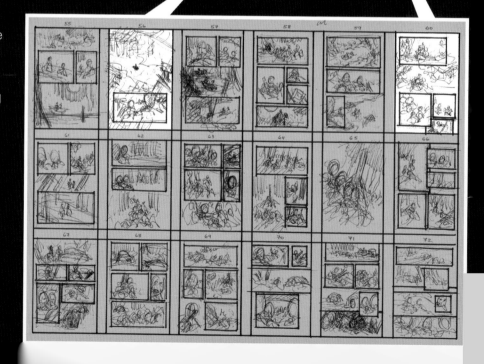

Yet another portfolio set of comic pages painted in 1983. Again Matt Smith came to the publishing rescue and it appeared as a *Future Shock* in *2000AD* prog 1943. Dialogue and finished story by Sally Jane Hurst. (Rebellion) 2015.

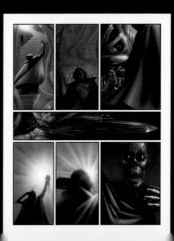

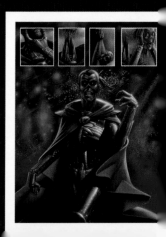

EVERYTHING YOU WANTED TO KNOW
BUT WERE AFRAID TO ASK

It's often said that the oldest profession is prostitution. I disagree – I believe the earliest formal occupation would be storyteller. I suppose we could debate the "profession" description, but look at how storytelling developed in so many forms in its early days. In the Middle Ages, troubadours and trobairitz were professional storytellers who held a certain protected position as they travelled between warring city-states. They conveyed news and information in a violent and volatile world, surviving on quick wits and the telling of stories. But long before that there would have been tribal elders around a campfire, reciting the history of the tribe, or religious leaders telling allegories and parables. And of course there were paintings and carvings in caves that showed aspects of prehistoric life, the hunting of long-extinct animals, or battles with beasts (and imaginary creatures). These images go back tens of thousands of years.

No matter what, storytelling is in our DNA. Every one of us tells stories. When asked, "What did you do at school today?" or "How did work go?" we will tell the story of our day. We all like to entertain or be entertained. Using words or pictures to create an "elsewhere" is one of the most fundamental of all human talents, no matter where the story begins or ends.

When Eric Kripke took the book *Jacked* (or *Amped* as it was then called) to Vertigo in 2015 and asked for me, freelance life became sweet. The whole job was a fun collaboration all the way to the end. This was a project that fitted me like an artistic glove. I love drawing strong beautiful people … and monsters. But for the first time, I could use myself as the model with few changes or sucked-in stomach! Eric's description of the hero, Josh, did seem very familiar … particularly when I looked in the mirror!

Our first good look at our hero – Josh Jaffe, 40. From the chest up. He's shirtless – he's got chest hair, shoulder hair, presumably back hair. Josh is whiskered. Haggard. Dark circles under his eyes. 15 pounds overweight, with a Cinnabon gut. Thinning hair. He looks like shit.

The largest panel on the page. A full body shot of Josh. He leans back against his bathroom counter (cluttered with his wife's beauty supplies). He is facing us. Lethargically brushing his teeth. A little toothpaste spittle drips from his mouth. He's wearing nothing but an unflattering pair of tighty-whiteys and a knee brace. We get a better look at his hairy legs, arms, shoulders. His gut, his sunken chest. His expression is numb.

I may not have "tighty-whiteys and knee brace", or be 40, but…!

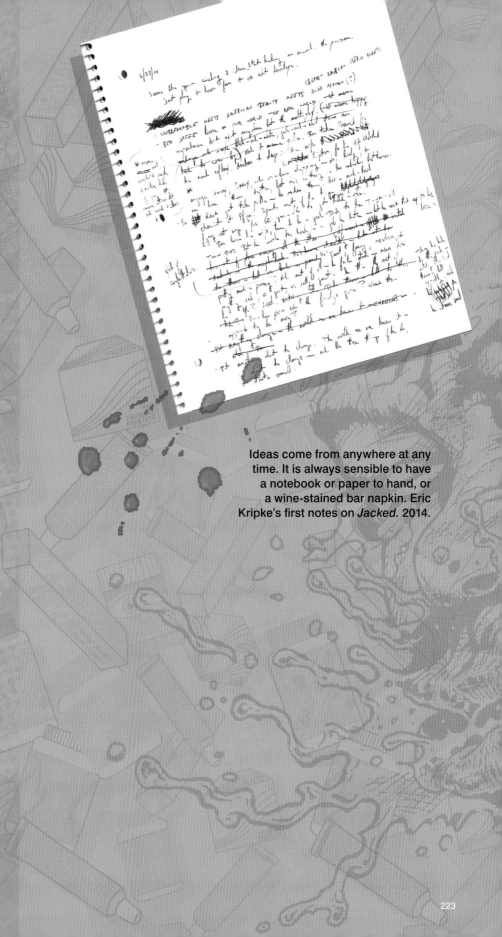

Ideas come from anywhere at any time. It is always sensible to have a notebook or paper to hand, or a wine-stained bar napkin. Eric Kripke's first notes on *Jacked*. 2014.

223

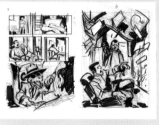
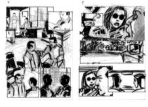
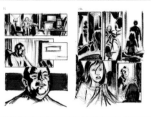
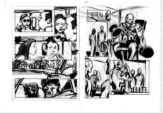
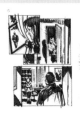
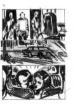

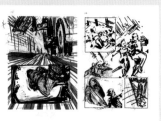

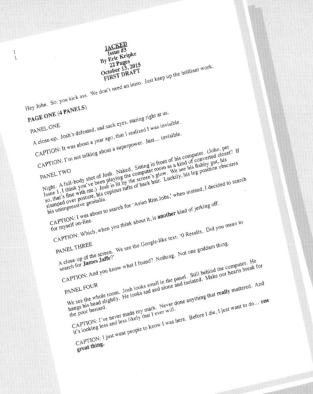

Jacked – script, thumbnails and
finished breakdowns.

JACKED
Issue #3
By Eric Kripke
22 Pages
October 29, 2015
SECOND DRAFT

Hey John. So: you kick ass. We don't need an intro. Just keep up the brilliant work.

PAGE ONE (4 PANELS)

PANEL ONE

A close-up. Josh's defeated, sad sack eyes, staring right at us.

CAPTION: It was about a year ago, that I realized I was in...

CAPTION: I don't mean a superpower. I...

PANEL TWO

Night. A full-body shot of Josh. Naked. Sit... computer room as a kind of converted closet? ... his slumped over posture, his copious tufts of b...

CAPTION: I was about to search for 'Sloppy Ri...

CAPTION: Which, when you think about it, is and...

PANEL THREE

A close-up of the screen. We see the Google-like text...

CAPTION: And you know what I found? Nothing. No...

PANEL FOUR

We see the whole room. Josh looks small in the panel. Stil... alone and isolated. Make our hearts break for the poor basta...

CAPTION: I've never made my mark. Never done anything t... will.

CAPTION: I just want people to know I was here. Before I die,...

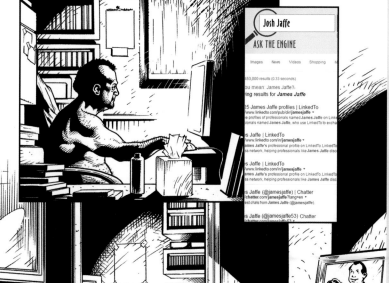

Finished page 1, issue 3, from script to rough to my finished inks. This page digital colour by Chris Sotomyor. (DC Vertigo) 2015.

PANEL ONE

PAGE TWO (3 PANELS)

This panel dominates the page. It's Damon. Last issue, Josh kicked his ass right into a coma. And now, Damon's still in his hospital bed, still in a coma, two days later. His face is a swollen, bruised, broken mess. A tube is shoved half-way down his throat. There's more tubes snaking from his body—under his nose, I.V. out of his arm, catheter. And equipment everywhere. Make us wince with the graphic, gnarly truth of what a smashed face and body looks li...

SFX (from the heart monitor): BEEP! BEEP! BEEP!

CAPTION: This isn't what I had in mind.

RAY (from off-panel): Fell down the stairs, m...

PANEL TWO

Over the prostrate, comatose, smashed-up Da... Gothic tattoo peeking up onto his neck. Still c...

SFX: BEEP! BEEP! BEEP!

RAY: Fell down the stairs, my ass.

PANEL THREE

An extreme close-up of Ray. We can see the murder...

SFX: BEEP! BEEP! BEEP!

RAY: Fell. Down. The. Stairs. My. Ass.

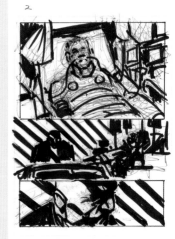

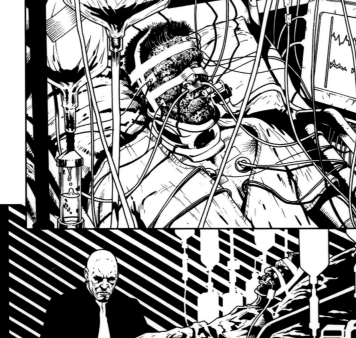

Finished page 2, issue 3, from script to rough to my finished inks. This page digital colour by Chris Sotomyor. (DC Vertigo) 2015.

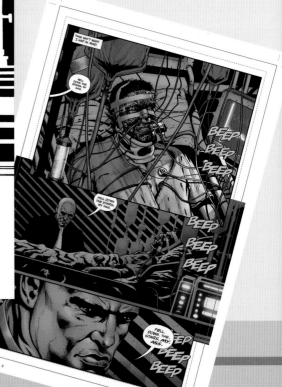

226

All forms break down into quantifiable measurements – even cute animal strips need recognisable animal forms. And monsters? They all have to be believable. Stick to your own world logic and be consistent or your readers will become confused and you will lose them. Inconsistency breaks the bubble of believability.

Children love to be scared when safe in their own bed with Mum or Dad telling them a story. A controlled environment kept safe by the encompassing arms of parents. True story: a friend was taking her seven-year-old to bed up the long, dark, creaking wooden staircase (no, this wasn't *Gormenghast*: they had just moved to an old house). The kid asked, "Mummy, are there monsters upstairs in this house?"

"No, of course not. And Mummy and Daddy are just downstairs; you will be snug in your new bed."

Up another creaking wooden step.

"Well, if there *were* monsters I would not be afraid."

"Oh, that's very good Caspar. Why not?"

"I would just say to myself, 'Blend in Caspar, blend in!'"

The best sort of survival instinct, that kid!

Children do say the most wonderful things, and can believe wholeheartedly in a story told in the simplest way, through the spoken word or in books with sophisticated pictures. It makes no difference to them. A good story is a good story. They have the power of limitless imagination – nothing has yet bound their belief in the unbelievable.

I start all my art with non-repro blue pencil.

I use a build-up of lines to find the face; bit by bit clarity forms, on to the finished pencils, then to finished inks.

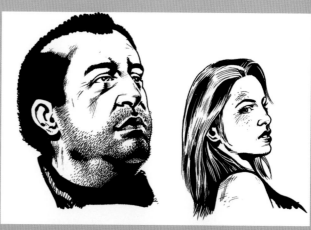

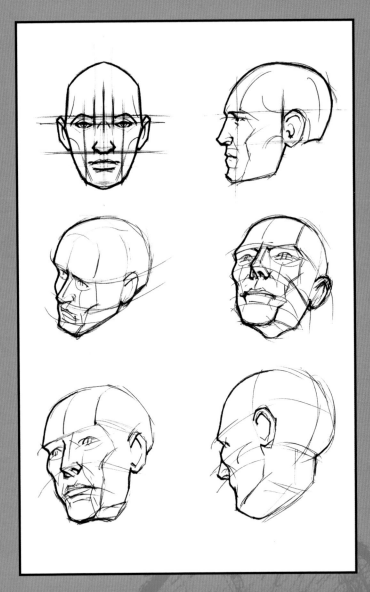

Every part of the body can be measured and quantified. Getting the right proportions on the face creates a recognisable character.

You can quarter the skull quite equally, and bear in mind that the topography of the skull will affect the surface detail of the face.

Forensic facial reconstruction has been proven to be pretty accurate in giving a recognisable face of an individual from a bare skull. There are quantifiable measurements that give thickness of flesh, fat and skin.

Certain aspects cannot be gauged such as racial type, weight, illness, accidental damage to soft tissue etc. That is when the art comes in to recreate an individual's facial physiognomy.

On most faces you will see the top and bottom of the ears will give a line across the brow, below that line, the eyes and the top of the nose. Bottom of the nose = bottom of the ears.

Lines dropping from the eyes' pupils will edge the mouth.

With any rotation of the head, you bear all these measurements in mind.

Any of the universal rules I have espoused … You should study them, understand them, apply them. And then break them when necessary, but there are a few you break at your artistic peril. Accurate figure drawing in particular is a prerequisite for most comic strip work. You need to know the human figure in simple measurements. The head is used to proportion all bodies. Proportions are probably the only rules you need to stick to and to get right. All your characters' shapes and sizes will be dictated by proportions, and this can be used to create a recognisable type of character. An old crone bent double by age: fewer heads. A powerfully built superhero: more heads.

Male and female forms are measured in heads. The average body will be seven-and-a-half heads.

The skeleton will affect how the body moves. Bones are just a set of sticks and levers that can only bend at certain points.

Muscles and soft tissue overlay the hard-core bones giving dimension, shape and character.

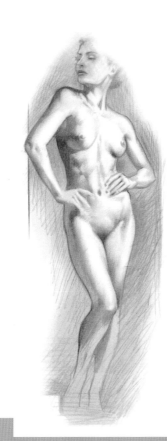

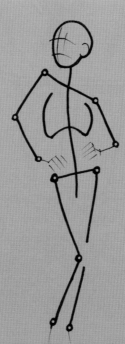

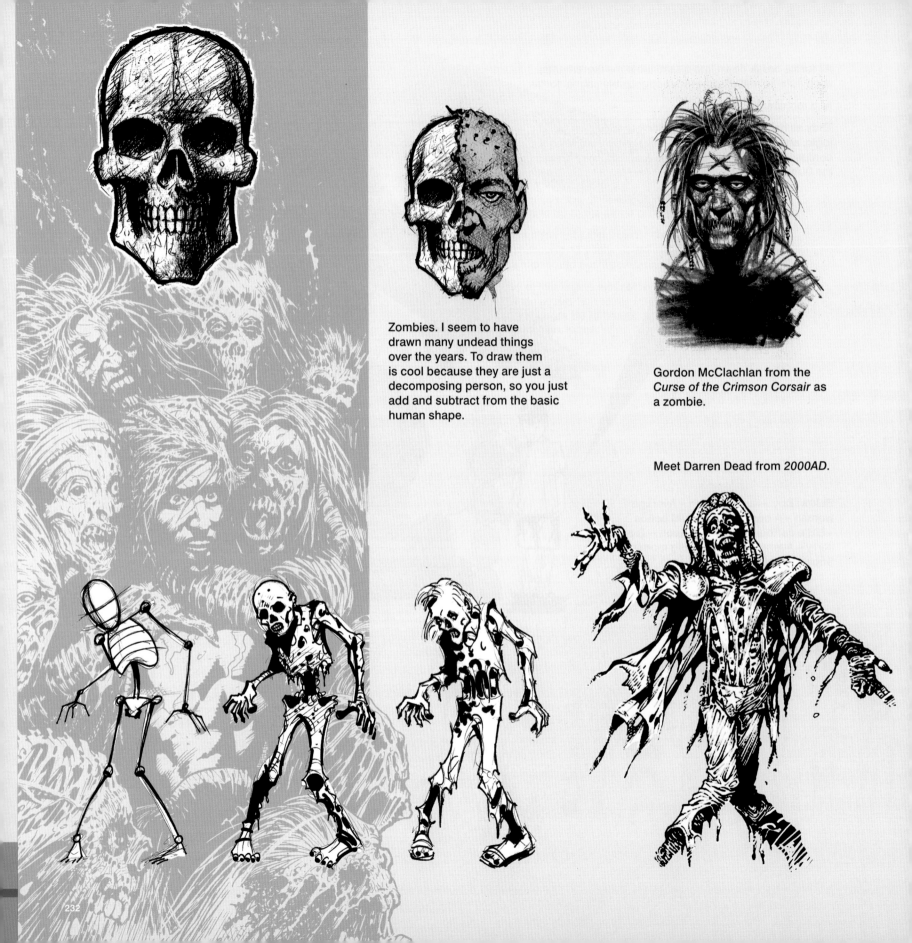

Zombies. I seem to have drawn many undead things over the years. To draw them is cool because they are just a decomposing person, so you just add and subtract from the basic human shape.

Gordon McClachlan from the *Curse of the Crimson Corsair* as a zombie.

Meet Darren Dead from *2000AD*.

Books and comics are a place you can go, to meet monsters on your travels in those worlds and then close the book and be safe and secure in your own home. We as imaginative people need monsters, Carl Jung believed they were essential to our emotional development, representing the 'otherness' with in our selves, 'a bright day world and a dark night world peopled with monsters and fabulous creatures.'

Worlds Without End was greatly satisfying thanks to all the opportunities it gave me to design monsters, along with these biomechanical zombie types. Mixing metal with soft rotting flesh gave great scope to create weird hybrids.

Books and comics are a place you can go to meet monsters on your travels in those imaginary worlds, and then you close the book and are safe and secure in your own home. We as imaginative people need monsters: Carl Jung believed that they were essential to our emotional development, representing the "otherness" within ourselves, "a bright day world and a dark night world peopled with monsters and fabulous creatures".

One critic of my work, when seeing the original paintings of some of my SF and horror art, asked, "Did you do these?"

Proudly I said, "Yes." And waited for the praise and commendations to flow.

"You're sick!"

"Why, thank you," I said, thinking she meant it as a compliment. That was one of the reactions I was trying to elicit with this sort of content, one of the pictures being the exploding head from *The Thing from Another World* cover. That emotion – along with shock, horror and disgust, tinged with respect for a job well done – would mean I had got it right.

"No, you are really sick. There is something wrong with you!"

"Hang on," I said. "This is what I do for a living. People pay me to imagine their worst nightmares!"

I am not sure I changed her mind.

I don't think she was quite my audience, but I think SF and horror is where we can go to face our worst fears. Imaginary other worlds that we can safely dip into in complete control. Yes, we go there to be scared, but also to be entertained and educated.

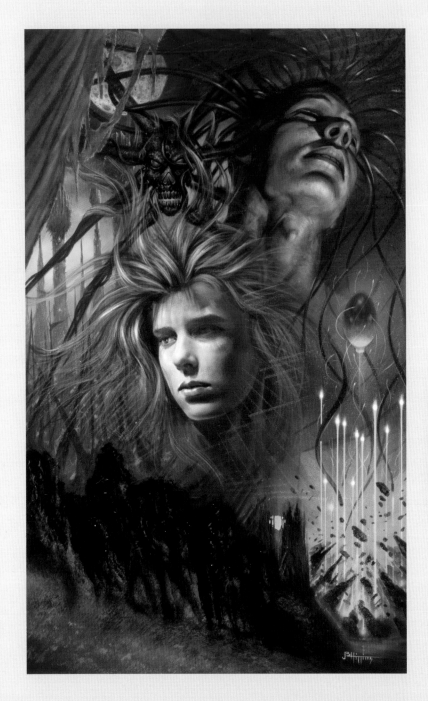

Photo reference and models are not possible when you need to create monsters and zombies, but when you want an attractive face and well-proportioned features then photo reference makes life so much easier.

Model: Clare Welch, at 14 years. Today running a successful furniture studio.

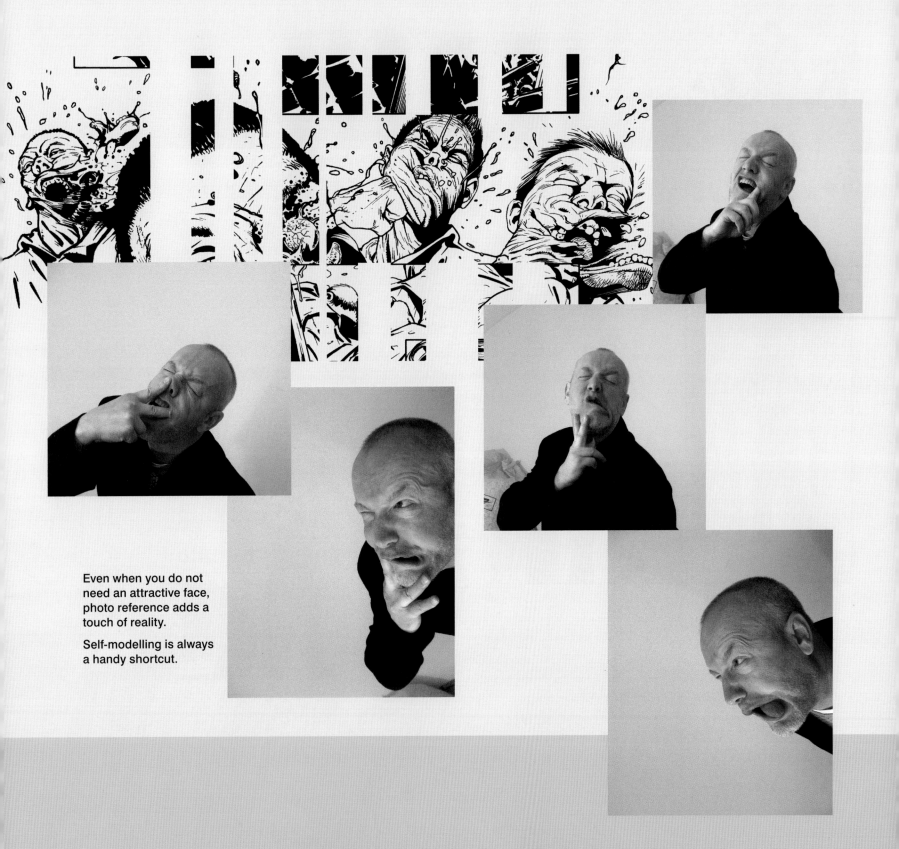

Even when you do not
need an attractive face,
photo reference adds a
touch of reality.

Self-modelling is always
a handy shortcut.

Jacked. From thumbnails to placement in finished inked page. Never be a slave to your reference, add shadows or adjust pose when required.

Model: Annie MacGregor, my gardener.

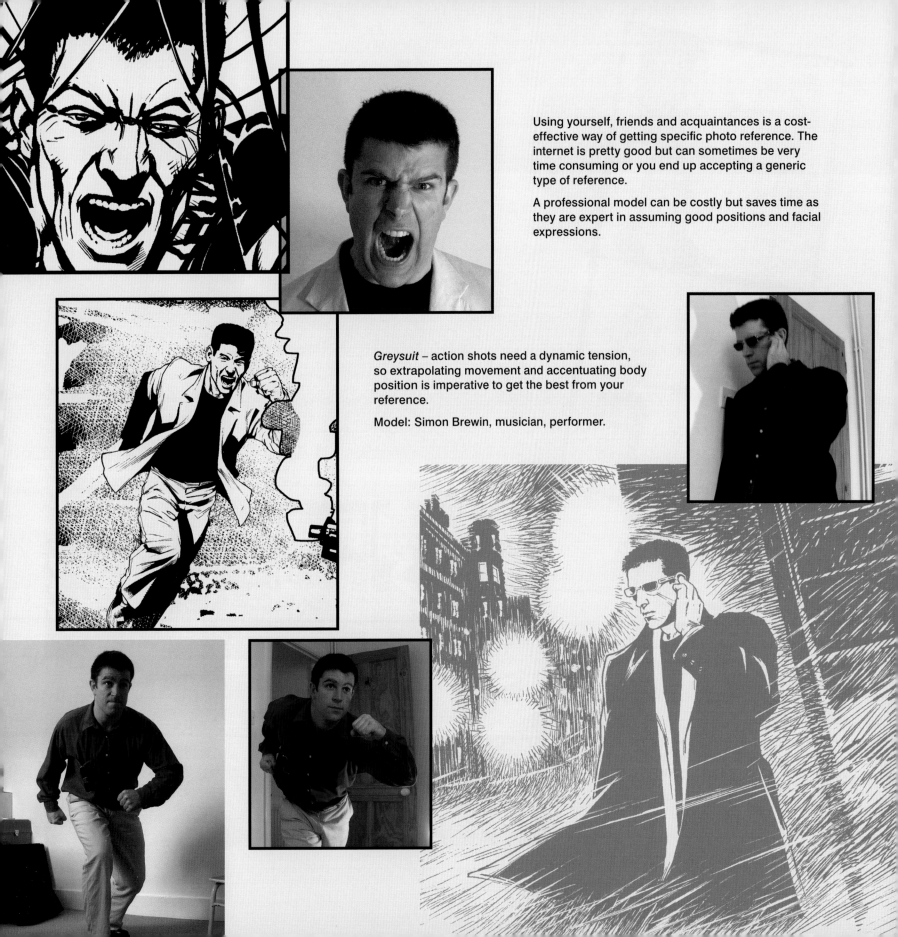

Using yourself, friends and acquaintances is a cost-effective way of getting specific photo reference. The internet is pretty good but can sometimes be very time consuming or you end up accepting a generic type of reference.

A professional model can be costly but saves time as they are expert in assuming good positions and facial expressions.

Greysuit – action shots need a dynamic tension, so extrapolating movement and accentuating body position is imperative to get the best from your reference.

Model: Simon Brewin, musician, performer.

The Biz Niz

TRACY CONSTANCE:

Did her father have Elvis killed?

UNCLE MORT:

Why won't Aunt Emily tell the DHSS he's dead?

CONAUGHT CONSTANCE:

Would you buy a used tactical nuclear weapon from him?

TERRY GILL:

From tea-boy third class to chairman of a multinational company, in one day!

Storytellers have always created alternate worlds through which to impart knowledge, convey specific ideas, manipulate the audience's emotions, or reinforce a particular viewpoint. Sometimes that alternate world is far removed from reality (*Alice's Adventures in Wonderland*, published in 1865, is crammed with political satire that today is barely recognisable), sometimes it's only a step or two away, as seen in countless political cartoons, or in caricatures where a subject's facial features are greatly exaggerated for comedic effect (draw a scary politician with an over-large nose or grossly prominent eyebrows and suddenly she's a monster, or a buffoon, or someone else's puppet, depending on how you want the audience to feel about her). When the audience experiences a seemingly solid and coherent world in which the storyteller's message makes sense, it's much easier for them to accept that message as "true".

The Biz Niz, a regular weekly series I wrote and illustrated in 1982 for *The Street*, a music magazine. You might notice that I did a number of the "no nos" I told you many new comic artists and writers tend to do in their first comic strips.

Too many words in word balloons, bad lettering, terrible spelling and punctuation.

Writer Michael Carroll (my friend, collaborator and editor on this book) once said to me: "Punctuation. You can't even *spell* that, never mind use it, but you can tell a good story." (Editor's note: Yes, I did say that... And today I had to edit this caption because you *still* don't know how to use punctuation! But I shouldn't complain: I'd love to be able to draw as well as you write!)

I did like the characters. There was supernatural leanings, some hard-boiled detective threads. It could be said it was a practice for *Razorjack*.

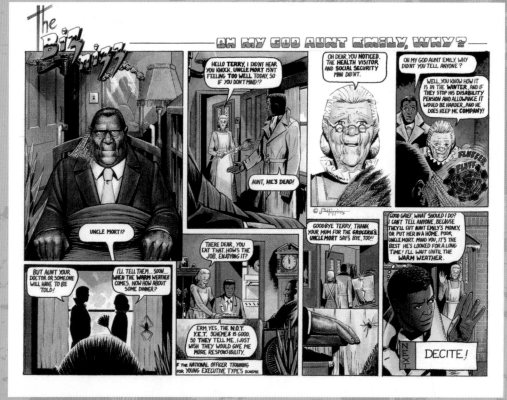

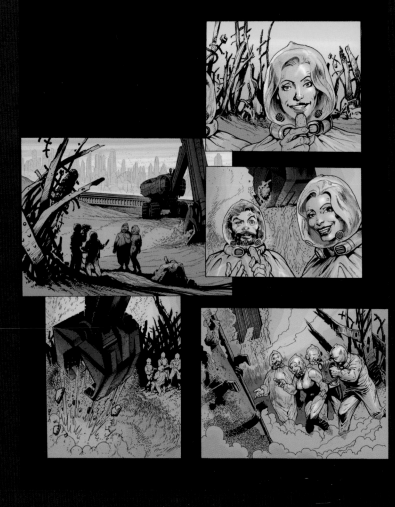

My favourite funny undead person Darren
Dead. Writer Rob Williams. (Rebellion) 2005.

This for me was one of the funniest pages
of a very funny series, with just one word of
dialogue: all Darren said after coming out of a
radioactive coffin after five hundred years was
... "Ta da!" It was the end of a magic trick gone
seriously wrong!

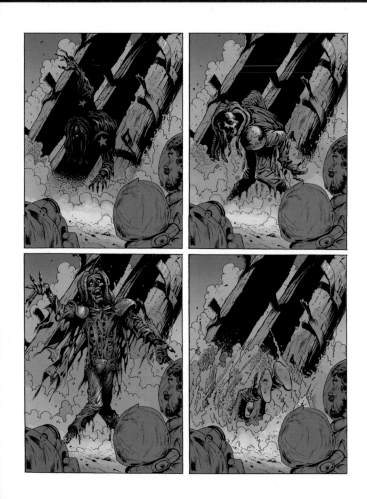

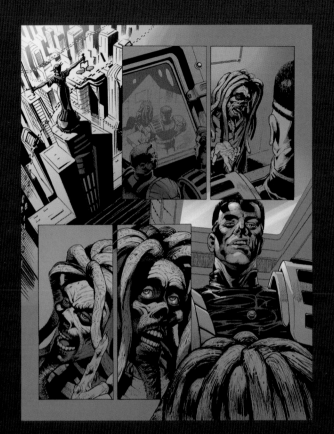

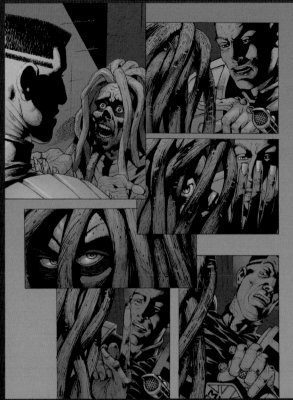

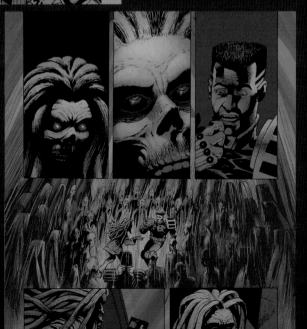

The colour palette was as striking as I could make it. I turned the colour approach on its head as he is a dead thing, rather than the usual sombre palette associated with horror. I wanted vibrant complementary colours as a key to Darren's dark but humorous story.

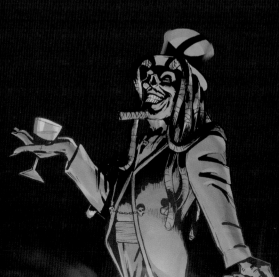

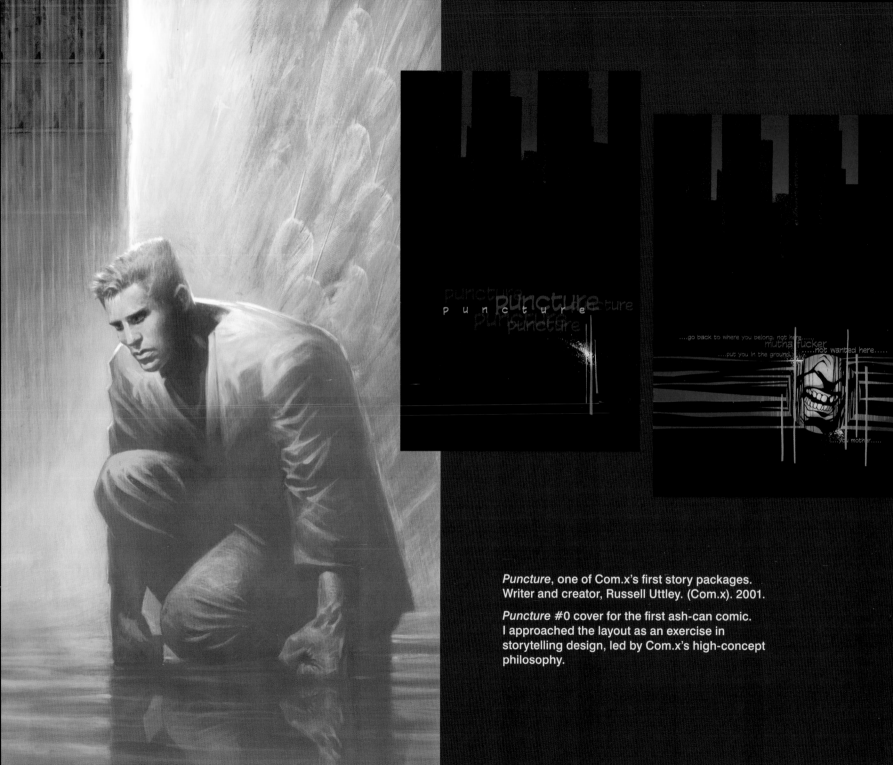

Puncture, one of Com.x's first story packages.
Writer and creator, Russell Uttley. (Com.x). 2001.

Puncture #0 cover for the first ash-can comic.
I approached the layout as an exercise in
storytelling design, led by Com.x's high-concept
philosophy.

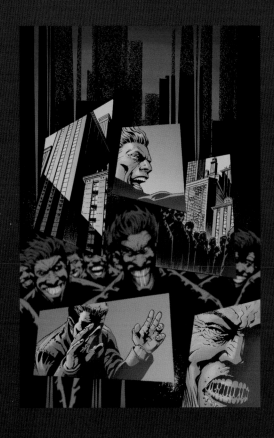

To design a layout across multiple story pages was an adventure in storytelling, but the story flow must always come first. If the design confuses the story then it fails as a comic-strip story.

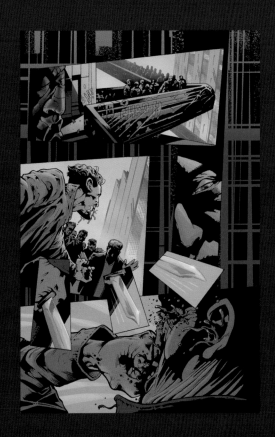

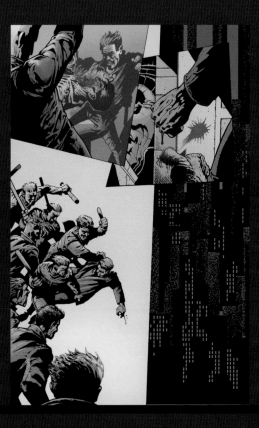

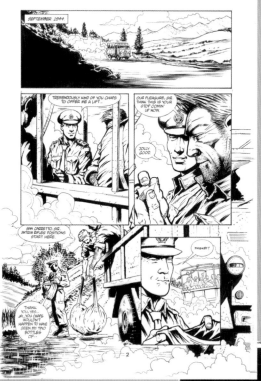

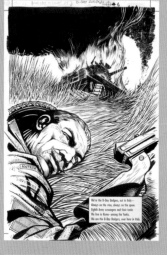 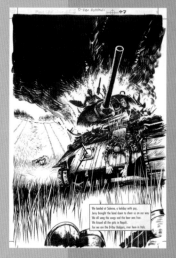 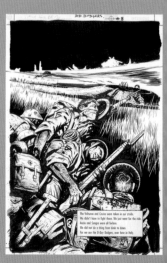

 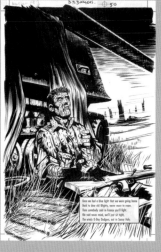 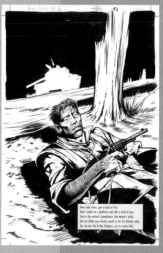 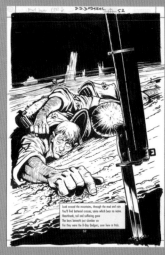

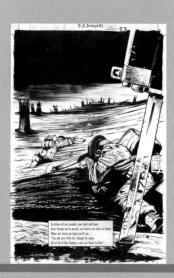 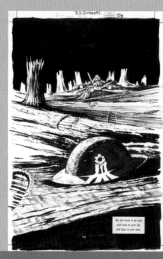 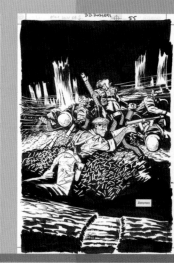

The stories I have collaborated on with Garth Ennis have always entertained and involved me as a reader before I do my job as the artist: your enjoyment must show throughout any job you do.

Garth used the true Second World War story as the basis for *D-Day Dodgers*, originally done for DC Comics in 2001. A new edition will be coming out 2017.

The first page starting with Garth's signature humour, with the last ten full pages showing the poignant aftermath of the battle of Monte Cassino, one of the bloodiest battles of the Italian front in the Second World War.

Each scene has a visual connection in the background to the next panel page.

The opening sequence of *Haunted*, written by Warren Ellis, showing over four pages the all-too-painful recovery from a brutal beating of John Constantine.

No shaking-off this attack with little sign of physical damage as we usually get in superhero comics.

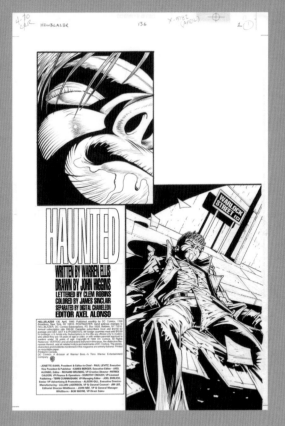

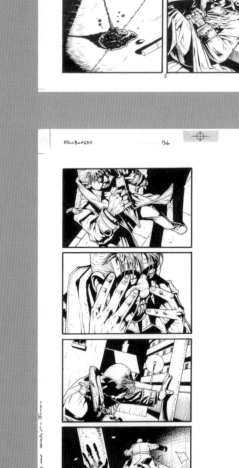

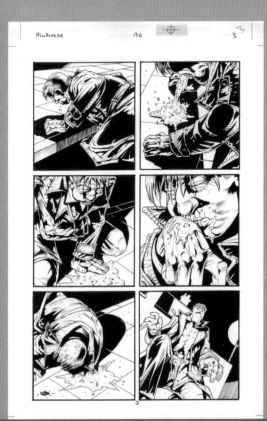

Poor John suffered over the rest of the issue and into the next before he recovered sufficiently to get back to fight demons and black-art magicians.

After working on *Curse of the Crimson Corsair* in 2013, a project that was particularly immersive and pressured, I decided that I wanted to step back a bit and do more personal projects in 2014. I was being asked to collaborate on a number of proposals that had great potential, with what I saw as very good prospects, but for one reason or another all four projects ended up with me doing a lot of work for very little reward. There is only so far you can go with creative enthusiasm on projects that go nowhere and do not earn more than a cent – as my accountant keeps telling me. So as a freelance I will go back to working on licensed characters for publishers who pay a page-rate with potential royalties somewhere down the way. Then when (or if) I have managed to save a little, I will do more *Razorjack* or other personal projects that appear to have potential. I am already planning the next one … or two. I can feel the excitement of an untold story forming, elements are fizzing and popping in my mind already and I just need to find the right story alchemy and client.

Yuval Noah Harari, a world-renowned historian whose book *Sapiens* postulated theories and possibilities for why *Homo sapiens* became the dominant species on Earth, pointed out that compared to many other species, we are small, weak and slow. And our success is not because of brain-size either, as some other species have larger brains. What he appears to be saying is that we became dominant because of our imagination. We can speculate and believe the most abstract speculations. The thunder crashing over the mountains means that God is angry. Let us appease that god. We have contained a god's power by this idea. The sabre-toothed tiger kills and eats us, but, we then make this powerful beast the totem of our tribe, we take his power for ourselves. We humans have written the story of our own dominance.

I love this idea, which seems to suggest that we as a species are living a story written for us by us. We have a way of communicating, what Harari calls "fictive language". No other animal has this way of communicating abstract ideas, of using imagination in language to take "possession" of our best dreams and worst nightmares, which we can then communicate to others.

So here we are, combining the oldest profession – storytelling – with the oldest art form. By combining such ancient traditions we create one of the most modern forms of art, the comic strip. Modern comics as we know them started in the USA in the early 1930s, and graphic novels became an accepted form of literature only in the 1980s, just when my freelance career started! I do not claim it is all my doing, but for once I was in the right place at the right time.

A freelancer's lot is to propose many ideas for different projects. Not all will see print, no matter the provenance of the client, creative team or how original the characters are.

This is a set of characters designed for *Arcadia*, collaborating with writer J.P. Rutter.

A fun project, collaborating with writer Richmond Clements on Sally Jane Hurst's *Zodiac*. This is a long-in-gestation idea that I think will see completion in the future.

My apologies to all letterers, I placed the word balloons on the page solely as a guide to the story, with not a lot of consideration to the design!

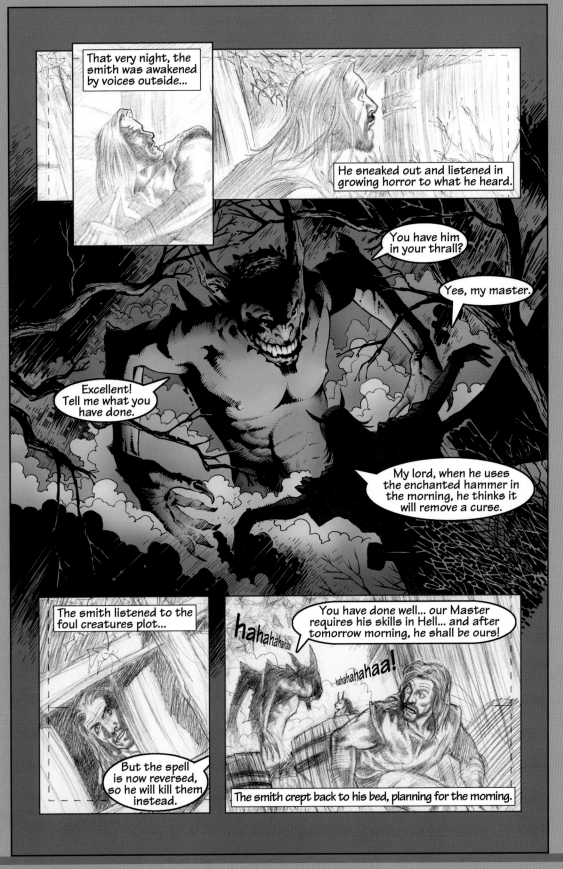

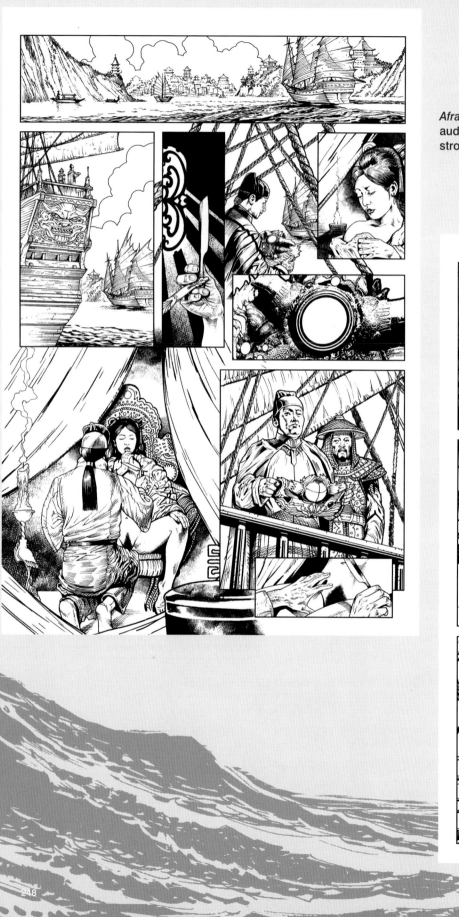

Afrasia – sample pages for Dcybelart, a French audiovisual company. European comics have a strong tradition of historically based stories.

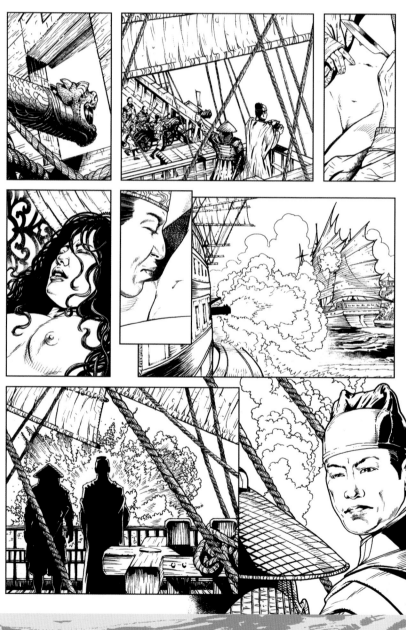

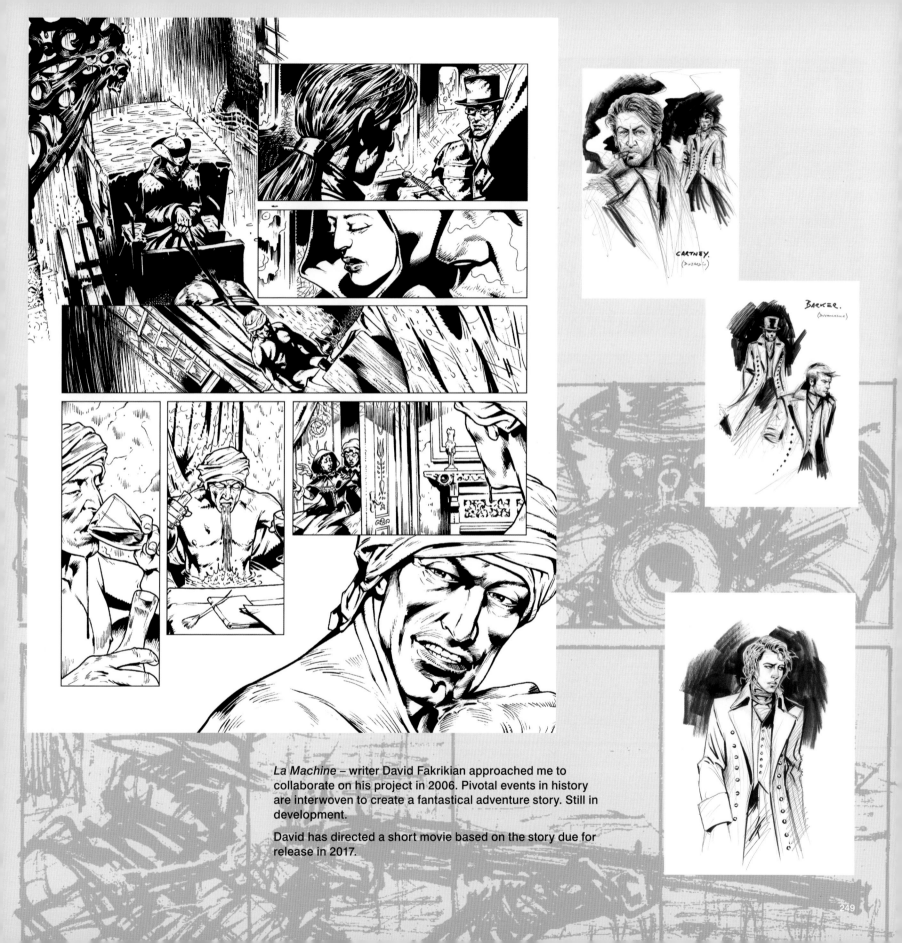

La Machine – writer David Fakrikian approached me to collaborate on his project in 2006. Pivotal events in history are interwoven to create a fantastical adventure story. Still in development.

David has directed a short movie based on the story due for release in 2017.

CARTNEY.
(DUTDAGE)

BARKER.
(DUTDAGE)

249

Project Trinity. I was approached by a well-established media company to develop a character for an ongoing comic strip. The company did not carry it through. I think it has great potential and I intend to develop it further.

The mechanics and process of story and art are not smoke and mirrors, it is not magic. Someone once said, "Genius is ninety-nine per cent perspiration and one per cent inspiration!" That also applies to comic-strip storytelling. All the processes are exactly the same for anyone who wants to be a freelance comic artist, even if they were born a Will Eisner, a Frank Hampson or a Jack Kirby. Those three are comics geniuses, but every aspect of being a successful freelance artist is exactly the same whoever you are. You have to find clients, produce the work for deadline and get paid. It's as simple as that.

I love the connection all creative people have, past, present or future; you can never learn too much about other artists or how they approach their art. Computers and digital hasn't changed how you start a story, and the finish is still just colour and words. The readers' perception has not changed in how they enjoy reading, printed or digital.

No question is too stupid to ask a writer or artist about how he or she creates a story … unless it's "Where do you get your ideas from?" And even that one has an answer. Ask Neil Gaiman.

Always enjoy the job you are working on – if you don't it will show: remember how important fluidity is.

Always give yourself wriggle room.

Never let the writing stop you being creative: if you need to throw out a great idea, do so – never shoehorn it in.

Never finalise the panel layout on the first go (unless you have decided to do a strict panel layout, for example *Watchmen*).

Never finalise the composition of each panel until you have read and reread the story and have done thumbnails to compose the layout: first thumbnail, second thumbnail, then resize to 50 per cent up with more detail while considering the position of the word balloons.

Even when you get to the art stage continue to add and subtract; change anything if it makes for a better story.

You never become freelance to have an easy life. You have to be driven and – I'm ashamed to admit it – to be selfish. It does not always come before everything else every time, but in the end the story and deadline will come first.

Oh, and one final element to be a successful freelance … you need to be eternally optimistic.

I probably did more research for this book than for most of the other projects I have done, but in most other projects who can tell me how a mutant gets mutated, or how a zombie decomposes?

(Page 232 of this book if you need to know how I do them!) I wrote this book because even though I knew that *I* loved storytelling, I wondered what it meant to other people. I found the best answer ever, and it is one agreed by everyone: storytelling is an imperative within all of us. I had not been kidding myself for all these years – it really *is* important!

One last quote from a singular and particularly brilliant storyteller, Roald Dahl (*Willy Wonka*, *James and the Giant Peach* etc.):

"Watch with glittering eyes the whole world around you because the greatest secrets are always hidden in the most unlikely places. Those who do not believe in magic will never find it."

And so, good night children of all ages, wherever you are.

Illustration for *Dementamania*, a horror movie produced in 2014. Writer/creator Anis Shlewet.

MATERIALS AND TECHNIQUES
FROM PENCIL TO DIGITAL

I am now going to talk about materials and methods. All artists love talking shop … I have been looking forward to this chapter since the introduction!

To be an artist you only need a pencil.

Materials: a clutch pencil is a versatile way of using graphite leads which you can buy in refill capsules of any hardness.

The designations for pencils go from 9H (very hard) to 9B (very soft) and every weight in between.

Avoid the H pencils for drawing. HB is my favourite weight: it retains a hard point for longer than a softer lead but can go from light guide lines to a very dark tone.

For comic-strip pencils I tend to go for non-repro blue 0.5mm leads in propelling pencils.

You do not need to erase these blue lines as much as graphite pencil lines. If you do need to erase I use a variety of rubbers, starting with a soft putty rubber for very light erasing to an electric eraser that will take any pencil line off and even a light ink line.

All you might need in a studio.

Comfy chair, plate of biscuits, a hot drink and good reading material for when you require a break from the drawing board.

A large clear window to let in as much natural light as possible. A good drawing chair, to support your back and adjustable in height.

A drawing board that you can adjust the height and surface angles. As many flat surfaces as you can get in the studio. Anglepoise or adjustable lamp with a daylight bulb. A laptop holder or flat surface. Sound system and shelving for models, reference books and DVDs.

Artist Leigh Gallagher's mixed traditional and digital studio.

UGEE 19-inch graphics drawing pen tablet, connected to a Mac using Photoshop, on the left.

Drawing board still the dominant feature in Leigh's studio to the right.

Artist Wayne Nichol's full digital studio:

PC Eizo 23-inch Dell 24-inch

Photoshop

Paint Tool Sai

Wacom Cintiq 22HD

Monitors are Eizo fs2333 & Dell Ultrasharp 2407.

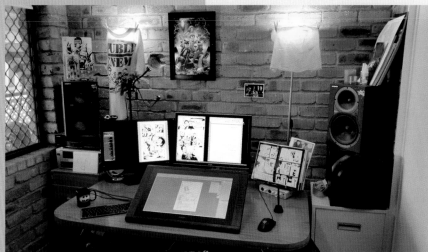

I start any idea rough with a black ballpoint pen.

Potential major problems with any studio work are repetitive strain injury, a bad back and muscle pains.

Changing position is very important, as is taking regular breaks.

I started wrapping tape around my fingers very early in my career, this stops pencil pressure on your digits but also stops strain on your joints by putting gentle tension across the knuckles.

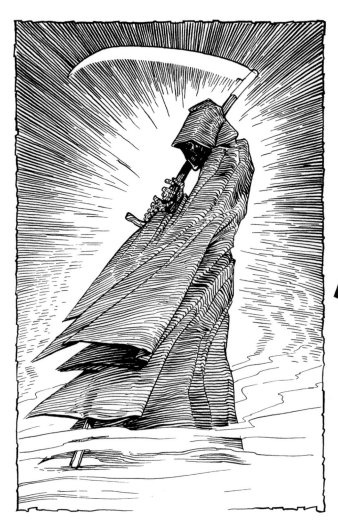

Grail Quest was when I first practised a dip-pen technique.

A good permanent black Indian ink, with a variety of nibs, different points and hardness. Soft nibs allow a thick and thin flowing line. Hard for outlines and rendering.

With a dip pen you can reverse the stroke and come back on the line, which is difficult with brush inking.

HP (Hot press) CS10 board or paper is a good surface to work on. Also Bristol board. Both are produced specially for ink work and can be used for airbrush.

A round-tipped scalpel #10 can be used to scrape the surface clean of ink mishaps or scrape white lines across black ink lines on HP board or paper.

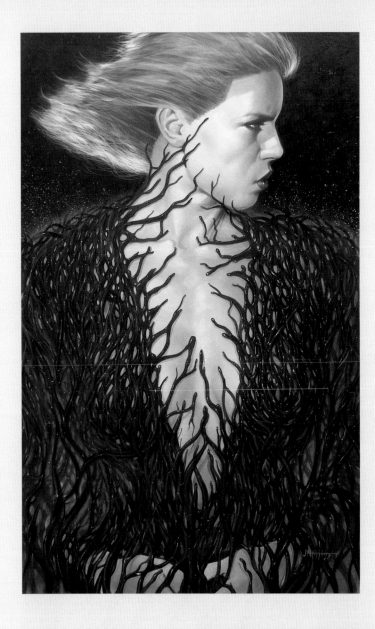

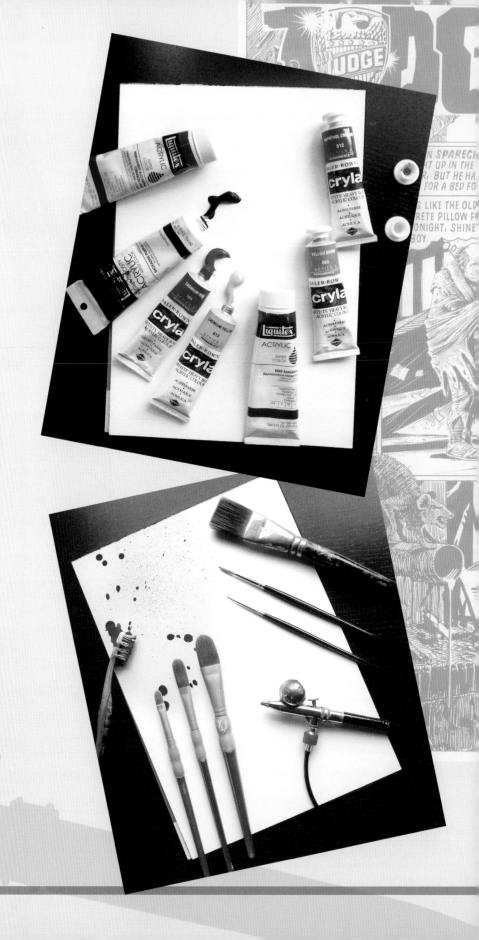

World Without End was a great learning curve for me and a style crossover title, using many techniques on the interior pages. But the covers were acrylic, mainly Liquitex. The art was larger than A2 (see page 266 for A-sizes) on HP board.

I block in areas with very large soft squirrel-hair brushes, then working down to the finest Windsor & Newton sable brushes, which are very expensive but hold the point and shape, and last longer. Always wash your brushes in soap or even shampoo to keep them soft and dandruff free (joking about the dandruff).

Using airbrush for glazes and soft graduated tones. The toothbrush was used for the red spatter around the figure.

I tried many line techniques before I arrived at one that suited me completely. This art is dip-pen and brush on CS10 paper; Windsor & Newton sable brushes 3a up to 5 are good sizes for inking.

The advantages for brush over dip pen is that the feathering can be more accurate and clean. Sable brushes are expensive but they keep the point and shape for longer.

Little hand tremors that go straight to the tip of the nib on a dip pen are softened by the flexible sable hair end to a brush, so no wobbly lines.

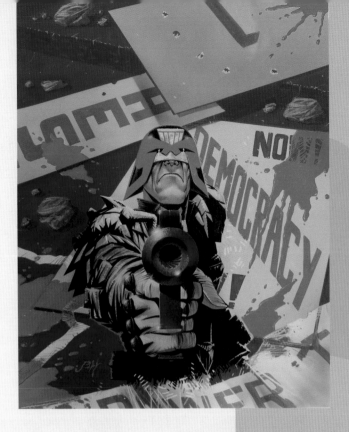

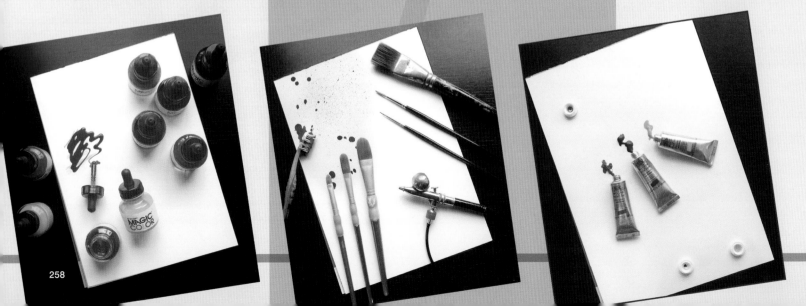

Here on Dredd's chin,
build-up gave a texture
that created a bristle and
pore effect.

Probably my favourite paint technique: gouache and magi-colour acrylic inks. The gouache colour is vibrant and can be used for very delicate brush glazes and it has a nice build-up facility.

Gouache paint works very well in the airbrush, but you cannot work over the gouache-sprayed surface with a fibre brush again as it is just too delicate. This is where magi-colour works best; with a light airbrush spray it not only gives a transparent colour glaze but also slightly fixes the paint, so working over it again can be done.

Both paintings are on A2 not surfaced, wash and line board. This cold-press watercolour board can be used with paint, line and airbrush. The surface is smooth but not HP, so it has a slight porous surface with tooth to accept washes cleanly.

Gouache is a water-based paint, the surface can be reactivated or damaged with water. Acrylic is a water-based paint that dries with a permanent surface, impervious to all but flame! Magi-colour is a permanent ink that can be thinned with water but dries permanently.

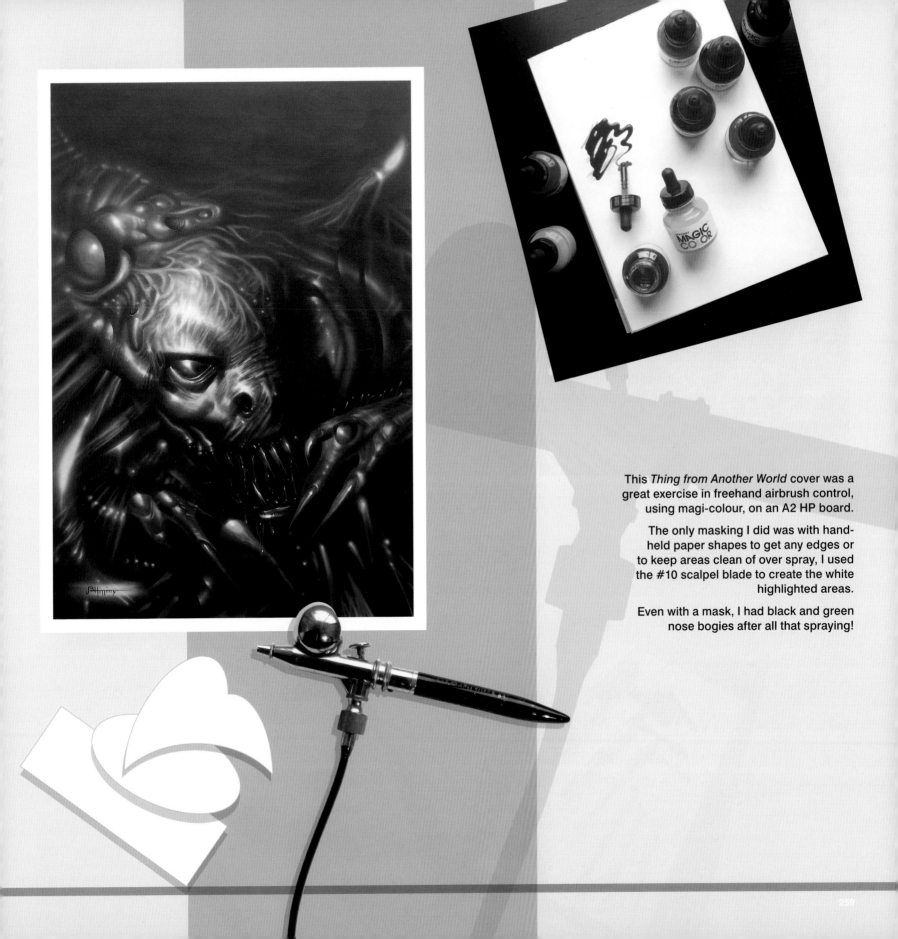

This *Thing from Another World* cover was a great exercise in freehand airbrush control, using magi-colour, on an A2 HP board.

The only masking I did was with hand-held paper shapes to get any edges or to keep areas clean of over spray, I used the #10 scalpel blade to create the white highlighted areas.

Even with a mask, I had black and green nose bogies after all that spraying!

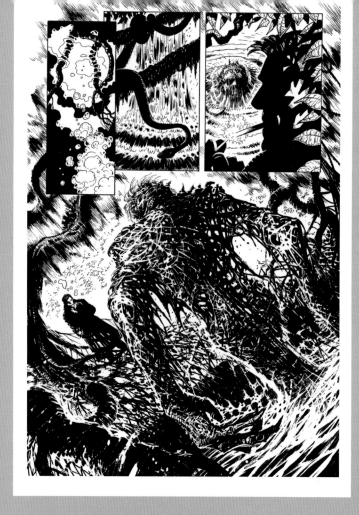

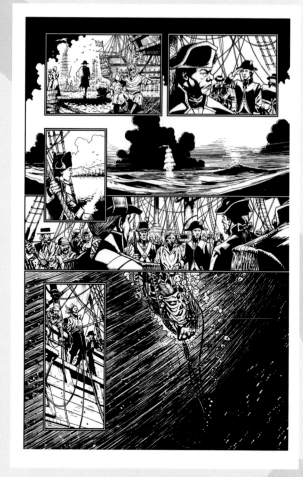

For this sample page in 2001, I had arrived at the technique I now used for all my black-line art. Felt tips from the largest blocking in size down to the smallest .005 fine tip.

For whiting out I have found water-soluble Tipp-Ex works perfectly with no bleed-through, and dries in seconds.

Both art pages are on A3 Bristol board.

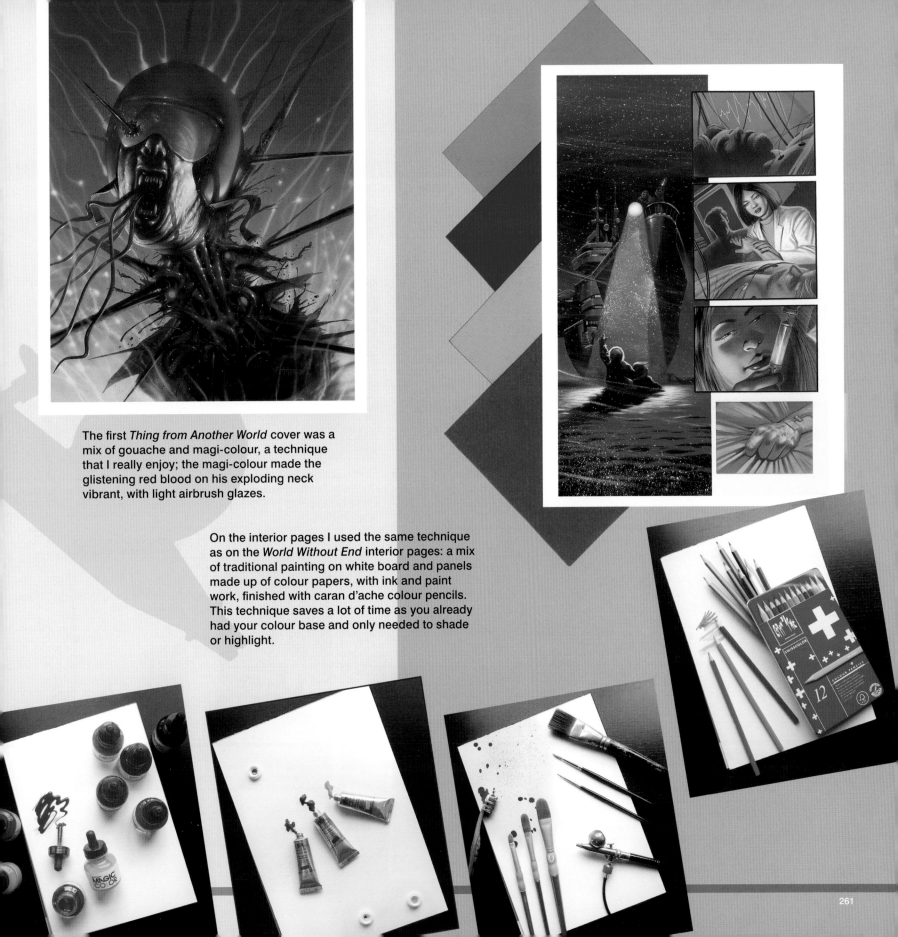

The first *Thing from Another World* cover was a mix of gouache and magi-colour, a technique that I really enjoy; the magi-colour made the glistening red blood on his exploding neck vibrant, with light airbrush glazes.

On the interior pages I used the same technique as on the *World Without End* interior pages: a mix of traditional painting on white board and panels made up of colour papers, with ink and paint work, finished with caran d'ache colour pencils. This technique saves a lot of time as you already had your colour base and only needed to shade or highlight.

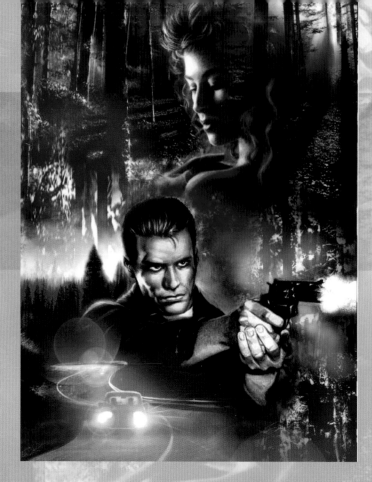

The digital age, this *Razorjack* cover was a straightforward photograph of model Una, against a mirror with cling film draped over her.

B/W photo scanned in and then digitally coloured.

Scanned into Photoshop as an RGB file, I made three or four copies of the cover on separate layers, coloured each layer the appropriate colour in curves, then erased down to the other layers, creating a full-colour effect.

I flattened the layers, then tweaked the hue and saturation until I had the colour effect I wanted.

A similar technique to the *Pride & Joy* covers, which I painted in black-and-white acrylics on very cheap stretched paper.

Converted to CMYK and tweaked for print.

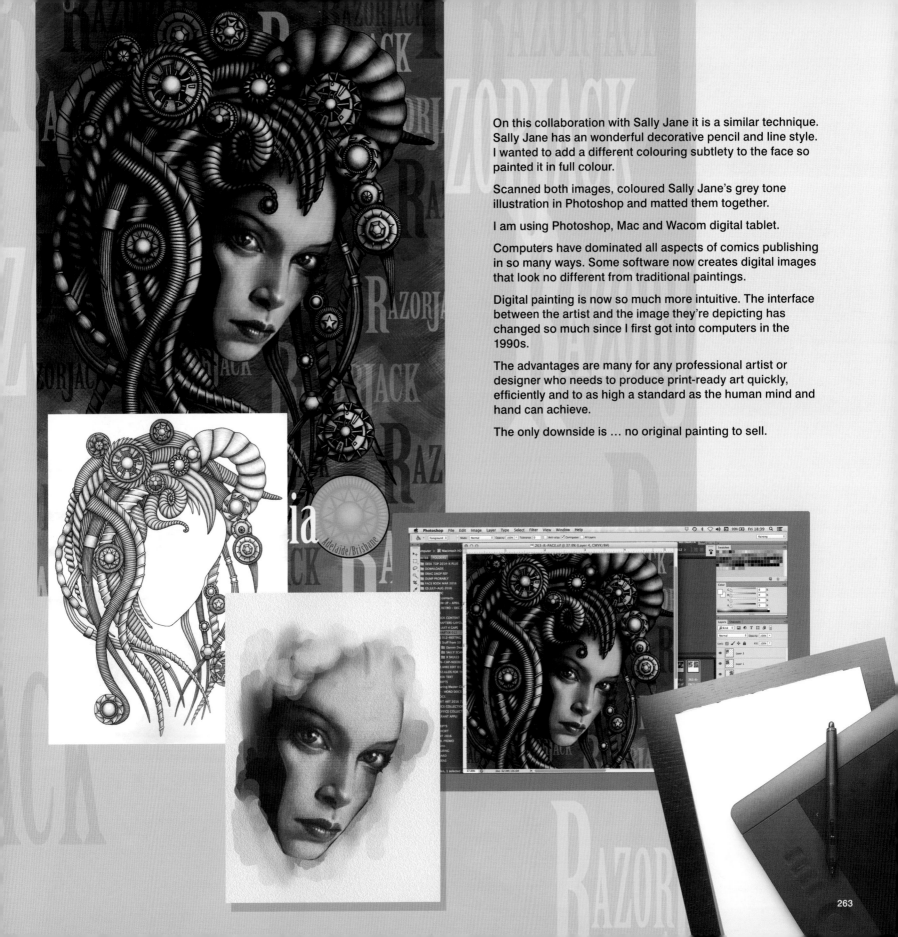

On this collaboration with Sally Jane it is a similar technique. Sally Jane has an wonderful decorative pencil and line style. I wanted to add a different colouring subtlety to the face so painted it in full colour.

Scanned both images, coloured Sally Jane's grey tone illustration in Photoshop and matted them together.

I am using Photoshop, Mac and Wacom digital tablet.

Computers have dominated all aspects of comics publishing in so many ways. Some software now creates digital images that look no different from traditional paintings.

Digital painting is now so much more intuitive. The interface between the artist and the image they're depicting has changed so much since I first got into computers in the 1990s.

The advantages are many for any professional artist or designer who needs to produce print-ready art quickly, efficiently and to as high a standard as the human mind and hand can achieve.

The only downside is … no original painting to sell.

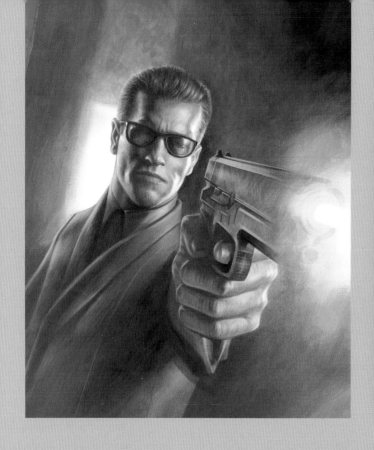

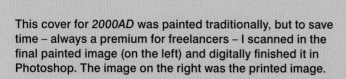

This cover for *2000AD* was painted traditionally, but to save time – always a premium for freelancers – I scanned in the final painted image (on the left) and digitally finished it in Photoshop. The image on the right was the printed image.

Adding more colour in Photoshop, highlights on the gun and muzzle flash. Tweaking with Photoshop paint brushes added more definition across the whole image.

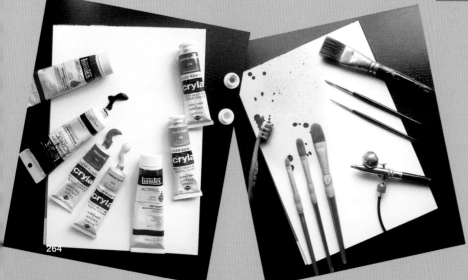

The arrival of the computer has had a greater impact on colouring than any other aspect of the comic-creation process.

I strived to create this airbrush effect in the early days of my career; now I can achieve it in a fraction of the time – as here on *Meet Darren Dead* – and with no coloured nose bogies.

It may not be as much fun picking your nose now, but is a much more effective way of colouring a page.

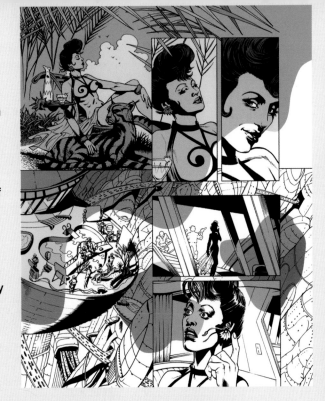

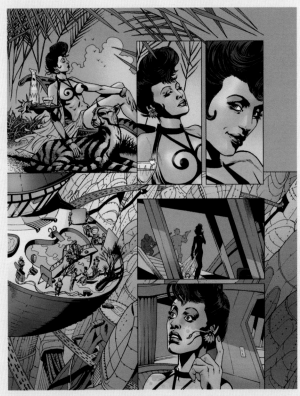

Start with blocking in the flats. This gives you the option of selecting individual areas. Then colour tonally, adding modelling, highlights and shadow.

Digital creation and manipulation now gives you the opportunity to step back as many times as you need. Even if you start traditionally with pencil, paint and ink, once you scan your work into a digital environment you can change every aspect of it before it goes to print. This is a great help for a freelancer on a tight deadline.

The minor downside for me of digital is it can preclude the "lucky accident". I believe that a form of creative fear can give a different dynamic to a picture, and particularly to a traditional painting. The lucky accident is when you have to follow an inadvertent choice (freelancers working to deadline never make mistakes, only inadvertent choices). This is an undecided painting avenue because of the mistake … er, inadvertent choice, that leads to the lucky accident. You can discover a new method or technique and find it adds substantially to the end result. The airbrush painting of *The Thing from Another World* cover was my attempt to precipitate the lucky accident in a controlled way.

Lucky accidents are usually precipitated by time constraints, and can be anything you have not planned for, such as when you are rushing and you see the paint you are airbrushing suddenly pool and dribble down the painting. You can't brush it away, so you incorporate it into the design and it looks incredible. Or you do brush it away and it suddenly opens the images and creates a quiet moment on the painting as you blend it in. It is anything that changes the picture for the better that started with an inadvertent choice … or mistake.

It is important to remember that when you work digitally, you are basically working with light. RGB refers to the colours red, green and blue used for representing what you see on a computer display. These can be combined in various proportions to obtain any colour in the visible spectrum. However, all professional hard copy printers create colours through combinations of cyan, magenta, yellow and black inks, abbreviated to CMYK. For an RGB image to be printed, it must first be converted to CMYK. Usually your software or hardware can convert the image automatically, but the conversion doesn't always create a perfect match: colours might appear darker or brighter or even a totally different hue to the ones you saw on screen in RGB. If you want your printed work to look good in print, you need to be familiar with how RGB will convert to CMYK. Example: black should be a mix of C60 M40 Y40 K100 for printed coloured line art.

The total saturation values for the four ink colours should not exceed 280%. Any higher and you risk the paper becoming "wet" through ink-pooling. It's unlikely that you wouldn't see onscreen saturation as high as this – in a colour perception sense it would look *wrong* – but most digital illustration software will allow you to stipulate a maximum percentage output.

You *can* calibrate your computer settings for your colour image to print out as you see it on screen, but these days most computers are so efficient that it is not usually necessary to do this.

A0 = 841 x 1189mm, 33.11 x 46.81 inches.

A1 = 594 x 841mm, 23.39 x 33.11 inches.

A2 = 420 x 594mm, 16.53 x 23.39 inches.

A3 = 297 x 420mm, 11.69 x 16.53 inches

A4 = 21.0 x 29.7cm, 8.27 x 11.69 inches

A paper sizes against each other and relative to a human figure.

AO

A1

A2

A3

A4

Line art should be scanned at 400dpi (dots per inch) or higher. On *Absolute Watchmen* we worked at 600dpi. For full-colour art (with no line work) you do not need to be at such a high resolution, but I still prefer to work at a minimum of 400dpi.

Whether working on a digital painting or line art, the final printed size should be your *minimum* working size: if you work too small and then scale up the image, any sharp edges will become blurred. It's simplest to work one size-unit larger than you'll need: if your final work will be printed at A4, then work at A3. For A3, work at A2, and so on. Reducing art for print tightens up all the elements and any "inadvertent choices" will smooth out.

While working digitally, be wary of zooming in too tight on the screen and making tiny tweaks to the artwork, because that's a sure-fire way to lose huge chunks of your workday on elements that in the final print will be barely visible to the naked eye. Instead, try to work with the image on screen just a little larger than it will be in print, and regularly pull back to look at all the image on screen to keep your eye on how it is developing as a whole.

The art paper I use regularly.

HOW TO

… be a comic artist … write a comic script

… plot a comic story … produce a page of art

… self-publish

… keep copyright

… produce digital art.

All the above and more has been covered throughout this book. If you skipped to the end to find out what happened, shame on you – go back and read it all properly! And the final words of the book are three personally guaranteed methods of getting you work! And that is no idle boast.

In this book I have tried to touch on every part of the process required to become a comic-book artist, but to cover in detail every facet of every one of the myriad roles required to produce a comic-strip story ready for print would take a book a least a hundred times longer. If you would like more specific detail on any aspect, then look to your local bookshop, library or the internet: there are some incredibly helpful books, articles, magazines and online tutorials that will give you as much detail as you need. There are countless online forums where you can exchange notes, problems and ideas with other creators at every level, from absolute beginner to accomplished genius, and everyone is happy to share their knowledge.

Remember, knowing everything that you need to know is just the first step in knowing what you *don't* need!

The three guaranteed methods for getting work:

> 1 – Be cheap or, even better, work for nothing.

> 2 – Be the best you can, hit the deadlines and don't complain.

> 3 – Sleep with the editor.

OK, two of those you definitely do *not* do!

If I have repeated certain things (I am not blaming the editor for not picking them up!), then they *needed* to be repeated.

Now go forth and create!

"Creativity is contagious, pass it on" – Albert Einstein

English Department at Liverpool University for the last five years. One of the highlights of the course has been the contribution from various comics' creators who have held workshops for the students to help them with the creative elements of assessment on the module. John has been particularly generous with his time in this respect – offering extremely insightful technical expertise, delivered with great charm and a fantastic mixture of entertaining anecdotes and philosophical advice. All of which is on ample display in this excellent retrospective of his extraordinary career to date.

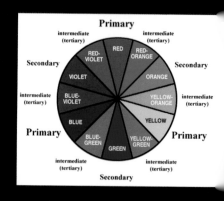

One of the great pleasures of teaching comics to undergraduate literature students is in expanding their sense of how stories can be told. The interrelationship of words and pictures, the sequencing of images, the strange accommodation of time and the illusion of three-dimensional space within a static and two-dimensional medium give comics a unique storytelling grammar and vocabulary.

John's colour work for *Watchmen* is a perfect example of the surprising ways in which pictures can tell a story. *Watchmen* is a densely constructed text, rich in allusion to a bewildering range of material from classical satire to late twentieth-century history, Romantic literature to comic books from the 1940s to the 1980s. But, particularly for readers unfamiliar with this wealth of intertextual connection, perhaps the most striking thing about the comic is its distinctive use of colour. Each of the Watchmen is identified with a particular colour – whether it's the Comedian's yellow smiley, Ozymandias' royal purple or Nite Owl's prosaic brown. The relationship between these colours in terms of their position on the colour wheel allows the comic to establish subtle hierarchies of power and interdependence. By associating particular events with particular colours, the comic can signal the dramatic interweaving of story lines through a simple alternation of colour.

This is particularly apparent in the opening of Chapter II in which the complicated histories of the relationships between Ozymandias, the Comedian and Silk Spectre are hinted at by the way in which the purple backgrounds and muted palette of the Comedian's funeral contrast with the bright yellows and reds of Laurie Juspeczyk's interwoven visit to her mother. Various plot twists are signalled in the colours of this sequence (spoiler alert, in the unlikely event that anyone reading this hasn't already read *Watchmen*) – Adrian Veidt's responsibility for Edward Blake's death, Blake's relationship with Sally Jupiter (and thereby with her daughter) are all brought together wordlessly by John's use of colour.

Some of my favourite pieces of John's are the beautifully dynamic pen-and-ink drawings in which hard-boiled crime stories are told virtually wordlessly. As with much of his work on *Judge Dredd*, these showcase John's fantastic ability to give structure and meaning to his compositions, embedding connections that draw the reader on from panel to panel, expanding the scope of the narrative beyond the simple matter of plot. The excellence of John's draughtsmanship, his command of gesture and the representation of three-dimensional space all allow him to achieve with deceptive ease that great alchemy of comics' storytelling – the creation of a compelling and believable world out of a series of black lines on white backgrounds.

However extreme or exaggerated, however far-fetched – from the Cursed Earth and Mega-City One of *Judge Dredd* to *Razorjack*'s Twist Dimension – John's carefully realised worlds never fail to convince and engage his readers. With this book John has shared many of the technical secrets behind this achievement, with the same good-humoured generosity with which he has

John Higgins is probably best known for his colour work on *Watchmen*. John has worked as an artist, and sometimes writer, on such diverse characters as Judge Dredd, Batman and Jonah Hex. John self-published the acclaimed comic-book *Razorjack* in 1998, for which he was the sole creator, artist, writer and tea maker. He illustrated a set of stamps for the 350th Anniversary of the Great Fire of London for the Royal Mail in 2016. John wrote this autobiographical art book, *Beyond Watchmen & Judge Dredd – the art of John Higgins*, to coincide with a major retrospective exhibition of his work at the Victoria Gallery and Museum in Liverpool, in which ran from March until October 2017.

www.turmoilcolour.com

@razorjackrealm

Michael Carroll is the author of 25(ish) books, including the acclaimed New Heroes / Super Human series of superhero novels for the young adult market. He currently writes *Judge Dredd* and *DeMarco, P.I.* for *2000AD* and *Judge Dredd Megazine*. His other works include *Jennifer Blood* for Dynamite Entertainment, contributions to the Titan Books edition of John Higgins' *Razorjack* graphic novel and a series of Judge Dredd e-novellas for Abaddon Books. A former Herald of Galactus, Mike lives in Dublin, Ireland with his wife Leonia and their twin imaginary children Tesseract and Pineapple. He is over half-a-hundred years old and some days it really shows. In his spare time he writes short autobiographical pieces in the third person.

Visit his awesome website at www.michaelowencarroll.com

Leonie Sedman has worked at the University of Liverpool for fourteen years, originally in the Art Collections Department, but since 2004 as the Curator of the Heritage Collections, working on the development of the museum, managing the collections and developing exhibitions. Her academic background is in the archaeology of southern Jordan, and her research on the small finds from Busayra was included in the British Academy monograph *Busayra Excavations by Crystal M Bennett 1971–1980*.

Julian Ferraro is a Senior Lecturer in English at the University of Liverpool. He is writing a book on contemporary pictorial narrative and the intersection between literature, architecture and nostalgia, and supervises doctoral projects on the construction of city-space in the work of contemporary British and American writers, cartoonists and film-makers.

BIBLIOGRAPHY
(MOSTLY COMPLETE AND REASONABLY ACCURATE...!) MC – EDITOR

1975
"Untitled" – *Brainstorm* #5 (Alchemy Publications) – JBH's first published work.

1977
Brainstorm Fantasy Comix #1 (Alchemy Publications): Front and back covers by JBH.
"TIT Company" – Written and illustrated by JBH.
2000 AD #43 (IPC) – Cover.

1978
Graphixus #1 (Media & Graphic Eye Enterprises) – Cover.
Graphixus #4 (Media & Graphic Eye Enterprises) – Cover (The Spirit) drawn by Garry Leach, coloured by JBH.
Graphixus #5 (Media & Graphic Eye Enterprises): Full page illustration by JBH. "Barbarian" – Written and illustrated by JBH.
Star Lord #17 (IPC) – Cover.
Rock Art (Media & Graphic Eye Enterprises) – posters:
"Amazoid on Phobos"
"Deborah Harry"
"Sid Vicious"
"Laurel & Hardy"
"David Bowie"
Battlestar Galactica Annual (Grandreams):
"Battlestar Galactica" – B/W comic strip: Summarisation of the pilot episode.
"Doomsday Rock" – Text story: 6 B/W illustrations.
"Swamp World" – Text story: 4 colour illustrations.
"Chess-Players of Space" – Full colour painted comic strip.
"Bane of Baal Faar" – Full colour painted comic strip.
"Hijack in Space" – Text story: 6 B/W illustrations by JBH.
"Amazons of Space" – B/W comic strip.
Home Grown #2 (Alchemy Publications) – Cover.
Home Grown #3 (Alchemy Publications) – Cover.

1979
"Tharg's Future Shocks: Together" – *2000 AD* #108 (IPC) – Written and illustrated by JBH.

1980
"Ro-Jaws' Robo-Tales: The Robo Shrink" – *2000 AD* #176 (IPC).
Mission Galactica Annual (Grandreams):
"Switch in Space" – B/W comic strip.
"Dice With Death" – Text story: 6 illustrations.
"Planet of the Cyclops" – Full colour comic strip.
"Skirmish Beyond Skarfax" – Full colour comic strip.
"Enemy Within" – Text story: 5 illustrations.
"Final Showdown" – B/W comic strip.

1981
"Last Thought" – *2000 AD* #202 (IPC).
"Tharg's Future Shocks: The Last Rumble of the Platinum Horde" – *2000 AD* #217 (IPC).
"Joe Black's Tall Tale" – *2000 AD* #241 (IPC).

1982

"Tharg's Future Shocks: Salad Days" – *2000 AD* #247 (IPC).
"Tharg's Future Shocks: Horn of Plenty!" – *2000 AD* #248 (IPC).
"A Joe Black Adventure: The Hume Factor" – *2000 AD* #252 (IPC).
"Tharg's Future Shocks: The Bounty Hunters" – *2000 AD* #253 (IPC).
Star Wars: The Empire Strikes Back #154, #157 (Marvel UK) – Covers.
"A Joe Black Adventure: Joe Black's Big Bunco" – *2000 AD* #256 (IPC).
"Tharg's Future Shocks: No Picnic" – *2000 AD* #272 (IPC).
"Hot Item" – *2000 AD* #278 (IPC).
"The Great Detective Caper" – *2000 AD* #289–#290.
Star Trek Winter Special (Marvel UK) – Cover.
Daredevil Winter Special (Marvel UK) – Cover.

1983

"Time Twisters: Family Trees" – *2000 AD* #298 (IPC).
Star Wars #166–#168, #170 (Marvel UK) – Covers.
"Time Twisters: Einstein" – *2000 AD* #309 (IPC).
The Daredevils #4 (Marvel UK) – Illustration for text article.
"Pin-up: Mephisto" – *The Daredevils* #6 (Marvel UK).
"Time Twisters: The Startling Success of Sideways Scuttleton" – *2000 AD* #327 (IPC).

1984

Star Wars: Return of the Jedi #37 (Marvel UK) – Cover.
"The Castle of Darkness" – *Grail Quest* #1 (Armada) – Gamebook: Illustrations by JBH.
"The Den of Dragons" – *Grail Quest* #2 (Armada) – Gamebook: Illustrations by JBH.
"The Gateway of Doom" – *Grail Quest* #3 (Armada) – Gamebook: Illustrations by JBH.
Big K #9 (IPC) – Cover.
Nightmares #1 (Armada) – Anthology: Illustrations by JBH.
Nightmares #2 (Armada) – Anthology: Illustrations by JBH.
Nightmares #3 (Armada) – Anthology: Illustrations by JBH.
Star Wars Special (Marvel UK) – Cover.

1985

Star Wars: Return of the Jedi #81 (Marvel UK) – Cover (re-used from *Star Wars: The Empire Strikes Back* #154).
"Voyage of Terror" – *Grail Quest* #4 (Armada) – Gamebook: Illustrations by JBH.
"Tharg's Future Shocks: Car Wars" – *2000 AD* #434 (IPC).
"Tharg's Future Shocks: Project Salvation" – *2000 AD* #436 (IPC).
"Kingdom of Horror" – *Grail Quest* #5 (Armada) – Gamebook: Illustrations by JBH.
"ABC Warriors: Red Planet Blues" – *2000 AD* Annual 1986 (IPC).
Doctor Who Magazine Special (Marvel UK) – Cover by Dave Gibbons and JBH.
Carlton Heroes – Promotional poster featuring Captain Atom, The Question, Blue Beetle, *et al*.

1986

"Realm of Chaos" – *Grail Quest* #6 (Armada) – Gamebook: Illustrations by JBH.
"Judge Dredd: Beggar's Banquet" – *2000 AD* #456 (IPC).
The Transformers #50 (Marvel UK) – Cover.
"Judge Dredd: Letter From a Democrat" – *2000 AD* #460 (IPC).
"A War Between Blue and Red Zoids on Planet Zoidstar" – *Zoids Special* #1 (Marvel).
"Tomb of Nightmares" – *Grail Quest* #7 (Armada) – Gamebook: Illustrations by JBH.
"Judge Dredd: The Exploding Man" – *2000 AD* #471 (IPC) *2000 AD Sci-Fi Special* 1986 (IPC) – Cover.
"Judge Dredd: Russell's Inflatable Muscles" – *2000 AD* #480 (IPC).
The Transformers #79 (Marvel UK) – Cover.

Watchmen #1–#12 (DC) – Colours by JBH.

"Judge Dredd: Phantom of the Shoppera" – *2000 AD* #494–#495 (IPC).

2000 AD #500 (IPC) – Cover (part) by JBH.

"Judge Dredd: Crime Call" – *Judge Dredd Annual* 1987 (IPC).

The Transformers: Island of Fear (Corgi) – Gamebook. Illustrated by JBH.

The Transformers: Highway Clash (Corgi) – Gamebook. Illustrated by JBH.

1987

"Judge Dredd: On the Superslab" – *2000 AD* #504 (IPC).

"Legion of the Dead" – *Grail Quest* #8 (Armada) – Gamebook: Illustrations by JBH.

2000 AD #520 (IPC) – Cover.

Sinclair User #62 and #63 (Emap) – Cover.

"Judge Dredd: Revolution" – *2000 AD* #531–#533 (IPC).

"Pin-up: D.R. & Quinch" – *2000 AD* #536 (IPC).

"Pin-up : Rogue Trooper" – *2000 AD* #537 (IPC).

Watchmen graphic novel (Titan) – Colours by JBH.

"Freaks" – *2000 AD* #542–#547 (IPC) *2000 AD* #551 (IPC) – Cover.

2000 AD #552 (IPC) – Cover.

"Watchmen" – *Heroes Role Playing Module* #227 (DC) – Cover drawn by Dave Gibbons, coloured by JBH.

Eagle Annual 1988 (IPC) – Cover.

1988

2000 AD #555 (IPC) – Cover.

"Judge Dredd: Oz" – *2000 AD* #564–#565 (IPC).

2000 AD #569 (IPC) – Cover.

Batman: The Killing Joke graphic novel (DC) – Colours by JBH.

"Superman" – Radio Times (BBC Magazines) – Two-page strip, first page coloured by JBH.

"The Blob" – *Judge Dredd Mega Special* (IPC).

2000 AD #593 (IPC) – Cover.

"Death's Head: Keepsake" – *Doctor Who Magazine* #140.

2000 AD #602 (IPC) – Cover.

2000 AD Winter Special 1988 (IPC) – Cover.

"Judge Dredd: Last of the Bad Guys" – *Judge Dredd Annual* 1989 (IPC).

Earthworks by Brian Aldiss (Methuen) – Cover.

The Malacia Tapestry by Brian Aldiss (Methuen) – Cover.

The Shockwave Rider by John Brunner (Methuen) – Cover.

A Matter of Oaths by Helen Wright (Methuen) – Cover.

1989

"Judge Dredd: Breakdown on 9th Street" – *2000 AD* #620–#621 (IPC).

The Chronicles of Morgaine by CJ Cherryh (Mandarin) – Cover.

Exile's Gate by CJ Cherryh (Mandarin) – Cover.

"Follow that TARDIS!" – *Doctor Who Magazine* #147.

"Do Not Forsake Me Oh My Darling!" – *Death's Head* #5 (Marvel UK).

2000 AD #634 (IPC) – Cover.

The Fraxilly Fracas by Douglas Hill (Gollancz) – Cover.

The Sleeze Brothers #1 (Epic) – Cover designed by Andy Lanning, painted by JBH.

"Clobberin' Time!" – *Death's Head* #9 (Marvel UK).

Serpent's Reach by CJ Cherryh (Mandarin) – Cover.

"Judge Dredd: The Shooting Match" – *2000 AD* #650 (IPC).

"Judge Dredd: Joe Dredd's Blues" – *2000 AD* Annual 1990 (IPC).

"Mr. X: Windows" – *A-1* #2 (Atomeka Press) – Single panel on page 2 by JBH.

1990

Clone by Richard Cowper (Gollancz) – Cover.

The Colloghi Conspiracy by Douglas Hill (Gollancz) – Cover.

The Steerswoman by Rosemary Kirstein (Pan) – Cover.

The Knights of Pendragon #1 (Marvel) – Cover by Alan Davis and JBH.

The Twilight of Briareus by Richard Cowper (Gollancz) – Cover.

World Without End #1–#6 (DC).

"The Temple of Sweat" – *A-1 True Life Bikini Confidential* #1 (Atomeka Press) – Single page illustration.

Judge Dredd Annual 1991 (IPC) – Cover.

Abslom Daak – Dalek Killer (Marvel) – Cover pencils by Steve Dillon, finished art by JBH.

2000 AD Special #3 (IPC) – Judge Dredd: Full-page illustration by JBH.

1991

Orion in the Dying Time by Ben Bova (Methuen) – Cover.

Swamp Thing #110–#115, #118–#120, #122–#128 (DC) – Covers.

The Thing from Another World #1–#2 (Dark Horse).

Swamp Thing Annual #6 (DC) – Cover.

1992

"Swamp Thing" – *Who's Who in the DC Universe* (DC) – 2-page feature.

Batman vs. Predator #2 (DC) – Pin-up: Batman.

Mutatis #1–#3 (Epic).

"The Spider: Vicious Games" – *2000 AD Action Special* (IPC).

Judge Dredd Classics #67 (Fleetway Quality) – Cover.

The Thing from Another World: Climate of Fear #1–#4 (Dark Horse) – Covers.

The Terminator: Endgame #1–#3 (Dark Horse) – Covers.

Dinosaurs: A Celebration #3 (Marvel) – Illustrations: Bone-Heads and Duck-Bills.

1993

"Pin-up" – AIDS Awareness.

"Judge Dredd: Ex-Men" – *2000 AD* #818 (IPC).

"Wildside" – *Animal Man* #58 (DC) – Cover.

"Keepsake" – *The Incomplete Death's Head* #4–#5 (Marvel).

"Do Not Forsake Me Oh My Darling!" – *The Incomplete Death's Head* #6 (Marvel).

The Thing from Another World & Climate of Fear graphic novel (Dark Horse).

"Clobberin' Time!" – *The Incomplete Death's Head* #10 (Marvel).

Dark Horse Comics #15 (Dark Horse) – Cover.

"Zirk in 'Marooned'" – Heavy Metal.

1994

Scarlet Witch #1–#4 (Marvel).

"Storm" – *Batman: Legends of the Dark Knight* #58 (DC).

"Judge Dredd: Scales of Justice" – *2000 AD* #884–#885 (IPC) – Written and illustrated by JBH.

"Judge Dredd: Casualties of War" – *2000 AD* #900 (IPC).

Judge Dredd: The Hundredfold Problem by John Grant (Virgin) – Cover.

"What if Archangel fell from grace?" – *What If--?* #65 (Marvel).

2000 AD #919 (IPC) – Cover.

DC Master Series trading cards (Skybox):

#37 – "Monarch"

#38 – "Vandal Savage"

#39 – "Raven"

#40 – "Poison Ivy"

#41 – "Black Adam"
#42 – "Darkseid"
#43 – "Brimstone"
#44 – "Dr. Polaris"
#45 – "Blaze"
Superman: Man of Steel Platinum Series trading cards (Skybox):
#75 – "Last Son of Krypton?"
#77 – "Mongul Returns!"
#80 – "Hi-Tech!"
"The Bump in the Carpet" – *The Big Book of Urban Legends* (Paradox Press).

1995
"Things Fall Apart" – *Blood Syndicate* #24 (Milestone Media).
2000 AD #934 (IPC) – Cover.
Judge Dredd: Legends of the Law #5–#7 (DC) – Covers.
"Days Of Future Past – *Uncanny X-Men* #144" – *Marvel: Portraits of a Universe* #4 (Marvel) Illustration by JBH.
Judge Dredd movie poster.
"Judge Dredd: Caught Short" – *2000 AD* #953 (IPC).
"Judge Dredd: My Son the Hero" – *2000 AD* #955 (IPC).
John Jakes' Mulkon Empire #1–#6 (Tekno Comix).
"Chopper: Supersurf 13" – *2000 AD* #964–#971 (IPC).
2000 AD Winter Special 1995 (IPC) – Cover.
WildStorm Gallery trading cards (Image/WildStorm):
#19 – "Eliya"
#20 – "Emp"
#21 – "Fahrenheit"
Woodstock 1969–1994 (Marvel) – JBH's contribution unknown.

1996
2000 AD #975 (IPC) – Cover.
"Vector 13: Case Two: Trinity" – *2000 AD* #989 (IPC).

1997
The Lords of Misrule #1–#6 (Dark Horse) – Covers.
Pride & Joy #1–#4 (Vertigo).

1998
"Son of Man" – *Hellblazer* #129–#133 (Vertigo).
"Snakeyes" – *Nighthawk* #2 (Marvel).
"Interview: The Joker" – *Batman Villains Secret Files and Origins* #1 (DC) – Illustration.

1999
The Worm (Slab-O-Concrete).
"Haunted" – *Hellblazer* #134–#139 (Vertigo).
"Kosovo Refugee Benefit Special" – *Tales of Midnight* (Blue Silver Entertainment) Pin-Up.
"Citadel" – *Razorjack* #1 (Jack Publishing) – Written and illustrated by JBH.
"World Without End" – *Razorjack* #1 (Jack Publishing) – Reprints issues 1 and 2 of World Without End.

2000
"Puncture – preview" – *ComX Issue Zero* (ComX).
"Judge Dredd: Generation Killer" – *2000 AD* #1212 (Rebellion).

"Pin-up" – *Preacher* #66 (Vertigo).
Battletanx (TPI) – A mini-comic given free with the computer game of the same name. Written and illustrated by JBH.

2001
2000 AD #1234 (Rebellion) – Cover.
"Nexus Zero" – *Razorjack* #1 (Com.X) – Written and illustrated by JBH.
"Pencils and Sketches" – *Razorjack* #1 (Com.X).
"5 of Diamonds card: Razorjack" – Comics Festival 2001 charity deck – Trading card.
"Pin-up" – *Just a Pilgrim* #2 (Black Bull).
"D-Day Dodgers" – *War Story* (Vertigo).
Razorjack #2 (Com.X) – Written and illustrated by JBH.

2002
"A Night 2 Remember" – *2000 AD* #1280 (Rebellion).
Judge Dredd: Justice One (Rebellion) – Cover.
The Rookie's Guide to the Justice Department (Mongoose).
"Judge Dredd: Citizen Sump" – *Judge Dredd Megazine* #4.12–#4.13 (Rebellion).
"Chas Chandler" – *Vertigo Secret Files: Hellblazer* #1 (Vertigo) – Illustration by JBH.

2003
Hellblazer: Haunted graphic novel (Titan).
"Judge Dredd: Monkey on my Back" – *Judge Dredd Megazine* #204–#206 (Rebellion) – From an idea by John Higgins.
Alan Moore: Portrait of an Extraordinary Gentleman (Top Shelf Productions):
"Pin-up: The Little Things"
"Text article: Blue Man Blues" – Article written by JBH.
Doctor Who: Cabinet of Light by Daniel O'Mahony (Telos) – Frontispiece by JBH.
A Bold New Breed #1 (Levi Strauss) – A promotional comic for Levi's Type1 Jeans. Wrap-around cover.
"The Winning Side" – *Time Hunter* #1 (Telos) – Cover.
Comics Festival 2003 charity deck trading cards:
"Christmas Hulk"
"Christmas Hulk – line art"
"Ka-Zar"

2004
Hellblazer: Son of Man graphic novel (Vertigo) *Pride & Joy* graphic novel (Titan).
"The Clockwork Woman" – *Time Hunter* #3 (Telos) – Cover.
Identity Disc #1–#6 (Marvel).
"Faces" – *2000 AD* #1412–#1419 (Rebellion) – Written by JBH and Mindy Newell, drawn by JBH.

2005
"Judge Dredd: Fat Christmas" – *Judge Dredd Megazine* #227 (Rebellion).
Identity Disc graphic novel (Marvel).
"Hulk / Iron Man" – *Marvel Rampage* #7 (Panini).
Watchmen: Absolute Edition (DC) – All artwork completely recoloured by JBH.

2006
"Meet Darren Dead" – *Judge Dredd Megazine* #240 (Rebellion).
Thunderbolt Jaxon #1–#5 (Wildstorm).
2000 AD #1510 (Rebellion) – Cover.
"The Embarrassment of the Watchmen" – *Watchmen: 20 Anni Dopo* (Lavieri) Article written by JBH.

2007
Thunderbolt Jaxon graphic novel (Titan).
"Greysuit; Project Monarch" – *2000 AD* #1540–#1549 (Rebellion).
The Hills Have Eyes: The Beginning (Harper Paperbacks).

2008
"Townkiller" – *Jonah Hex* #28 (DC).
The Mythical Creatures Bible (Godsfield Press Ltd).
"Greysuit: The Old Man of the Mountains" – *2000 AD* #2009, #1617–1624 (Rebellion).

2009
"We Gotta Go Now" – *The Boys* #26 and 28 (Dynamite Entertainment).
Razorjack: Collected Edition (Com.X).
Razorjack Box Set: Standard Edition (Foruli Publications).
Razorjack Box Set: Deluxe Edition (Foruli Publications).
"Meet Darren Dead Eats, Shoots & Kills" – *Judge Dredd Megazine* #287–#289 (Rebellion).

2010
"Judge Dredd: What's Another Year?" – *Judge Dredd Megazine* #292 (Rebellion).
"Judge Dredd: The Talented Mayor Ambrose" – *2000 AD* #1674–#1678, #1684–#1685 (Rebellion).
"Judge Dredd: Idle Hands" – *Judge Dredd Megazine* #303 (Rebellion).

2011
Greysuit; Project Monarch graphic novel (Rebellion).
"Judge Dredd: Seved Cold" – *2000 AD* #1718–1725 (Rebellion).
"Judge Dredd: Unchained" – *Judge Dredd Megazine* #316–#317 (Rebellion).
"Judge Dredd: Choose Your Own Christmas" – *2000 AD* #2012 (Rebellion).

2012
"The Curse of the Crimson Corsair" – *Before Watchmen* (DC).

2013
Razorjack: Collected Edition (Titan).

2014
"Greysuit: Prince of Darkness" – *2000 AD* #1901–#1911 (Rebellion).

2015
2000 AD # (Rebellion) – Cover.
"Tharg's Future Shocks: Cloud Nine" – *2000 AD* #1943 (Rebellion) – Written and Illustrated by JBH and SJ Hurst.
"Jacked" – (DC).
"The Great Fire of London" – 5 special edition stamps (Royal Mail).

2016
"Greysuit: Foul-Play Book 4" – *2000 AD* (Rebellion).

2017
"Greysuit: Foul-Play Book 4" – *2000 AD* (Rebellion)